Pocket Guide to Color
with Digital Applications

Dr. Thomas E. Schildgen
Arizona State University

with
Frank Benham
Dot Lestar
Bob Jose

Delmar Publishers

an International Thomson Publishing company I(T)P®

Albany • Bonn • Boston • Cincinnati • Detroit • London • Madrid
Melbourne • Mexico City • New York • Pacific Grove • Paris • San Francisco
Singapore • Tokyo • Toronto • Washington

NOTICE TO THE READER

Publisher does not warrant or guarantee any of the products described herein or perform any independent analysis in connection with any of the product information contained herein. Publisher does not assume, and expressly disclaims, any obligation to obtain and include information other than that provided to it by the manufacturer.

The reader is expressly warned to consider and adopt all safety precautions that might be indicated by the activities described herein and to avoid all potential hazards. By following the instructions contained herein, the reader willingly assumes all risks in connection with such instruction.

The publisher makes no representations or warranties of any kind, including but not limited to, the warranties of fitness for particular purpose or merchantability, nor are any such representations implied with respect to the material set forth herein, and the publisher takes no responsibility with respect to such material. The publisher shall not be liable for any special, consequential or exemplary damages resulting, in whole or in part, from the readers' use of, or reliance upon, this material.

Cover Illustration: John MacDonald

Delmar Staff
Senior Administrative Editor:John Anderson
Development Editor: Michelle Ruelos Cannistraci
Production Manager: Larry Main
Art and Design Coordinator: Nicole Reamer
Marketing Manager: Jennifer Curran
Editorial Assistant: John Fisher

COPYRIGHT © 1998
By Delmar Publishers
a division of International Thomson Publishing Inc.
The ITP logo is a trademark under license.
Printed in the United States of America

For more information, contact:

Delmar Publishers
3 Columbia Circle, Box 15015
Albany, New York 12212-5015

International Thomson Editores
Campos Eliseos 385, Piso 7
Col Polanco
11560 Mexico D F Mexico

International Thomson
 Publishing Europe
Berkshire House 168-173
High Holborn
London, WC1V7AA
England

International Thomson
 Publishing Gmbh
Königswinterer Strasse 418
53227 Bonn
Germany

Thomas Nelson Australia
102 Dodds Street
South Melbourne, 3205
Victoria, Australia

International Thomson
 Publishing Asia
221 Henderson Road
#05-10 Henderson Building
Singapore 0315

Nelson Canada
1120 Birchmount Road
Scarborough, Ontario
Canada M1K5G4

International Thomson
 Publishing–Japan
Hirakawacho Kyowa Building, 3F
2-2-1 Hirakawacho
Chiyoda-ku, 102 Tokyo
Japan

3 4 5 6 7 8 9 10 XXX 02 01

Library of Congress Cataloging-in Publication Data

Schildgen, Thomas E.
 Pocket guide to color with digital applications / Thomas E.
 Schildgen, with Frank Benham, Dot Lestar, Bob Jose.
 p. cm.
 Includes bibliographical references (p.247).
 ISBN 0-8273-7298-1
 1. Electronics in color printing. I. Title
 Z258.S33 1997
 686.2' 3042--dc21 97-18609
 CIP

Contents

Preface

Over the years, the ability to visualize and reproduce color has been scientifically analyzed and quantitatively defined. Despite these efforts to quantify the processes, color still remains a human sensation. Color is not digital, but color can be reproduced through digital applications. Regardless of the existing technologies and future developments, the business of color reproduction remains a subjective evaluation made by the customer. It is the intent of this publication to present both the quantitative and qualitative aspects of color. This book will address how we perceive original color images and how we digitally reproduce them. The primary focus will be the printing of color reproductions from electronic or digital data.

Some color originals are simple to reproduce, while other color images are very difficult. There are some color images that are virtually impossible to reproduce accurately. The most important concern is to understand the different customer needs. In this industry, fulfilling customer needs requires mutual effort and understanding. For example, one customer may need to match the color of a product regardless of what the photographer created. As in the mail order business, accurate color reproduction reduces customer returns, and thus facsimile color becomes a business necessity. Another customer may represent a travel agency and desire the enhancement of color images in an effort to improve the color of the sky and landscape. While yet a third customer may desire only pleasing color for the reproduction of children's books or inexpensive tool catalogs. Therefore a sales representative

needs to determine whether the usefulness of the product will define the color requirements.

Understanding color and how it is reproduced can be one of the most difficult concepts in the graphic arts, but it is also one of the most rewarding to understand. Fortunately, all aspects of the color reproduction process can be defined in a quantitative manner. Recent simplifications in the digital desktop technology of color reproduction should not discount the fact that color and its reproduction are a function of the hard sciences such as physics and chemistry. The ability to assign numbers and to apply the sciences to this reproduction process ensures that there will be consistency in results. Modern technical innovations make the science of color reproduction easier. The interactive densitometer in a desktop color manipulation software, or a handheld spectrophotometer, provide a customer or designer with the ability to accurately evaluate the reproduction process.

In the production environment, the ability to reproduce and evaluate color reproductions is often limited by human perceptions rather than the available technology. Regardless of the sophistication of processes and hardware, the customer preferences and service orientation of the business allow human differences to control the acceptance of color reproductions.

The collective efforts of the author and several supporting authors have made this book practical for industry applications. The supporting authors were chosen for their industry background. The work by Frank Benham represents years of service to industry organizations through his position as Vice President of American Color. The years of training and teaching, in combination with her prepress development work for Heritage Graphics, provide Dot Lestar a valuable perspective that she brings to this book. The work by Bob Jose highlights his years of industry experience and his current consulting activities.

This book is not designed to be another of the many "How-to Cookbooks for Color." The basic "how-to" can be gleaned from the ever-changing software/hardware man-

ual. Because the text has practical application to industry, it will also be a valuable resource for the academic community. Additional contributions to this book were provided by LaVerne Harris, an educator and editorial artist for Phoenix Newspapers, and Douglas Gasser, a technical sales representative for Imation.

This book is written for advanced high school students, community college students, and university students who have a desire to better understand the basic principles of color and the processes used in industry to deliver commercial quality color reproductions. Students of the fine arts or graphic design will benefit from the practical technical knowledge now required for a successful career. This book will be of value for prepress color personnel, sales representatives, and any professional involved in purchasing color printing.

As a pocket guide, this book offers a useful amount of information for both students and industry practitioners, and provides sources for additional in-depth information at the conclusion of each chapter. Both educators and industrial trainers may select to use these sources which include books, interactive CD-ROMs, and video tapes. There is an appendix to the book that addresses industry standards. The appendix presents a historical context for industry standards plus a listing of international standards. In addition, there is a glossary of terms for easy reference.

Understanding that the technology of digital reproduction will continue to evolve, this book focuses on the primary principles necessary for printing color reproductions in a production environment. Perhaps it is the manipulation of the digital color data stream that will define the different future applications of color reproduction. Printed color will remain viable for many years to come, but new products will co-exist. Companies that print catalogs and inserts, or publish magazines, will also market on the Internet. The company that can successfully use digital color data for ink-on-paper reproductions, multimedia CD-ROM applications, on-line data bases, and other resources, will remain profitable in the future.

Acknowledgments

David Bergsland, Albuquerque TVI, Albuquerque, NM

Ray Fontaine, Springfield Technical Community College, Springfield, MA

George Hauber, Millersville University, Millersville, PA

Jim Herr, University of Wisconsin – Stout, Menomonie, WI

Kirk McDonald, Colorado Institute of Arts, Denver, CO

Ryan Smith, Milwaukee Area Technical College, Milwaukee, WI

David Weatherston, Toronto, Ontario

Linda Weeks, Art Institute of Fort Lauderdale, Fort Lauderdale, FL

About the Author

Dr. Thomas E. Schildgen is Chairman for the Department of Information and Management Technology at Arizona State University, where he has been a professor of Graphic Communications for the last sixteen years. Dr. Schildgen served four years on the faculty of Illinois State University prior to joining ASU. Prior to completing his advanced education, he worked in the printing industry as a pressman, and prepress technician. He is active in many professional organizations and has served on the Board of Directors of the Association for Graphic Arts Training and the Education Committee for GATF. Dr. Schildgen is a national and international consultant for educational development, industrial training and the graphic arts industry. He has done work for QuadGraphics, Treasure Chest Advertising, and Mannington Resilient Floors.

Recently, Dr. Schildgen has coordinated several World Bank funded projects with the Republic of Turkey, worked with the U.S. Department of Defense Dependent Schools in Germany, and conducted an industry tour group of South Korean CEOs. He has authored several chapters in two other textbooks and presents on a regular basis for industry associations.

Section I

Human Perception of Color

Physiological Factors of Color

Understanding the differences that occur in the evaluation of color originals and the reproduction of those originals, requires some knowledge of human limitations. The physiological functions of color perception have been long studied and well documented. The point of confusion centers on where the physiological aspects of color perception end and the psychological aspects of color perception begin.

Color is a phenomenon of light, and a visual perception using the physical sense of human sight. As with most human senses, vision is susceptible to sensory adaptation. *Sensory adaptation* refers to a reduction in sensitivity to stimulation as the stimulus persists for a period of time. There is an increase in sensitivity when there is a lack of stimulation. For example, if you were exposed to extreme sunlight for a period of time, your eye would become less sensitive. If you walked into a dim room after being in the sunlight, you would not be able to see many of the objects until your eyes have adapted. The converse of sensory adaptation is experienced when you are in a dark room for a period of time and the eye becomes sensitive to very low levels of light energy.

As with all human sense organs, the eye is sensitive to physical energy. The human eye is sensitive to a very small portion of the *electromagnetic energy spectrum*. This portion of the spectrum is referred to as light energy. The human sense of hearing responds to a different portion of the electromagnetic spectrum. Electromagnetic energy travels in wavelengths similar to large waves or small waves in the ocean. The size of a wave is measured in the distance from one wave crest to the next. The electromagnetic spectrum

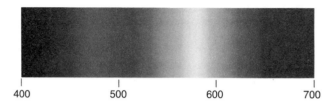

400	500	600	700

Figure 1-1 Visible light on the electromagnetic energy spectrum. See color section. *Illustration by LaVerne Harris*

begins with the shortest cosmic waves (10 trillionths of an inch) and extends to the longer radio waves that measure many miles. The human eye sees only about 300 nanometers starting with blue light waves that measure about 400 nanometers and ending with the longer red light waves of about 700 nanometers. A *nanometer* is a billionth of a meter. Some references refer to the use of millimicrons in the measurement of the electromagnetic spectrum. A millimicron is one millionth of a millimeter. The point is that visible light represents a very small portion of the electromagnetic spectrum (Figure 1-1).

Light is one of the four essential elements in the visual experience of color. For the human sensation of color vision, the following four elements are required:

1. A colored object

2. A light source to illuminate the colored object

3. The human eye as a receptor of the light energy reflected from the object

4. The human brain to interpret the electrochemical neural impulses sent from the eye

The colored object can be a swatch of cloth, a plastic object, or ink pigment on paper. There are many different pigments or colorants and these can be organic or inorganic in nature. The colored object either absorbs or reflects the incident light that illuminates it. Some objects,

such as a colored glass, can allow light to be transmitted through them, filtering all colors other than their own.

The light that illuminates the colored object provides the energy that is either absorbed or reflected from the object. Light travels at a speed of 186,000,000 miles per second or seven-and-one-half times around the earth in one second. At the speed that light travels, it is impossible for the human eye to see the different colored wavelengths of light. Light can vary in its Kelvin temperature, which ultimately affects the color of the light. It is critical in the graphic arts that a standard light source be used for color evaluation. The standard of 5000 degrees Kelvin provides for a balanced light source in the illumination of colored objects. A balanced light source refers to equal portions of red, green, and blue light.

The Role of the Human Eye

The human eye is the physical receptor of light energy. The major parts of the human eye are shown in Figure 1-2. As the eye focuses on a colored object, light passes through the cornea and is regulated by the pupil opening. The lens of the eye focuses the light on the retina in the back of the eye.

The retina is the light sensitive surface located around the back of the eye. The retina is made up of rods and cones, which are the photosensitive cells that convert the light energy into different nerve impulses. The retina also has ganglion cells and bipolar cells. Vision is a function of light energy reaching the rods and cones of the eye. The *bulbous cones* can see chromatic vision or color such as red, green, and blue. The cones can also see achromatic color such as white, gray, and black. There are more than six million bulbous cones distributed in the retina of the eye. The cones need higher levels of illumination to produce color vision.

There are around 100 million *rods* in the retina and they function in dim light conditions and produce mono-chromatic vision. The rods produce vision in times of low illumination. The rods see black and white or gray tonal values. If you look at a landscape during the daylight the

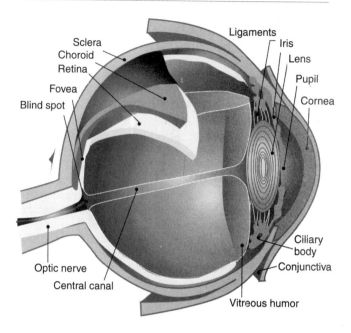

Figure 1-2 The major parts of the human eye. See color section. *Illustration by LaVerne Harris*

grass and shrubs are green and the sky is blue in color as a result of the different wavelengths of energy that stimulate the bulbous cones. Looking at the landscape at dusk requires the use of the rods in the eye and the green grass or blue sky appears to be a dark gray due to limited illumination.

The fovea is the most sensitive part of the retina in daylight conditions. The fovea is made up of only bulbous cones and is centrally located in the retina. The light reflected from a colored object is seen best when it strikes the fovea because these cones are connected directly to the optic nerve that transmits the data to the brain. Other cones and rods in the retina require a relay of nerves to the brain.

There are several theories regarding color vision. The most common theory regarding color (Young-Helmholtz

1802) proposed that the eye has three different color receptors, each sensitive to different wavelengths of the spectrum. Because the eye receives light energy it was proposed that the bulbous cones are either sensitive to red, green, or blue light energy.

Another more modern color theory includes elements from previous models of color vision. This theory is called either the zone or the opponent-process, and was proposed by Hurvich and Jameson. In the opponent-process theory, the eye has three color receptors, cones with broad bands of sensitivity, that peak at three different portions of the visible spectrum. These different wavelength receptors in the eye are connected to the ganglion cells, of which some are always active regardless of light energy. The ganglion cells that receive light energy pulsate faster and if the cell is inhibited in some way the pulsation diminishes. In this theory the ganglion cells can provide two opposing signals to the brain, which better explains differences in color vision and negative afterimages that we all share. If you stare at a bright green light source or, for example, an illuminated #58 green filter for 60 seconds or more in a dark room, then look at white light the eye will see magenta or red as a complementary or negative afterimage.

Physical Differences in Color Vision

If there are more than six million bulbous cones in the human eye, and some of the cones are sensitive to red while others are sensitive to green or blue, it would be difficult to imagine the odds of another person having exactly the same color sensitivity that you would have. If a red apple is placed in a viewing booth with a standard light source, it would be expected that each viewer would see an identical red apple. The reality of the workplace or viewing booth is readily apparent when individuals viewing the apple describe a slightly different color of red, based on their differences in physical color sensitivity.

It is difficult to describe color, even under a standard viewing condition, because there is no standard vocabulary or set of terms that explain visual differences. When

the attempt is made to use some common terms, the individual's visual color sensitivity would still represent a significant variable in the evaluation and definition of color. Thus the need for densitometry, colorimetry, and spectrophotometry to define color has gained popular acceptance. The only difficulty is that not everyone has these tools available, or they may choose not to use the devices. Often in the trade we tend to use ambiguous verbal descriptions and are willing to overlook differences in visual color sensitivity to make color approvals or to describe desired color corrections.

With experienced production or sales personnel, the business of evaluating and correcting color can usually survive at production pace without the need to quantify all of the variables. Having an understanding of the human variables can help determine when to use quantitative analysis or the different measurement systems. The evaluation of color printing is usually very difficult due to time constraints and other logistical difficulties. Over the last thirty years this industry has gotten better at improving color reproduction while shortening the production cycle time. The need to shorten cycle time will always be a critical factor in the reproduction of color, thus human evaluation is still used in place of some of the more exacting technologies.

The typical color prepress house or printing company works an average of three eight-hour shifts or two twelve-hour shifts. This is the best way of gaining maximum productivity and return on investment. Digital prepress equipment is capital intensive and a company cannot afford to have this equipment sit idle. The same expense is true for multicolor presses.

Difficulties occur when there are differences in color judgment between one work shift and another. Production people working days may perceive an image differently from the night crew. These differences can be based on the amount and color of light exposure the individual receives. Individuals working nights may see colder color as normal, and the personnel working days prefer warmer interpretations. These are just some of the subjective differences that result from physical adaptation over time.

Test for Color Blindness

Normal color vision is often called *trichromat.* Trichromat refers to a person having the ability to sense or discriminate light from dark, red from green, and yellow from blue. Color blindness is when an individual is limited in his/her ability to discriminate color such as red from green and yellow from blue. If a person has the ability to see contrast from light to dark and still discriminate one color pattern from another, that individual has *dichromat* vision. If the individual has only the ability to see contrast of light to dark, the person has the vision of a *monochromat.*

Research has indicated that women are usually less prone to being color blind. If a color blindness test is administered to 100 men, approximately eight would be color blind, usually in the red-green portion of the spectrum. If 100 women were administered the same color blindness test, only one woman would test color blind. Each time this research is replicated, the numbers increase for the gender differences in visual color deficiencies.

Metameric Color and Metamerism

When matching color or evaluating color reproductions, it is important that the viewing be performed under a standard light source. The industry standard of 5000° Kelvin provides a balanced amount of red, green, and blue light in a combination that creates average white light. The concept of average white light refers to partly cloudy conditions between 10:00 A.M. and 2:00 P.M. in the northern hemisphere.

The human eye has difficulty comparing color under different light sources. There are some colors that are called *metameric* because they appear to match under one light condition but are visually different under another light condition. A spectrophotometer has the ability to distinguish color by measuring its output on the electromagnetic spectrum. If colors have equal spectrophotometric curves, the colors should match under any light condition.

Figure 1-3 Rhem strips produced and distributed by GATF are an example of metamerism and are used to identify the standard light source of 5000° Kelvin. *Courtesy of GATF*

The effect of color matches changing in visual appearance under different light sources is called *metamerism. Metamers* is another term used to describe colors that have different spectrophotometric curves, but appear visually the same under a specific light condition.

The visual appearance of color will change if the light source, the colored object, or the response of the eye changes. This is why metameric matches are a problem in color reproduction that requires making a match using different materials. The match may visually appear acceptable under one light source, but when the light source is changed or the nature of the viewer is altered the color match will be affected.

Another term for a metameric match is a conditional match. The use of colorimetry to match colors is dependent on the Commission Internationale de l'Eclairage (CIE) standard observer viewing under one of the CIE standard light sources. The best way to get the correct color match is to follow a procedure for color evaluation that avoids the potential of metamerism.

For the last decade, the Graphic Arts Technical Foundation (GATF) has marketed the Rhem strip that can be carried by industry personnel to identify standard light conditions. Graphic designers, photographers, and print buyers, should all utilize these simple metameric matches for determining 5000° Kelvin viewing conditions (Figure 1-3). It is

not uncommon in the trade to find viewing booths that may have inexpensive fluorescent tubes as replacements for the original expensive viewing lights that burned out. Be aware that the fluorescent tube sold at the local hardware store is not color balanced. The Rhem strip will quickly identify such viewing problems.

Color Fatigue

A common effect that occurs when viewing a color for a period of time and then viewing another is called *color fatigue*. Color fatigue is sometimes referred to as negative afterimage. When the eye examines a bright light source or hue for a period of time, the bulbous cones that have been activated are overstimulated and will affect the next color or hue that is examined. It is as if part of the first color is subtracting from some of the second color. This effect does not last for more than several seconds, but should not be ignored when visually comparing color or hue. As a person becomes tired or mentally exhausted, this effect tends to increase. Professional photographers who used color compensating (CC) filtration viewing kits to examine color photographs were always instructed to keep the CC filters moving over the image to be viewed so that color fatigue would not become a factor in the analysis.

Perhaps you recall looking at a bright light source or looking out of a window on a sunny day, and then closing your eyes or walking into a dark room. It seemed as if you could still see a pattern of light because the cones had been activated or overstimulated. If you were to look at a bright magenta color for about 60 seconds and then shut the magenta light off, chances are that you would see a green patch where the magenta was. This complementary color effect is referred to as a negative afterimage. This phenomena will vary from individual to individual, but we are all affected and should be sensitive as to how this can modify color evaluation.

Physical Limitations of Vision

In its simplest form, color vision requires a colored object, a light source to illuminate the colored object, the human eye as a receptor of the light energy, and the human brain to interpret the experience. In the printing industry, color viewing is also a function of the physical differences and sensitivity of the human eye and brain under different conditions. If the average person is doing a color approval at 2:00 A.M., or has consumed alcoholic beverages, it can be expected that there will exist measurable differences in judgment. What is important to remember is that no computer application or quality control device can replicate these physical differences.

As we age, our eyes tend to lose their elasticity and transparency. The pupils of our eyes tend to get smaller with age and the reaction is more feeble. Age increases the incidence of cataracts and defective color vision. As the eye ages, a yellow filter effect increases over the eye. This effect may alter a person's ability to describe hue or color comparisons.

Research indicates that for the average person, vision is best at about 18 years of age. Vision will decline gradually between the ages of 18 to 40 years, and more rapidly from about 40 to 55 years. Another aspect of vision and aging is the increased need for illumination. For people over 50 years of age the amount of illumination becomes a factor. A person who is 50 years old may need 50% more illumination than when he/she was 20 years old. These physical changes in vision tend to occur over a yearly, monthly, weekly, daily, and hourly basis, and thus the brain adapts over time and the effect is not overly noticeable. Graphic arts industry personnel assigned to the tasks of color imaging should visit an eye doctor or be color tested on an annual or biannual basis.

One limitation of color vision is our inability to memorize color or tonal gradation. A person is only capable of comparing color under a standard light source. In an

industry where customer service is critical, an understanding of differences in color vision becomes a necessary work skill. The difference in color vision between a 22-year-old and a 52-year-old can have an effect on the evaluation of a color separation. These differences can and should be understood for effective communication to occur in the color viewing booth or next to the printing press.

The fact that human perception of color is dependent on the current status of the eye is valuable to identify the variables present in the field of vision. When fatigued, the eye and brain can be deceived by the adjacency effects of surrounding colors. Complementary or contrasting colors adjacent to a selected color can create illusions or visual differences that make comparisons very difficult.

In the book *Human Color Perception,* Joseph Sheppard, Jr. discusses the role of adaptation in human vision. A major point raised in the book is that white paper and common colored objects tend to be perceived as unchanged even when the light source varies between daylight and tungsten light. This means that the human visual process naturally performs a color adaptation for different types of illumination. White and object colors that are part of a color scene will still appear white and have their same approximate color under different lighting. The eye tends to focus on contrast in a colored image, and what appears as a white surface may in fact be light gray when compared to other values of white. Color adaptation is increased by greater details in the scene that require more complex analysis, thus allowing the eye to detect tonal range in the context of the image rather than by memory color or by different illumination.

The color that is seen is a mental interpretation by the brain of what the eye receives as a stimulus. The stimulus of the eye is a function of a light source and a colored object or sample. Variations in the light source, the colored object or the reaction of the eye, will result in an apparent change of color.

It has been estimated that the average human eye can see over nine million colors, while the color film can image

only 10,000 to 15,000, the sheet-fed printing press delivers 5,000 to 6,000, and the web press can only deliver 2,000 to 3,000 colors. This color compression is a limitation of color reproduction that must be understood by consumers as well as production personnel. Digital color technology is no longer limited to this color compression, but eventually the digital file will convert to the limitations of the press.

Digital color systems use bytes or eight binary digits (8 bits = 1 byte) to describe an image. A gray scale scan will produce 256 shades of gray, which is the maximum information to be stored in 8 bits. Thus in RGB color systems, each color represents 8 bits, or 24 bit color for all three, red, green, and blue. The use of 24 bit color (3 bytes) will produce a color palette of 16,777,216 values of color. The use of 24 bit color is acceptable because it exceeds what the average person is capable of viewing.

For More Information

The following sources will provide you with the additional information necessary to better understand the concepts introduced in this chapter. Some of the information in this chapter can also be found in basic psychology books and tutorials prepared by industry manufacturers.

Color Expert, Interactive CD-ROM. Albany, NY: Delmar Publishers, 1996.

Field, G. G. *Color and Its Reproduction.* Pittsburgh: Graphic Arts Technical Foundation, 1988.

Green, Phil. *Understanding Digital Color.* Pittsburgh: Graphic Arts Technical Foundation, 1995.

Sheppard, Jr., J. J. *Human Color Perception.* New York: American Elsevier Publishing Company, 1968.

3M Imaging. *Understanding Color.* St. Paul, MN: Printing and Publishing Systems, 3M Center. 1994.

Psychological Factors of Color

The ability to visualize and reproduce color images depends on the understanding of several phenomena that occur when an optical message is interpreted by the brain. The psychology of color is a soft science that tends to be more subjective than objective. Human preference to color can bias our perception of an image or the reproduction of the image. Many colors are considered to be *memory colors* because of their common occurrence. Some colors evoke an emotional response from a viewer, while other colors may be linked to a previous event in history or childhood occurrences. It has been suggested that different ethnic backgrounds or cultural differences may affect the way some people see color.

Some of the variables that influence color perception include adjacent or surrounding colors, light sources, the mood of the viewer, and personal sensitivity of the eye. In the business of color, several alcoholic drinks can influence decisions or facilitate an attitude adjustment. Performing color approvals while physically exhausted or mentally stressed will affect the discretionary evaluation of color reproductions. With respect to color trade shops and printers, many have a separate facility for customer viewing of color. The customer viewing room is typically very comfortable, well furnished, and distanced from the noise and activity of production departments. Creating an environment that controls or manipulates variables affecting color viewing is critical to the success of a color reproduction business.

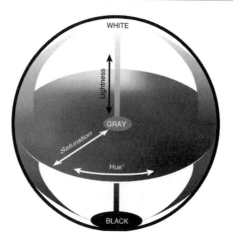

Figure 2-1 The three-dimensional color model illustrates the hue positioned around the color circle with saturation of a hue changing as it moves toward the center. The third dimension of lightness is a vertical orientation with white at the top and black at the bottom. See color insert. *Courtesy of X-Rite*

Color Perception

Because the electromechanical spectrum allows for the accurate description and measurement of the wavelengths of colored light, color measurement is a precise science. In the everyday real world a person must use less exacting terminology to describe color. Color is a three-dimensional phenomenon that is best described using the terminology of hue, chroma, and lightness or value (Figure 2-1).

The first dimension of color is the *hue,* or the difference between the color of red, blue, or yellow. In most color models, the hue is plotted around the circumference of the color circle. By design the hues are positioned around the color circle from shortest to longest wavelengths. The perimeter of the circle represents the linear color spectrum or continuum of hue wrapped around the circle. For the layperson,

describing the hue in a box of crayons would be the identification of red, green, yellow, or blue crayons.

The second dimension of color relates to the *saturation* or chroma and can be described as the purity of a color or hue. The saturation refers to the purity of a color or freedom from gray. Using the example of a box of crayons, there are perhaps eight different shades of red crayons and maybe seven variations of the blue crayons. The difference between the eight red crayons is often a variation of color saturation and complementary contaminants. There may be a fire engine red crayon and a brick red crayon in the selection of red crayons. The brick red appears darker (or more gray) in color than the pure, bright, fire engine red. The brick red color would plot toward the center of a color model, while the brighter hue would be represented on the outside of the circle.

The third dimension of color defines a specific hue and saturation of color and provides a variable in the *lightness* or darkness that the color appears. Another name used for lightness is the *value* of color. The brick red crayon can vary in degree of lightness when reproduced. The vertical dimension of the color model provides an axis for lightness, with white at the top and black at the bottom. The term *brightness* is sometimes used for lightness in describing the third dimension of color.

Memory Color

When a person evaluates a colored object, the color is often a memory function from previous observations of similar objects. Memory colors play a significant role in what a customer may see in a color reproduction. For example, if a color trade shop in Phoenix, Arizona is preparing color separations for a customer in Rochester, New York, the customer may reject the work based on what appears as unnatural color. Perhaps the original artwork included buildings and landscapes that were color adjusted by a person native to Arizona. The customer in Rochester may see the color of concrete as more blue-green in cast

Figure 2-2 An example of two different separation adjustments of a color original that may be based on differences in memory color. See color insert.

because of the different moisture content and the difference in the number of sunny days in comparison to Phoenix, Arizona. The landscape, climate, and sunlight in Arizona represent a difference in the perception of the color of grass, shrubs, and buildings from Rochester, New York.

Much of color imaging depends on mental comparisons of the reproduction to the original image that may have been recorded days or weeks earlier (Figure 2-2). The judgment of color is both a physical and psychological function that occurs as second nature to us. Color vision is a bodily function similar to breathing where the individual does not have to focus on the activity for it to occur. What makes the reproduction of color so subjective is the fact that any individual with color vision assumes the ability to evaluate an image, regardless of his/her ability to present or remember the original setting.

The concept of memory colors is not difficult to understand, but it is often overlooked in the discussion of color preferences. Specific color film emulsions manufactured by different companies produce subtle differences in color because of spectral sensitivities. The manufacturer of the color film emulsion creates memory colors that appear natural, but they may differ from another company. Much of color reproduction is "the process of robbing Peter to pay Paul." The manufacturer does not have the ability to create a color film emulsion that has complete spectral sensitivity,

Figure 2-3 An example of two different pieces of origi-
nal artwork, where memory of colors assist in the image
identification. See color insert.

so a compromise is attempted, but in some cases the cap-
ture of either warm or cold colors becomes a tradeoff.
Furthermore, when preparing a color separation of the orig-
inal, ink characteristics may affect color correction in a
way that the separator must prioritize so that what is
reproduced will represent an acceptable and pleasing com-
promise.

Often our ability to judge a color image depends on
our memory of what different colored objects look like
under normal conditions. Fruits and vegetables are good
examples of color images that we remember. A yellow
banana or lemon, if properly ripe, an orange carrot, or
green lettuce assist us in the evaluation of normal images.
The difficulty exists when the original color image is not in
a normal context or not in our memory. An original
abstract painting or a close-up of an object with no sur-
rounding context would be difficult to evaluate, or to create
a separation that would please the customer on the first
proof (Figure 2-3).

Response to Color Stimulation

The ability to see color requires three different responses controlled by the human brain. Burnham in his publication, *Color: A Guide to Basic Facts and Concepts,* discusses the need for three different conscious responses in seeing color. Assuming that a response is the behavior from a stimulated sense organ, there would be three: motor, glandular, and conscious. Muscles provide the motor response, glands generate other physical reactions, and conscious responses provide awareness from the brain that has been activated.

The perception of color is an integrated conscious response to the total visual experience. Furthermore, color responses are adjusted or interpreted through previous color experiences stored in your memory.

The emotional state of an individual can influence color perception, including size changes of the pupil or iris of the eye. The crystalline lens of the eye is located behind the iris and it functions as a reflexive muscle that changes shape to better focus visual images. As the lens of the eye changes to restrict or contract light, it tires the eye over time. The lens of the eye provides focus and reverses the image upside-down on the retina for transmission to the brain.

When someone evaluates a color picture in a viewing booth, they are depending on the eye to transfer information to the brain. However, the brain can be fooled by what information it receives from the eye. Several factors can affect the way we see a color image.

- The state of health and/or fatigue of the observer influences the physiological and psychological interpretation of the light energy.

- The effect of adjacent or surrounding color.

- The cultural or background differences of the viewer tends to lead to different interpretations, based on previous exposure to specific colors for different meanings or events.

- Economic and time restrictions have an impact on the depth of critical inquiry and/or scrutiny of color details.

Psychological Factors

The effect that color has on people tends to vary with personality, cultural background, education, and gender. These factors represent the softer sciences of color and lack overall consistency. When a customer is not personally satisfied with a color reproduction, these factors can play a critical role in the business world.

Based on an earlier Kodak publication addressing ergonomic design, it was suggested that color preference in the western culture is blue, red, green, violet, orange, and yellow. These color preferences are rather broad and will transcend racial and gender differences. Furthermore, children may prefer colors in the red end of the spectrum, and as they mature the preference changes toward the blue end of the spectrum.

Some colors, such as blue and green, are considered to be cold colors, while red and orange represent warm colors. The orange and red colors tend to be stimulating, while the cool colors tend to be soothing. Some individuals consider bright red to be aggressive.

Color can also be used to influence the perception of size and distance within a confined space. Darker colors or black create the appearance of something being smaller or more slender. Cool colors such as blues and greens can make the appearance of a room seem larger, while a darker blue would work the other way.

The second dimension of color, the saturation or chroma, can be described as the purity of a color or hue. As the saturation of a color is reduced to a more pastel value, the psychological effects will diminish. It has been suggested that young children exposed to a significant amount of bright colors from birth may react to color differently than a child who was not overly exposed.

The aesthetic aspects of color are often defined by the fine arts discipline. The rules of color harmony and tonal variation are prescribed by the fine arts, and represent the background of most designers. Graphic arts personnel

Figure 2-4 An example of products in a store that have been enhanced by the use of color as a marketing tool. See color insert.

often do not see the subtle requirements of a designer's request and tend to dismiss the efforts as creative overkill. Most graphics arts production personnel learned their trade based on the limitations of the reproduction processes. Graphic designers spend a significant portion of their training on subtle differences and the refinement of the aesthetic attributes in an image.

Marketing executives use color to enhance a point of purchase, or to promote products that are otherwise lost in the mundane (Figure 2-4). When purchasing red meat in a high quality grocery store, it is common for the meat to be displayed against a green or blue background. The contrasting or complementary colors accent the red meat. If you examine the lighting in a good store, it is not uncommon to see different colored lights positioned over specific colored products. The use of complementary colors has a significant value—viewing the first hue creates an afterimage that often enhances or affects the perception of the other color. People are constantly exposed to color and its effects as a way to manipulate behavior and attitudes.

For More Information

The following sources will provide you with the additional information necessary to better understand the concepts introduced in this chapter. Furthermore, several densitometer manufacturers have produced excellent training publications that are well illustrated with strong glossaries.

Billmeyer, F. W., and Saltzman, M. *Principles of Color Technology.* New York: John Wiley & Sons, Inc., 1981.

Burnham, R. W. *Color: A Guide to Basic Facts and Concepts.* New York: John Wiley & Sons, Inc., 1963.

Field, G. G. *Color and Its Reproduction.* Pittsburgh: Graphic Arts Technical Foundation, 1988.

Sheppard, Jr., J. J. *Human Color Perception.* New York: American Elsevier Publishing Company, 1968.

X-Rite. *A Guide to Understanding Color Communication.* Grandville, MI, 1990.

Section II

Color Theory

Additive Color Theory

The ability to experience color depends on four elements. These elements may seem simple, but need to be fully understood if facsimile reproduction of an original color image is desired. The first element necessary to experience color is a light source to illuminate an object. The *incident light,* or light source that is falling or striking on the color object provides energy that is either absorbed, reflected, or transmitted through the color object. The second element, a color object, could be a piece of cloth or a plastic container. For the printer, the colored object is ink pigment on a sheet of paper.

The incident light energy that is reflected from or transmitted through the colored object is received by the retina of the eye. The eye is the third element required of a color sensation, and it is the bulbous cones in the eye that communicate the color experience to the brain. The brain is the fourth element that provides the final interpretation of the color sensation.

All color that is reproduced is accomplished through either additive or subtractive color theory. Additive theory is synonymous with light energy and the direct experience of light. Subtractive theory describes the experience of light reflected from a colored object, such as paper coated with printing inks.

When red, green, and blue light are combined they produce white light. When using additive primary colors to produce printed images on paper, the combinations of colors appear dark because they block the white light that is reflected off the paper. Thus, the additive primary colors are not desirable for printing ink pigments. All the colors in a printed color separation are made possible from the red,

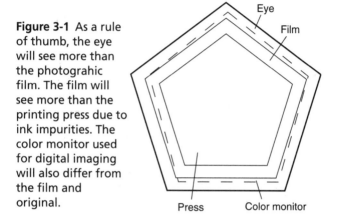

Figure 3-1 As a rule of thumb, the eye will see more than the photograhic film. The film will see more than the printing press due to ink impurities. The color monitor used for digital imaging will also differ from the film and original.

green, and blue light energy reflected from the white paper. Process inks (subtractive theory) act as transparent filters of the red, green, and blue light.

The natural colors we see in a landscape can be replicated with water colors or oil paints, or they can be photographed on film transparencies and separated for reproduction with inks on a printing press. The difference between what the artist may have seen while painting, and the printed color reproduction, can be explained in the reduction of color space due to lighting, film sensitivity, and ink impurities.

It is important to be sensitive to the needs of the customer and have a working knowledge of that customer's specifications. Sales people and customer service representatives need to be educated about the limitations of printing. As a rule of thumb, the eye will see more than the film used to photograph the original color scene, and the film will see more than the printing press due to ink impurities (Figure 3-1). Certain printed products follow specifications such as Specifications for Web Offset Publications (SWOP) or Specifications for Non-heatset Advertising Printing (SNAP), and thus the color reproduction may be limited by self-imposed total density limits.

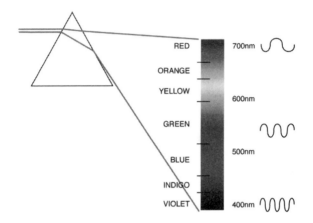

Figure 3-2 The three primary additive colors are red, green, and blue light which, when combined in equal proportion, create white light. See color insert. *Courtesy of X-Rite*

Understanding Basic Color Theory

Color printing is a function of light energy and colored pigments combined to represent a facsimile of an original image. In basic color theory it is understood that there are three additive primary colors and three subtractive primary colors. The three *additive primaries* are red, green, and blue *(RGB)*, which represent the broad bands of light energy. In equal proportions, the three additive primaries equal white light (Figure 3-2). Due to the fact that adding the three colors of red, green, and blue light will create white, the primary additive colors of light would not make for suitable colors of ink.

The three *subtractive primary colors* are yellow, magenta, and cyan. The primary subtractive colors receive

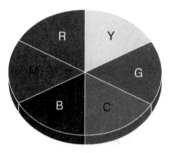

Figure 3-3 The relationship between the additive and subtractive primary colors is complementary. See color insert. *Illustration by LaVerne Harris*

their name from the fact that each color absorbs one-third of the white light spectrum. These subtractive primaries will make suitable ink colors because when all are mixed they create black or the total absence of color. Printers subtract color from the white sheet of paper. Basically, all the colors we see in a printed separation are contained in the red, green, and blue light energy reflected from a white sheet of paper. To produce the image different degrees of red, green, and blue light are subtracted from the white light spectrum or paper. The printing inks used to reproduce color images are transparent (process colors).

The relationship between the additive primary colors and the subtractive primaries is considered complementary (Figure 3-3). The term complementary comes from the paired relationship that each subtractive color absorbs its complementary one-third of the light spectrum. Yellow ink on white paper absorbs its complementary color of blue light. Magenta ink on white paper will absorb one-third of the light spectrum, or its complementary color of green. Finally, the cyan ink will absorb its complement of red light.

The color wheel is used as a graphic aid in understanding basic color theory. Though simple in design, the color wheel represents a significant amount of information. The theory behind the color wheel may seem different than what you remember from your elementary art teacher. The printing of color reproductions involves creat-

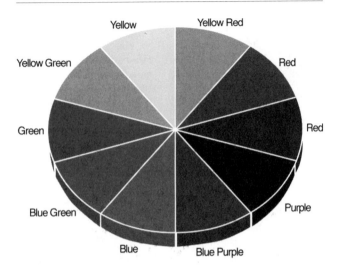

Figure 3-4 This enhanced color wheel provides a graphic representation of the three primary additive colors sandwiched between variations of colored light. See color insert. *Illustration by LaVerne Harris*

ing color separations of the primary colors contained in the original image, and reproducing them with transparent (process) inks. Your elementary art experience may have involved opaque pigments or paints and thus when you mixed red and green tempra paints they created brown paint. The color wheel used in the graphic arts is built on the physical sciences and when red and green light are mixed we see the color yellow.

Using the color wheel in Figure 3-4, note that the three additive primary colors are separated by the subtractive primary colors. Also, the complementary color pairs are opposite each other in the color wheel. Finally, note that the two additive colors of light that make up a particular subtractive primary are located on each side of that ink color.

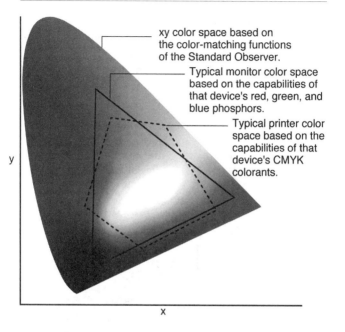

Figure 3-5 The visible portion of the electromagnetic spetrum illustrates the blue, green, and red portions of white light on a chromacity diagram. See color insert. *Courtesy of X-Rite*

Applications of Additive Color Theory

In nature, the sun is the primary source of incident light that illuminates color objects. *Average daylight*, or partly cloudy skies between 10:00 A.M. and 2:00 P.M. in the northern hemisphere provides a balanced white light for the illumination and visualization of colored objects. Without light there is no color, and the less light, the less color is visible. Light is energy made up of waves of different lengths. The different wavelengths appear as different colors, with white light being made up of all wavelengths. The three broad bands of light energy that make white light are red, green, and blue (Figure 3-5).

The use of artificial light sources to reproduce color, such as a color television, must also use the blue, green, and red portions of the spectrum to produce a white image. The television set has three cathode ray guns that project different degrees of red, green, and blue onto the phosphor coating on the inside of the picture tube to create different colors in the spectrum. The mixing of light energy to create a color image is additive color theory. In a dark room, the overlapping of red, green, and blue light beams will create additional colors, such as magenta, cyan, and yellow. Additive color can also be seen in a television studio where colored lights are used to create different effects on a studio backdrop. The various light adjustments on a control panel allow for different amounts of red, green, and blue filtered lights to create any color desired.

RGB Monitors

The color monitor on a desktop computer or color workstation also uses red, green, and blue dots of phosphor on a black background to produce images. When electronically activated the phosphor dots emit light energy. Unfortunately the range of light energy emitted from these monitors differ just like color televisions for the home market. With this in mind, it becomes critical to understand that one color monitor on a desktop workstation will vary from another. Furthermore, as a color monitor and phosphor coating age the color output will shift. There are some more expensive color monitors that have been color calibrated and can be adjusted to a production standard every day. The need to calibrate color devices is becoming more critical as the hardware and software become more sophisticated.

Regardless of the differences in RGB color monitor output, it remains a constant that the separations of color reproduction must be converted into the four process colors of cyan, magenta, yellow, and black *(CMYK)*. There is a visual difference between RGB color images and CMYK color images. The thought of soft proofing color images on a

RGB monitor has significant limitations depending on customer tolerances. Digital production workstations require color and gamma correction for accurate color reproduction. In addition to the color space adjustment, the gamma or contrast range of a RGB monitor can be predetermined for optimum viewing conditions.

As a point of clarification, the abbreviation of CMYK process color is sometimes referred to as YMCK for those in the industry who remember light-to-dark ink laydown sequence. The history of process color includes a color sequence for both proofing materials, as well as printing ink that started with the lightest pigment and progressed to the darkest pigment. To this day many overlay or laminate color proofing systems require light-to-dark laydown sequence to limit light refraction problems. The K abbreviation represents the black ink, and the K stands for the *key printer*, or the printing plate that carries the text copy or keyline information. Another name for paste-ups or mechanicals is a keyline, and the keyline contains the type matter or other line information. Black ink is primarily used for text and most of the line copy due to its high contrast with the printing substrate and the fact that it is one of the least expensive inks.

Modern offset lithographic production techniques and changes in tack sequence of the process inks allow for the laydown of cyan, magenta, yellow, and black. Cyan images printed first on the press sheet provide significant image information for registration of other colors, and the cyan ink often contains the most color impurities that can be compensated for by reducing other inks during their laydown.

Color desktop software developers have selected to use the CMYK color sequence when referring to process colors. Desktop color manipulation software, such as Adobe Photoshop, allow images to be converted from RGB color modes to CMYK color modes. This color conversion or image mode change of the digital file allows process color to appear more realistic on a RGB color monitor.

For More Information

The following sources will provide you with the additional information necessary to better understand the concepts introduced in this chapter. Furthermore, the Eastman Kodak Company and Imation (3M) have each produced several excellent publications that are well illustrated, and AGFA has released an interactive CD-ROM.

Adams, Michael, Faux, and Rieber. *Printing Technology.* Albany, NY: Delmar Publishers, 1996.

AGFA. *Digital Color Prepress: Interactive Edition.* AGFA Prepress Education Resources. Mt. Prospect, IL 1996.

Basic Color For The Graphic Arts. Eastman Kodak, Publication Q-7, 1980.

Shapiro, C., *The Lithographers Manual,* Pittsburgh, PA: Graphic Arts Technical Foundation, 1985.

3M Imaging. *Understanding Color.* Printing and Publishing Systems, 3M Center. St. Paul, 1994.

X-Rite. *A Guide to Understanding Color Communication.* Grandville, MI, 1990.

Subtractive
Color Theory

The full spectrum of color seen in any printed repro-
duction is accomplished on the printing press by subtract-
ing color from the white light reflected off the paper or
substrate. In the previous chapters, we discussed the fact
that the white paper contained nearly the entire visible
portion of the electromagnetic spectrum. What printers do
is subtract about one-third of the visible spectrum each
time one of the three process colors of yellow, magenta, and
cyan is laid on the press sheet.

Subtractive color theory uses the primary colors of yel-
low, magenta, and cyan to create secondary colors and
overprints. Black ink represents the total lack of color, and
is used to create contrast in shadows or three color over-
prints. The black ink used in process color printing pro-
vides another method to create variations in overprints as
well as the total color space.

Primary Ink Pigments

Using subtractive color theory, the yellow ink acts as a
filter that absorbs its complementary color of light, thus
nearly all of the blue third of the spectrum is absorbed,
and the paper loses some brightness or energy. When the
magenta ink is printed on the paper, nearly all of the green
third of the spectrum is absorbed, and where it overlaps the
yellow, a secondary color of red is created. The secondary
color will appear darker than a single primary because
nearly two-thirds of the spectrum has been absorbed.
Finally, when the cyan ink is printed, it absorbs nearly all
of the red third of the light spectrum. Where the cyan ink

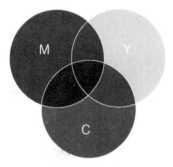

Figure 4-1 The primary subtractive colors and the secondary colors produced. See color insert. *Illustration by LaVerne Harris*

overlaps the yellow, it will equal a green secondary color, and the cyan overlap of magenta equals a blue or violet secondary (Figure 4-1).

The ability of a process ink to absorb one-third of the visible light spectrum depends on the purity of the ink pigments. Ink pigments can be organic or inorganic in nature and are ground to tiny particles measured in microns. The ink manufacturer purchases ink pigments from different sources depending on price and quality. It is not uncommon for a national ink manufacturer to purchase ink pigment from different sources throughout the year. Thus, there is a potential for process inks to vary slightly in their hue error or ink efficiency.

Some of the more common process ink pigments used in offset lithography include the following.

Phthalocyanine for cyan ink

Lithol rubine for rubine magenta

Rhodamine Y for rhodamine magenta

Diarylide yellow for yellow ink

Carbon black for black ink

There are other ink pigments available or combinations of those in the preceding list that can be used. It should be noted that there are two types of magenta ink available, rubine and rhodamine. The *rhodamine magenta* usually costs more and has a purple cast as compared to

the fire engine red of the *rubine magenta*. The rhodamine magenta produces more pleasing flesh tones and wood grains than the rubine magenta.

The combination of these four process pigments provides a gamut of color that is capable of delivering very high quality color reproductions. However, there is a gamut of artistic colors that cannot be produced by the combination of these transparent inks. In select cases, a special fifth, sixth, or even seventh color can be used to overprint the standard process colors. There are some publications that print a great number of flesh tones, and will choose to print both a rubine and rhodamine magenta ink.

In recent years, the use of *hi-fi color* printing has become popular in selected high quality products. Many of these hi-fi color reproductions use seven colors, to include modified versions of the four process colors, and red, green, and orange. The majority of hi-fi color reproductions use stochastic screening in an effort to resolve the moiré issues.

The use of a reflection densitometer and a GATF color triangle can graphically portray the available gamut of pure color for a given set of process inks. Colorimeters and spectrophotometers are also used to define color gamut.

Working Characteristics of a Set of Process Inks

Because pure subtractive color theory does not exist in the real production environment, there is a need to measure ink pigment impurities. There are four basic working characteristics of a set of process inks. The first characteristic is *ink strength*. The strength of an ink used on press to produce a color reproduction is measured through its complementary color filter using a reflection densitometer. The strength or density of the primary inks are read with a reflection densitometer on the solid patches of the color bar. Process color work should always include a standard color bar such as the GATF, X-Rite, RIT, or Gretag control devices. The largest density reading will typically be the ink strength as seen through the complementary color filter.

It is important to know the ink strength on one-color and two-color presses that are producing four-color process work. Typical four-color presses allow for adjustment during makeready and at the time of printing, but if you can only print two colors and must print the other two colors in a second pass through the press, the strength of ink cannot be readjusted.

The second working characteristic of a set of process inks is the *hue error* of the ink. The hue error of the ink is expressed as a percentage, with a low percentage being most desired. The hue error refers to the fact that a color or hue (process ink) is determined by the values of light that it reflects and absorbs. The perfect process ink would reflect two-thirds of the visible light spectrum and absorb one-third.

The percentage of hue error indicates the amount of difference that exists between the two colors of light that a process ink reflects. For example, if a cyan ink had 0% hue error the green and blue light would be reflected at an equal 100% (Figure 4-2). If another manufacturer's cyan ink had an 85% hue error toward blue, the ink would appear blue in color because it would reflect very little green light and almost all blue light. In summary, the hue error of a process ink is measured by the amount of blue, green, and red light that it reflects. The equation used by GATF, ink manufacturers, and manufacturers of proofing systems for many years is:

$$\text{Hue Error} = \frac{\text{M-L}}{\text{H-L}}$$

L = Lowest density filter reading

M = Medium density filter reading

H = Highest density filter reading

The modern digital reflection densitometer is capable of calculating the hue error of the ink. If older densitometers are used, the ink is read through all three filters and the low, medium, and high density filter readings are used in the equation for hue error. (It is interesting to note that some offset inks and some gravure publication ink groups

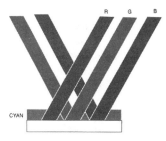

Figure 4-2 A perfect process cyan would reflect 100% green and blue light while absorbing 100% of the red light. See color insert. *Illustration by LaVerne Harris*

have such a high hue error, that the cyan inks are really blue, and the magenta inks are really red in color.)

The third characteristic represents the *grayness factor* of the process ink. This grayness value is expressed as a percentage, and the lower the grayness percentage the more pure the process color. A color will appear more gray if the level of reflectance for the dominant pigment is less than the substrate that the color is printed on. The cyan ink used in an earlier example should reflect equally blue and green light, but would be considered a dirty gray cyan to the extent that it reflects less blue light than the paper or substrate that the ink is printed on. Digital reflection densitometers, colorimeters, and spectrophotometers can calculate the grayness of a process ink, but if manual calculation is required the following formula will assist you.

$$\text{Grayness} = \frac{L}{H}$$

L = Lowest density filter reading

H = Highest density filter reading

The lowest density filter reading divided by the highest density filter reading multiplied by 100 will equal percentage of grayness.

The fourth and final working characteristic of a set of process inks is the *ink efficiency*. Expressed as a percentage, the efficiency of an ink should be as high a percentage as possible. Of the four different working characteristics for a set of process inks, the ink efficiency does the best job of evaluating the quality of the color. The higher per-

centage of a process color's ink efficiency, the greater the range of pure colors it can produce with the other process colors. The issue of color correction is reduced when a process ink has a high percentage of ink efficiency.

The ink efficiency of a process color is expressed as a percentage ratio between its correct light absorption and its incorrect light absorption. We said earlier that a perfect process ink should reflect equally, two-thirds of the light spectrum and fully absorb its complementary color of light. The percentage of ink efficiency measures how well a process ink reflects light, with respect to how much of that light it absorbs. The equation for ink efficiency is a little more complex, but it can be calculated by the use of some of the digital handheld reflection densitometers or other measuring devices.

$$\text{Ink Efficiency} = 1 - \frac{L+M}{2H}$$

L = Lowest density filter reading

M = Medium density filter reading

H = Highest density filter reading

The working characteristics of a set of process inks are not new, and this data should be readily available from the ink manufacturer. Furthermore, the manufacturers of color proofing systems also need to understand this data in an effort to best match pressroom conditions.

The Role of the Black Printer

The inability to produce perfect process inks, that is an ink that can absorb 100% of its complementary color of light and reflect 100% of the two remaining colors of light, necessitates the need for black ink. The fact that a three-color overlap of yellow, magenta, and cyan produces a dark brown color indicates that not all of the light energy has been absorbed by the three inks. The use of black ink absorbs all remaining light energy and creates the total absence of color (Figure 4-3).

Figure 4-3 Three process color overprint of yellow, magenta, and cyan produces a dark brown value on the top, and the four-color overprint on the bottom shows the visual contrast of black. See color insert.

There are four major reasons for the use of a black printer in modern process color printing:

1. To increase density and visual contrast in the shadows of the color reproduction.

2. The black plate hides register problems internal to the color image.

3. The black separation provides outline to the details or picture elements.

4. The black ink is the least expensive and can be used in gray component replacement (GCR) or under color removal (UCR) as an inexpensive substitute for the more expensive yellow, magenta, and cyan inks.

It is important to remember that the black separation is printed with the use of a process or transparent black ink. Opaque black ink substitutes will alter the visual appearance of the printed color separation. The fact that black ink was the cheapest of all inks because it was a simple ink to make is changing. The increase in the use of UCR and GCR has created a greater demand for a better black process ink.

Under color removal (UCR) is the predecessor of gray component replacement (GCR), and is responsible for reducing the use of expensive yellow, magenta, and cyan ink pigments where they overlap in the neutral shadow

areas, and replacing them with black ink. *Gray component replacement (GCR)* is a software improvement of UCR, which allows the tertiary color, or the weak contaminant color, to determine the level of subtractive primary removal in the three-color overprints throughout the entire image. Both UCR and GCR will be discussed later in this book.

For More Information

The following sources will provide you with the additional information necessary to better understand the concepts introduced in this chapter.

Field, G. G. *Color and Its Reproduction.* Pittsburgh: Graphic Arts Technical Foundation, 1988.

National Association of Printing Ink Manufacturers (NAPIM). *Printing Ink Handbook.* Harrison, NY, 1988.

Scitex Training Systems Department. *Story of a Color Picture.* Scitex America Corporation, Bedford, MA, 1991.

The Lithographers Manual, 8th ed. Pittsburgh, PA: Graphic Arts Technical Foundation, 1988.

Section III
Color Measurement

Color Tolerancing

Whether you are buying paint to match new kitchen wallpaper, a shirt to match a pair of pants, publishing a photo on a web page, or printing a corporate brochure, it is necessary to make color matching decisions. In our day-to-day life, we typically use visual comparisons to match color. As we have seen in Section One a visual comparison is often suspect. The age, gender, and mental and physical state of the individual can interfere greatly with color perception. To accurately and consistently compare color it is necessary to have a quantifiable measuring system.

Color Gamut

Color gamut is the range of color that a particular color system or model can describe. If visible light is used as the ideal or maximum color gamut necessary, we can plot various color systems and compare them to visible light. Systems or color models such as those used for computer monitors and printing are not capable of reproducing as wide a color gamut as the human eye can see. Furthermore, the use of photographic color emulsions creates a reduced or different gamut of color than that of the human eye. These systems or models are said to have a smaller color gamut. The ideal color model would match the full visual spectrum and be quantifiable.

Color Models

Color models are systems used to define color. Color models provide a context to quantitatively describe the visual differences in hue, chroma, and value. Over time a

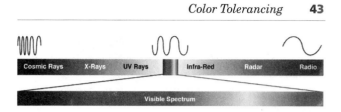

Figure 5-1 Color models differ in their ability to reproduce the visible gamut. See color insert. *Courtesy of X-Rite*

variety of color models have been developed to help us describe and compare color. Color models vary in both the way they define color and the way they are utilized. Some color models are used to describe how the eye perceives color, some are used to define projected color and others are used to describe pigments used in printing color reproduction (Figure 5-1).

Red, Green, Blue (RGB)

The RGB color system or model is based on additive color theory and is used to define projected colors such as those on a monitor or television screen. Additive color theory is synonymous with light energy. In these cases the values for RGB describe the colored phosphors which are activated to create the picture on the screen. RGB has some serious limitations as a color model. RGB cannot be used to describe the full gamut of visible light. RGB is also device dependent—meaning the same signal or image can look different when viewed on different devices.

Cyan, Magenta, Yellow (CMY)

The CMY color system or model is based on subtractive color theory, and is used to define pigments for printing. Cyan, magenta, and yellow are generally combined with black (K) to create the process inks used in process color printing. It is important to remember that black is the total absence of color, and is used to make up for the deficiencies in pure color pigments. If each of the primary subtractive

Figure 5-2 The Munsell color tree system. See color insert.
Courtesy of X-Rite

pigments, cyan, magenta, and yellow could absorb 100% of their complementary additive primary while reflecting 100% of the other two additive primaries, there would be no need for black. Again this color model has its limitations; CMY is not capable of producing and describing the complete visual range of color, or even the complete range of RGB.

Munsell System

Some of the earliest efforts to measure color included physical color models that relied on human perception. The Munsell color tree system (Figure 5-2) was introduced in 1913 by an American artist and teacher, Albert H. Munsell. The Munsell color tree uses the vertical axis to represent the value or lightness of a color, and the horizontal axis to represent the chroma or saturation of a color. The purest color is located on the perimeter of the model. The various hues of color are arranged in a circle around the brightness/darkness vertical axis. Two other color reference systems are the Ostwald System, and the Deutsche Industrie-Norm (DIN).

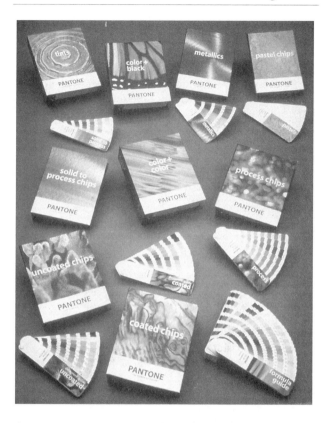

Figure 5-3 Pantone is one of the more common pigment guides. Books such as these provide the designer with a wide range of colors to choose from and the printer with formulas for creating ink. *Courtesy of Pantone*

Pantone Color

The Pantone color matching system, and others like it, makes an attempt to define color by comparison to a large library of color (Figure 5-3). Each Pantone Matching System (PMS) color corresponds to specific pigments that are combined to create an ink of a specific color. These com-

parison methods are limited to the number of colors available in the library. They also rely on a visual comparison which, as stated earlier, is subject to inaccuracies. Pantone has a history of acceptance in the industry, and is developing new ways to communicate color in the desktop applications, that is based on years of experience in working with impure inks. The Pantone Color Data System uses spectrophotometry to calculate matches.

There are many other color models similar to the Pantone that are accessible in the menu boxes of different desktop software applications. Color models such as Focoltone and Trumatch have become more mainstream and offer comparable results.

HSL

The HSL color model or hue, saturation, and lightness makes an attempt to describe color in a manner similar to the way the human eye perceives color. The human eye detects differences in saturation and brightness rather than colors as exact values. The HSL model is used to describe color in three dimensions. Hue is used to determine the dominant color, which in Figure 5-4, is located around the perimeter of a color wheel. For example, a color is green or red or yellow. Saturation is the intensity or purity of the given color. The saturation of a given color increases as it moves from the center of the color wheel to the perimeter. Lightness provides for the third dimension of this model. Lightness represents an achromatic value that indicates how dark or light the image or object is. The lightness indicates the amount of light reflected from the color. One of this model's most important features is that each of the attributes is independent of the others, i.e., hue can be varied without affecting saturation or lightness.

HSB

HSB or hue, saturation, and brightness is similar to HSL; however, this model is linked closely with the RGB model. Hue is described by the relationship or ratio of the

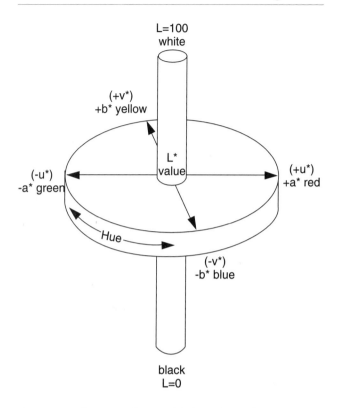

L=100
white

(+v*)
+b* yellow

L*
value

(-u*)
-a* green

(+u*)
+a* red

Hue

(-v*)
-b* blue

black
L=0

Figure 5-4 The HSL color model describes color using the attributes of hue, saturation, and lightness. *Illustration by LaVerne Harris*

RGB components. It can also be thought of as the primary or dominant color such as red, yellow, green. Saturation is the amount of complementary color present, or for example, is the contaminant color turning a true red to a maroon. Brightness is adjusted by increasing or decreasing the amount of each of the RGB components while maintaining their ratios, for example, light maroon versus dark maroon. The HSB model is commonly found in desktop applications for the color picker or slider adjustments.

CIE

Perhaps the most universally accepted system of color measurement is the CIE system, which was developed by the Commission Internationale de l'Eclairage (CIE) of France during 1931. This system was one of the early attempts to develop a device-independent, uniform color model. Starting with a standard observer and viewing condition, the CIE system has evolved into different color spaces to meet the needs of different market sectors.

In 1931, an effort to establish an international system or standard to measure color was conducted in England. The group assembled created the CIE chromaticity diagram based on the previous Maxwell Triangle. The Maxwell Triangle, developed by James Maxwell, is an equilateral triangle that includes red, green, and blue as the three primary corners of the triangle. The CIE chromaticity diagram used the same primaries of light while indicating the different wavelengths of light. The CIE chromaticity diagram uses chromaticity coordinates or tristimulus data.

The measurements used by the CIE were based on a standard observer. The CIE sampled 1,700 individuals to establish a standard red, green, and blue wavelength of light that represented the average observer. Tristimulus data (XYZ) could be calculated for a color by using RGB filters that match the way a human eye sees color. Colorimeters see color using tristimulus filter readings. The XYZ values of the tristimulus data are used to create the XY chromaticity coordinates required to plot color on a CIE chromaticity diagram. The third value used to plot color on a CIE chromaticity diagram is the Y value (0 to 100) for luminance, and is plotted on a right angle to the chromaticity plane. The CIE chromaticity diagram was also used by the lighting industry for the measurement of light. It should be noted that there is no defined white value in the CIE chromaticity diagram.

In an effort to better refine color measurement, CIE LAB/CIE LUV were developed in 1976 and are still widely used today. The CIE LAB model is used primarily for reflective color, including printed sheets. The CIE LUV

model is used primarily for color monitors or displays. The
L*a*b* (or L*u*v*) colors are tristimulus values used in a
mathematical model. L* represents lightness. The a* (or u*)
value shows the position on a red-green axis and the b* (or
v*) value is the position on a yellow-blue axis.

CIE LCH is a color model that is derived mathemati-
cally from the CIE LAB or CIE LUV color models. This
model converts the rectangular coordinate system into a
cylindrical polar coordinate system. The L* value is the
same as Lab lightness. The c* value indicates the chroma or
saturation, and is the vector distance from the center of
the color space. The h* value describes the hue angle.

YCC

The YCC color model has become popular as a result of
Eastman Kodak's Photo CD system. This model allows for
the chromatic color data to be stored separately from the
lightness variables, and is typically the smallest image file
format. This color data format works well with color moni-
tors, and can speed up data compression and decompres-
sion. YCC color data can be converted into a RGB format
through interpolation techniques.

When the color scanner records a color image, the
RGB, data is converted into one luminance value (Y) and
two chromatic values (C1) and (C2). The YCC model pro-
vides a way to store the full range of luminance found in
the original color image.

Color Measuring

The ability to measure color systematically and accu-
rately is essential for quality control in a color reproducing
environment. There are three main devices commonly used
in industry today: the densitometer, the colorimeter, and
the spectrophotometer. Each of these measuring devices
has its special applications.

Densitometry

Densitometers measure the various degrees of optical density. *Density* can be defined as the light stopping or absorbing property of a substrate. Density can be measured for either reflecting material such as paper, or transmitting materials such as film. Density is defined mathematically with the following equation in which R is reflectance and T is transmitance.

$$\text{Density} = \log_{10} \frac{1}{\%\text{R}}$$

$$\text{Density} = \log_{10} \frac{1}{\%\text{T}}$$

Densitometry is widely used in the graphic arts industry. It is used to measure the density of original copy, film, proofs, or press sheets, and densitometers are used to measure tint percentages. Densitometers are often referred to as color blind, but the fact is that densitometers see color in a banded response as determined by the complementary filter used. Based on research developed by the Graphic Communications Association (GCA), a Status T densitometer is used in the graphic arts industry. Densitometers can use either narrow band filters or the commonly accepted wide band filters. The narrow band filter sees only pure color, and thus sees a smaller portion of the entire color image.

In the pressroom densitometers can be used to measure ink density on the press sheet. Filters are used to distinguish the primary printing colors of cyan, magenta, and yellow. The standard filters are wide band Wratten filters #25 red, #58 green and #47 blue. Each filter is used to read its complementary color. Densitometers are essential quality control tools for the printer today (Figure 5-5).

Densitometry is widely used in the pressroom as a quality control device. Some of the more common readings or calculations made by a densitometer are dot gain, trap, hue error, grayness, and print contrast.

Dot Gain. Dot gain is the difference between the size of the printed dot and the size of the same dot on the film. Dot

Figure 5-5 A typical handheld densitometer used in the industry. *Courtesy of X-Rite*

gain is expressed as a percentage, and includes both optical and physical gain. Dot gain will vary according to plate and press conditions. Dot gain is measured using the 50% dot, which is the maximum size of a conventional dot pattern.

Trap or Wet Trapping. Trap or wet trapping is the ability of one wet ink film to attract and adhere another wet ink film. The ability of inks to adhere to one another will affect the press's ability to reproduce over print colors such as reds, blues, and greens. Trap is measured as a percentage and the higher the percentage of trapping the better the color match will be. Printers are satisfied to see trapping in the 85% to 95% range. The tack of the ink is a function of the trapping process. The tack of an ink refers to the adhesive qualities of the ink and is measured in points. Tack is a measure of the force required to split an ink film between two rotating rollers. The higher tack ink is applied first, with the other inks in a descending tack sequence.

Hue Error. Hue error measures the ability of the process to reproduce neutral colors.

Grayness. Grayness is used to evaluate the impurities in the inks.

Print Contrast. Print contrast is used as a guide for ink/water balance. Print contrast measures the press's ability to reproduce shadow detail and is measured with the 75% dot.

Figure 5-6 A handheld colorimeter used in the packaging sector of the printing industry. *Courtesy of X-Rite*

Colorimetry

Colorimeters use tristimulus readings from filters designed to imitate the sensitivity of the human eye. Using red, green, and blue filters the colorimeter measurements are generally expressed as CIE values. Colorimeters can be used to measure the whiteness of paper or to compare color on a press sheet to an original object.

Colorimeters have been used in the manufacturing of paint, dyes, or plastics. Originally, colorimeters and spectrophotometers were used primarily in laboratories due to the size of the equipment and the cost. Now that the technology is more affordable and portable, more printers and ink manufacturers use colorimetry. In the printing industry, colorimetry is most common in the packaging sector (Figure 5-6). Packaging printers are constantly trying to match corporate colors or colors on a label. If a consumer sees a different color label on the same company's product, sitting side by side on a store shelf, the consumer will draw conclusions about freshness or product consistency.

Figure 5-7 A handheld spectrophotometer is perhaps one of the most accurate color measurement devices used in the industry. *Courtesy of X-Rite*

In addition to packaging printers, product printers, including wallpaper and decorative laminates, must maintain color consistency. Publication printers do not use colorimetry as much as densitometry or spectrophotometry. Colorimetric data is not as usable in the pressroom as densitometry. The press operator adjusts color on the CMYK press units similar to the banded responses of the filters on a densitometer.

Spectrophotometry

Spectrophotometry is the most sensitive of the color measuring systems. It measures the various wavelengths of light being transmitted or reflected from a surface and plots their intensity along the entire visible portion of the electromagnetic spectrum. These values can be translated to CIE LAB or other color models as needed. Spectrophotometers are increasing in use as they are being linked with software to control color on display and output devices. Several major printing companies use spectrophotometers to check incoming ink for color differences. Gravure printers typically measure ink shipments for differences in color, as well as other variables (Figure 5-7).

Measuring, describing, and controlling color are extremely important to reproducing color accurately. Proper use of color models and the measuring devices available plays a critical role in the quality control of color reproduction. Quality color houses, designers, printers, and publishers use color tolerancing to improve their product and maintain repeatability.

For More Information

The following sources will provide you with the additional information necessary to better understand the concepts introduced in this chapter.

Field, G. G. *Color and Its Reproduction.* Pittsburgh: Graphic Arts Technical Foundation, 1988.

Green, Phil. *Understanding Digital Color.* Pittsburgh: Graphic Arts Technical Foundation, 1995.

X-Rite. *A Guide to Understanding Color Communication.* Grandville, MI, 1990.

X-Rite. *A Guide to Understanding Densitometry.* Grandville, MI, 1990.

X-Rite. *Color Tolerancing.* Grandville, MI, 1992.

Section IV

Classification and Evaluation of Color Originals

Input Color Data Requirements for Reproduction

With the advent of electronic photography and the creation of color art by computers the type of pictorial data provided for reproduction has increased considerably from the conventional photographic materials associated with the graphic arts reproduction process. Although electronic imaging is a growing field, the majority of copy provided for the color separation arena is color photography. Input copy can be many things, such as transparencies, color prints, duplicates, paintings, wash drawings, original fabric, floor coverings, and printed pieces. The use of computers and digital photo imaging is yet another tool in the creative and production tool box.

Changes have occurred during the past ten years in the prepress area that are altering the work flow patterns from original idea to the printed page. With digital data moving forward at a rapid pace, much of the graphic arts hardware and software are being designed to minimize or complement conventional production steps normally associated with prepress. Design and layout functions, as well as basic color separations are moving closer to the creative people. As the creative people bring their ideas into visual renditions it is necessary that all those in the reproduction chain work in concert to provide the best pictorial data possible. This chapter will concentrate on the different aspects of original color input data with an emphasis on photographic applications. Electronic imaging for original art preparation and digital capture will be put into current perspective.

With all the electronic technology and technical advancements the basic tenant of print reproduction still holds true: "Garbage in = garbage out" or in a more modern vein—"WYSIWYG" (what you see is what you get) = maybe!

Creating Original Art

Creating art and the communication of color information become critical parts of the whole reproduction chain. Art, photos, and digital data created with the reproduction process in mind help to provide the printer with a more competitive communication system for print media. Art and creative concepts will need to gain more flexibility in order to respond to the needs of multimedia as well as global continuity in the advertising field.

Input copy should be in an approved color correct form as early as possible in the reproduction chain. All changes to color pictorial content should be made prior to platemaking. Judgment changes in color requirements at the printing press stage are costly and counterproductive and many times impossible. The limitations of the print process must be understood in order to evaluate those areas considered most important in the creation of visual images. There are over 1,000 variables to consider on the printing press alone with the multitude of paper, ink, printing plates, chemicals, and machinery combinations that exist today. So when you hear the statement, "we need to match copy" or "we'll make it up on press," be aware that all printing is a compromise in one way or another, and the aim of print is to create the illusion of subjectively matching an original object.

To illustrate this problem the following figures were compiled by Eastman Kodak to show the approximate limits of technical parameters under typical conditions that relate to photographic input to the four-color printing process:

	Color Transparency Film	Color Photographic Print	Four-Color Ink or Paper
Density Range	3.00	1.90	1.70
Brightness Range	1000:1	80:1	50:1

Combining these parameters with the subjective color interpretation of the eye and brain (which will see one way), photographic material that sees it differently, electronic separation equipment that interprets different color photo material differently, printing the image with inks that match none of the above exactly, and one can begin to see why printing's job is to create an illusion. The ICI color chart portrays what color the eye/brain can recognize, the limit of colors that the typical color transparency reproduces in a camera, and the colors that are available in normal four-color process ink combinations. None of these matches, and since this is a logarithmic function chart, the differences in the outer limits of the chart are many times more significant than those toward the center.

This illusion starts with input information tailored to best overcome the limitations of the process, and that is also designed to avoid or minimize those areas that are known problem centers in the total process. To understand this it is necessary to present information on color viewing conditions, film types, scanner operations, color correction, lighting, product identification, image recording methods, objective measurement and subjective decision making as they relate to color communication, and recording in the input copy and digital imaging area.

Viewing Conditions

The beginning of the reproduction process involves image capture and image interpretation. In the broad sense, image interpretation is a function of the human brain and visual art. The visual art can be photography, digital recording, paintings, or other media.

Figure 6-1 Patterns change colors. *Courtesy of Frank Benham*

The interpretation of color rests on four previously mentioned factors. The human eye, the brain, the object being viewed, and the light striking the object. The object is the choice of the client or the art creator and the eye is a fact of nature (but variable), so to maintain continuity and uniformity in color judgment some type of rules were required to control lighting conditions.

There are many things that are variable within our human interpretation of color that the removal of any one variable can significantly improve our ability to communicate. Colors, for instance, are very rarely seen as a separate entity. Normally they are surrounded, adjacent to, or in close proximity to other colors. These intermixes of colors and patterns affect the eye's ability to interpret a specific color. Figure 6-1 shows a good example of this well-known phenomena that is used to good advantage in the fabric design business.

Adjacency effects of colors can have a dramatic impact on customer satisfaction. Another example would be if a car manufacturer wants to promote the new sports car, it is highly likely that the new red car will be photographed against a green grass background, in part because of the complementary color relationship. Furthermore, it is likely that the customer (car manufacturer) will ask that the separation and proof be color corrected to increase the red in the new car. In years past, the separator agreed with the customer, and never took the time to explain that the magenta and the yellow secondary that makes red is at

100% ink coverage. The red car would not get any redder and the separator would go back and effect change on the green grass to get customer approval. In today's industry it is good practice to explain that the adjustment to the green grass will make the red car appear more vivid. The customer is now better educated and will be more accepting of what really makes the image more desirable. Adjacency effects of color are rather significant with respect to the context of human color evaluation.

The standardization of viewing conditions helps to eliminate variables in the judgment of color and allows for a more objective evaluation. Color judgments made under a wide variety of viewing conditions can be costly due to misunderstandings in interpretation, instructions, and actual color corrections. The importance of utilizing standardized viewing conditions from concept through to printed page cannot be overemphasized.

Standards for Viewing

Viewing standards for the graphic arts are covered in *ANSI* standard PH 2.3 (IT 2.30) titled, Color Prints, Transparencies, Prints and Photomechanical Reproductions – Viewing Conditions. This standard was last revised in 1994 and is currently under additional review in the United States as well as by the International Standards Organization.

The original standards on viewing conditions were initially presented in 1968 and approved in 1972. Since then there have been a number of revisions, mostly in the area of trying to accommodate the needs of the graphic arts.

Both reflection art and transparencies were considered under the heading of original art work. Proofing takes into account press proofing and off-press proofs.

Two major areas are covered:

1. Color quality appraisal involves the evaluation of original artwork as well as the comparison of the original artwork to the proofs and the proofs to the press sheet.

2. Color uniformity appraisal involves the comparison of various proofs to the press sheets but more importantly the comparison and continued evaluation of press sheets throughout the press run.

The recommended standards refer to three controlled conditions:

1. All elements are viewed under lighting of the same color temperature and color rendering index.

2. The viewing conditions are such that differences are reduced in appearance between original art, proofs, and press sheets when viewed together for comparison.

3. The areas surrounding the viewing areas have been designated so that these are similar between different locations and contribute in a minimum manner to visual differences in interpretation.

It is important to note that this standard specifies, "A set of conditions at the viewing surface," rather than a particular light source, fixture, or viewer. This set of conditions include the quality, quantity, balance, and geometry of illumination, as well as environmental conditions in the viewing area. Unless all these conditions are implemented and maintained there is no standard, and the benefits of a standard viewing system will not be realized.

The conditions of most general interest are:

1. The color temperature—5000 degrees Kelvin

2. The various wavelengths of light are in the correct proportions to produce 5000 degrees Kelvin—color rendering index (CRI)

3. The transparency should have an illuminated border at least two inches wide on three sides

4. The position of the reflected copy, art, proofs, or press sheets must be such as to minimize specular reflection

5. The physical surface of the viewer and/or viewing booth and the viewing room must be neutral in color and make no contribution to the viewing condition.

Why 5000° Kelvin?

Color temperature is used to describe the quality of light. The lower the temperature the yellower the light looks, the higher the temperature the bluer it looks. Practical testing and controlled experimentation indicated that a correlated color temperature of 50000 K provided the necessary white appearance of the illuminator surface under the broadest range of conditions.

Color Rendering Index (CRI)

White-looking light can be achieved by various blendings of color light. Some of them are not acceptable for objective viewing. What is needed is the proper blending of all ingredients that make up the color spectrum. Light sources of 5000° K which have a CRI of 90 or more fulfill this requirement.

Design and Maintenance of Viewing Equipment

In addition to these factors, difference in design of viewing equipment can and does affect light quality. Components such as baffles, defusers, and reflective surfaces may all affect the viewing light. Manufacturers of viewing equipment have to take these factors into account to provide units that fully satisfy the standards. The ANSI standards make no attempt to define design criteria, only the end product, namely the light quality and viewing conditions at the viewing surface (Figure 6-2).

Maintenance of the viewing conditions and the surrounding area is all important. The viewing area should be painted a neutral gray, comparable to Munsel N8 or an 18% value of gray. Repainting every two years is recommended. Stray light from other areas should be eliminated.

Clean lamp fixtures, light reflecting and light transmitting surfaces, and replace tubes every 2,500 hours.

For critical color judgment, the viewers should be on for at least 45 minutes. Eyes will take time to adapt to

Figure 6-2 A typical viewing booth with a transparency illuminator used for comparing original copy to proofs, or proofs to press sheets. *Courtesy of GTI Graphic Technology, Inc.*

color lighting conditions. Five minutes is a good guideline to follow. Many operators leave the viewing equipment on during working hours with no ill effects and claim better uniformity of evaluation results.

There are two common causes for color differences in viewing. One is the lamps used in the viewer, the second is the individual doing the viewing. The most common cause of color appearance differences between viewing equipment is a difference in total burning hours of the lamps utilized. The only valid color comparison between viewers is one made with identical lamps with identical hours of usage.

The viewer's color perception is the most subjective since it is affected by the physiological and psychological factors described in Section One. Some often overlooked variables include observers wearing tinted glasses, tinted contacts, or wearing a bright red shirt that affects the viewing area.

Are standard viewing conditions important? There is an old but true saying in the textile industry that, "Color is how you light it." No matter how sophisticated or automated the color reproduction process becomes, the bottom line for any color job is, "How does it look?" See Figure 6-3.

When buying viewing equipment, three questions should be asked:

1. Does it provide 5000° K?

2. Do the lamps have a CRI of 90 or higher?

3. Does the equipment meet *all* of the ANSI IT.2.3 standard specifications?

The response to these questions from the manufacturer should be put in writing to establish standard viewing conditions.

Film Type Differences

This chapter is on a subject not usually covered in most texts. Film types and their differences do have an effect on the printed results and their variance from the original object. As photography on film is image capture, so is digital picture recording on microchips, charged couple devices (CCD's), photo multiplier tubes (PMTs), tape, and so on. The problems that occur are not the same, but some of the considerations regarding image capture and its effect on printed results are similar.

Figure 6-3 A common viewing condition that is found in industry and addresses the proper standards. *Courtesy of GTI Graphic Technology, Inc.*

Thirty years ago the graphic arts input in photography was generally limited to two or maybe three worldwide suppliers. At that time, film utilized for reproduction was about 2¼" x 2¼" or up in size. Today, a color separator could easily receive film or prints from six or more manufacturers, each with amateur and professional types of emulsions, with 35 mm being the more common film size.

This proliferation of film types has been followed by an ever-increasing number of color separation systems. When photographic mechanical color separations were produced in the 1950s and 1960s only a few systems were in common use. The advent of the high-end color scanners moved that figure to five or six different systems in the 1970s and today with the low and medium flat bed and small drum scanners, the number is well over twenty different systems.

A brief review of history will provide the background on why the choice of image recording equipment or material is important. As we have learned in the past, no single method or image recording equipment will fit all occasions.

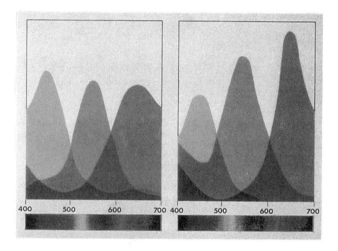

Figure 6-4 Two typical color transparency dye systems. See color insert. *Courtesy of Frank Benham*

Different film sets record the original artwork or photographs with slight differences due to the variety of dye sets, color balance, and spectral sensitivities of the recording film (Figure 6-4). The spectrophotometric curves show the dyes peaking at different locations with slightly different amounts of magnitude. Depending on how these curves are interpreted by either the eye or the electronic sensing devices will affect the color output.

The color separation process on electronic equipment sees film types differently due mostly to variations in dye sets between products and the color response of the color recording system, be it photo multiplier tubes or light sensitive arrays. Another factor contributing to variations is the UV or IR film transmission characteristics and variations in the color sensitivity of the color separation system. Other variables in the color separation system include filters, lenses, lighting, and color sensing devices, not to mention the variety of software circuits utilized in the digital capture. Different films produce different printed

results. Professional photographers long ago started to confine high quality projects to one film type with a specific emulsion coating. Color separators have come to know the differences in color photographic materials, and they have developed methods of adjusting for overall color shifts on copy utilizing the proper scanner programs for a specific film type. Many have four or five basic computer setups to handle the most common types of dye sets they might encounter. This presupposes that the scanner operator can identify the film type and dye set of the supplied original. This is no small job onto itself, and much testing and evaluation are required to do this properly.

In tests done by the Gravure Technical Association (currently the Gravure Association of America {GAA}) comparing different films and their effect on the finished printed product (all other things being equal), it was found that color differences were most significant in browns, the more saturated reds and greens, as well as the so-called dirty colors such as tartan plaids. Blues were fairly uniform, as were light pastels and other clean colors. Yellows did show subtle changes but was not overly significant.

Consideration should be given to the type of film utilized to record a specific scene, considering what colors are most important. Not one film does it all. The intermixing of film types within a page, brochure, publication, or other printed product will lead to poor results. Furthermore, mixing color separation systems and techniques can create exactly the same problem at the next stage. Each of these minor or subtle differences, when added up, can become problems in the reproduction of a quality printed product.

There is no easy way to assure getting the proper results without testing. Photographic dye sets and color balance are altered by the manufacturers from time to time. In color separation equipment, color sensitivity changes such as new sensing devices and circuitry are constantly evolving. If a suitable test object is utilized (there are many available from trade associations and film or scanner manufacturers), various films can be evaluated through one system to a common proofing process. Then the results can be judged. A critical eye and experience in color

judgment are a prerequisite for this evaluation. The photographer and the color separator should both be included in discussions on film type for establishing quality guidelines that will produce a better end result.

Duping—Photographic and Electronic

The term "duping" has more than one meaning. It most commonly refers to the generation of single or multiple duplicate transparencies from an original transparency. Duping also refers to creating transparencies from color hard copy, such as a painting, for either distribution or for use as input into a color scanning system. A better term is "second generation original." In some cases of analog duping, image manipulation may have occurred. Either the size has changed or the overall color balance has been altered from the original.

The term dupe or duping implies an exact reproduction of the original. In the strictest sense, this is not possible in photographic duping due to the limitations of the photography process. Photographic duping is altered by spectral sensitivity differences in film emulsions. Electronic duping, due to the ease of data manipulation, has been shown to produce a better result, but usually at a higher cost, as dupes are usually produced with some form of electronic local retouching. So, in effect, the electronic method produces a modified dupe more easily than the photographic method. Both methods produce entirely satisfactory results in the hands of experienced people.

Photographic Duplication

In the manufacture of a photographic dupe there are three major areas that control the results: the exposure, the material utilized, and the color of the light that exposes the film. Contrast is a function of the material utilized and film processing conditions. When these variables are properly adjusted, excellent dupes can be made. There are special color films made for duplicating transparencies.

The film sensitivity of duping films are established by the manufacturer. They see color a specific way, so when establishing the best set of conditions for duplicating color film "A" you must keep in mind that color film "F" or "K" has different dye systems and will probably require a different set of conditions to produce exact dupes as required. Duping is a highly specialized field where experience and high quality equipment and products are required for the best results. There is a saying in the photographic business "that there is no such thing as a good, cheap, dupe."

Electronic Duplication

In electronic duplication the original color art (transparency or print) is scanned into digital data. That data is then sent to a color electronic prepress system that modifies the data that is provided to an electromechanical printer. The printer exposes either color transparency or print material to provide a continuous tone color result. Both Hell and Polaroid were pioneers in this method that is used not only for making dupes in the commercial photographic sector, but also in the printing world for making photographic color proofs. The latter cannot be classified as a dupe since its objective is to simulate a printed page rather than match the original color art.

The flexibility of the manipulation of the digital data prior to filmmaking means less emphasis on the characteristics of the photographic products. It does require uniformity and predictability of the photographic materials and processing. In the end, however, the criteria for judgment is the same as in the photographic process, comparing: highlight detail, color balance, and contrast. In the comparison of original to dupe, the need to utilize standard viewing conditions is paramount.

Conversion of Hard Copy to Transparency

Most of the conversion of hard copy to transparency is done to provide input for scanners that require flexible

support, have a size limitation, or will not scan reflection copy. Conversions are also done to provide multiple transparencies for distribution purposes or to overcome improper retouching that has been detected in scanning. Conversion of this type does not really fit into the duping category, since the materials used are so different in media that a match is very difficult to obtain. There is very little published information on the "how to do it" phase of hard copy conversion. Those who specialize in this area have worked out methods and techniques that are proprietary.

There are a few general rules, however, that are worthy of consideration.

- If at all possible use the original art. The further one goes in generations from the original the poorer the results.

- The use of polarizing screens in sheet form seems most desirable. These can be used to cover the light source used to illuminate the hard copy as well as to cover the film being exposed.

- The control of contrast can be accomplished by two methods depending on the original hard copy:

 First, use contrast-reducing photographic masks.

 Second, use a flashing technique that allows an exposure for highlight density and an overall flashing for the shadows similar to black and white halftone photography.

- If retouching or unusual colors are incorporated in the hard copy, the type of transparency film to be utilized should be carefully considered. Most films see things slightly differently. Some are better than others in specific areas. No one film will do it all. Experimentation under specific conditions is the best method to determine what film is the most acceptable for specific circumstances.

Retouching—Photographic and Electronic

Retouching is used to alter color in specific areas on both color film transparencies and color photographic prints. It is also used electronically at the color prepress stage in the digital area prior to making separation films. The major need for retouching is to make a change outside of the photographer's ability to produce desired results, many of which are subjective in nature. This is true for conventional photography as well as digital photography.

Photographic retouching normally uses three methods, sometimes used separately and sometimes intermixed.

1. Add color

2. Remove color

3. Change of color

The change of color is the most complicated, while the addition of color is the least difficult.

The following suggestions are made with the intent of avoiding retouching problems at the color separation stage. Color electronic scanners see different films and their retouching differently. Practical testing is the only valid way to evaluate the effectiveness of any photographic retouching. Correcting incorrect retouching at the color separation stage is costly and time consuming. It is one of those rare instances where a customer can get billed twice for the same change.

1. Follow the film manufacturer's recommendations on the dyes and techniques to be utilized for retouching a reproduction. This assumes that the retouching dyes match the dyes in the film product being retouched in all spectral characteristics.

2. Use ANSI standard viewing conditions for all retouching and evaluation efforts. Retouch using the normal color separation filters (Wratten #25, 58, 47B) for evaluation.

3. Evaluate the film used in duping retouched originals. Duping films may see retouching differently than the eye or the scanner.

4. In order to evaluate any set of circumstances designed to determine retouching effectiveness for reproduction, it should be kept in mind that the three methods of retouching should be evaluated simultaneously through a very systematic approach. This system constitutes: film types, retouching materials, technique, and color separation conditions. The results obtained will verify the effectiveness of retouching for reproduction under a specific set of circumstances. Test objects utilized should consider all of the above conditions. Eastman Kodak has available an excellent retouching test target with complete instructions on evaluating retouching dyes and techniques for reproduction.

Retouching is a very complicated process. Many costly errors are made in retouching, mostly due to the retouched areas not matching the unretouched areas in all spectral properties. The less retouching the better.

Electronic color retouching can occur anywhere within the digital pathway, from scanning to final film, or plate-making. In the past, retouching by electronic means was done by highly experienced operators using high-end color electronic prepress systems. With the advent of desktop publishing and minicomputers, retouching software has allowed those closer to the creative process to make color correction changes if so desired. Not only are local spot color changes made easily, but overall color shifts and contrast can be altered as well. Considerable experience in judging color and an intimate knowledge of the differences between the RGB monitor and the YMCK inks on the printed sheet are required to adequately anticipate printed color changes when viewing a color monitor. Most color change judgment calls are subjective, which leads to such directions as, "make it a tad more blue," or " I want to get the feeling of warmth." This stresses the degree of complexity that is inherent in color correction of electronic pic-

ture data. As with photographic retouching "what you see is not always what you get."

Lighting Ratios

Lighting ratios are used by the professional photographer to create the illusion of contrast. These ratios are referred to as 1:1, 1:3, 1:5, 1:7, and the higher the number the higher the apparent visual contrast. This is accomplished by varying the type of lighting, the position of lights, and the lens and filters that are used.

Lighting ratios should not be confused with high or low key images. Lighting that produces few shadows and visually looks flat would be an example of a 1:1 or 1:2 ratio. A person who is in the dark with back lighting or with only one side of the face being illuminated would be an example of a 1:7 or 1:9 ratio. For most commercial work, 1:3 or 1:5 lighting ratios are the most common and, in general, provide the best originals for reproduction.

The visual effect of changing lighting ratios is one of contrast, so the contrast of the film being used is an important issue. Film latitude also plays a part. Negative films have much greater latitudes than positive films. Lighting ratios using negative color films must be exaggerated to accomplish the same visual effect that one gets on positive transparency film.

Different films are manufactured with subtle contrast changes, and lighting ratios have to be altered for different film types to accomplish the same visual results. Many professional photographers gain experience with a specific film type and adjust their techniques to get the desired results.

A word of caution would be in order for art buyers and creative people who buy photography for reproduction. Let the photographers create the visual contrast you desire using their own techniques, and try to avoid lighting extremes. The printing process has a tendency to minimize small differences and to expand on large differences. Communication between client, photographer, creative people, and the color separator are most important. Lighting ratio

misjudgments are very costly to correct at the separation stage and impossible to correct on the printing press.

There is a technique called "measured photography" that utilizes densitometry at the film plane to determine highlight detail and contrast on a subject being photographed. This puts exact numbers on contrast and highlight density. Measured photography is very useful in catalogs and brochures where many pictures on a page should have the same contrast and detail.

Sharpness and Mottle

Sharpness in either art or the printed result is a visual interpretation of the ability to see fine detail. Sharpness in the printed result is affected by many things, most notably the degree of sharpness in the original art work and the amount of unsharp masking utilized in scanning. In photographic art, the quality of the lens and its ability to focus all colors on a specific point are of paramount importance. Focusing methods vary from visual to automatic, which is another area that contributes to the degree of sharpness. Movement is a prime cause of unsharpness, especially when 35 mm handheld cameras are used.

Effective visual sharpness in a printed product can be varied by either photographic masking techniques (used primarily with camera back color separations of such hard copy as original paintings), or with electronic scanners and the subsequent electronic manipulation. Digital data sharpness becomes a function of edge enhancement (edge contrast) that produces the visual interpretation of sharpness. Electronic detail enhancement includes white line or black line features that outline the highlights of an image with thin black lines and shadow details with thin white lines.

In the traditional graphic arts process many steps are involved. A good rule of thumb is "the fewer the steps the better." Retouching and duping contribute to reduced sharpness in the printed result. This problem has been reduced considerably with the use of digital data. The best sharpness comes from the digital area, with the exception of some digital cameras. Sharpness is difficult to judge on

small transparencies and many errors in judgment about lack of detail would be detected if original input copy were viewed at finished page size. Special viewers for 35 mm films are available to reduce this problem.

Also to be considered is original film type utilized. Sharpness or detail in enlargement of 10X or over is affected by the grain size of the original photo, either print or transparency. The finer the grain the better the sharpness. In recent years, film manufacturers have improved grain size for this reason. In the world of digital cameras, grain size relates to the sensing device in the camera, normally a photosensitive array of some type. There is a wide range of array configurations available that produce a wide range of sharpness. None of the current arrays match color transparency film in resolving power, but depending on the finished printed size of the picture and screen rulings used in reproduction, satisfactory results can be obtained under certain conditions. The results are based on subjective judgment and the acceptance is in the eye of the beholder. Screen rulings as well as printing paper surface have a significant effect on visual sharpness. The higher the screen ruling and the smoother the printed paper surface, the better the sharpness.

Mottle in the printed result is also affected by the grain size in the film but is evidenced in different ways on the printed sheet. Mottle on a printed sheet appears blotched especially in areas of uniform color such as light gray, flesh tones, and wood grains.

When trying to improve sharpness the edge effects are related to the acuteness level being utilized in scanning. The use of high acuteness levels increases the likelihood of producing mottle when extreme enlargements are required, such as in 35 mm original enlarged to a printed two-page spread.

Register, ink and paper, plus screen rulings and screen angles play an important part in the degree or lack of mottle. There are emerging screening techniques referred to as "random dot" or "stochastic" screening within the digital system that eliminate or minimize the mottle problem and

improve the visual impression of sharpness. There are a variety of manufacturers supplying the software that produces these new dot formations. Not all utilize the same techniques, but they accomplish basically the same objective. Evaluation of the various system results would be in order prior to commitment.

Fluorescence in Hard Copy

The issue of fluorescence is not as critical as it was with traditional color separation or halftone reproduction, but it remains a factor in that some of the original copy used may possess brighteners that will influence digital imaging. Fluorescence in photographic materials, fabrics, pastels, paints, soaps, and other products is usually referred to as brighteners and comes from the fact that the ultraviolet absorption characteristics of the materials change UV energy in the visual area creating a brightness or whiteness effect (Rinso blue). The amount of brightness varies from product to product and between manufacturers. Photographic papers used in the creation of a color print exhibit wide differences in the use of brightness as do fabrics and acrylic paints.

Fluorescent brightness creates the visual impression of either improved contrast or increased color saturation. The problem is that various films, scanners, and digital cameras do not always see things the way the human brain does, thus the finished printed results are unsatisfactory when compared to the original input. This, of course, can be resolved by color correcting the digital data stream, but this is costly, time consuming, and another chance for misinterpretation. One solution is to eliminate the UV itself which can be done by placing UV filters, when possible, over the light source that illuminates the input copy.

There is no firm or fast rule on how various brighteners affect printed results, this all depends on how well the color separation system sees the colors generated by the UV brighteners.

There seems to be very little information available on fluorescence and its effect on the printed page. Very little, if

any, information is published by the manufacturers of film, photo multiplier tubes, or color sensitive arrays, on this phenomena. One thing to remember, if fluorescence is known to be present, "what you see is not necessarily what you will get."

Digital Imaging

Digital imaging, digital photography, and digital photo imaging are various names for the same thing, the recording of an image on a light sensitive array through an optical system that in turn produces red, green, and blue digital signals. Photographic color film is replaced with a CCD sensor or some similar device.

Electronic analog cameras, or still video cameras, are primarily used for television and multimedia. This type of equipment has not been utilized to any great extent within the color world catering to print production. Low resolution and color quality acceptability are the major current limitations. The use of these cameras does have an application in design and fashion work for preliminary approval, since the images provide quick access.

Many predict that the use of digital photography will rapidly erode the use of color films. It will have an effect, but in reality it will be just another tool used to create color input data. Designers and art directors like to have something in hand to judge the input copy for various attributes. They compare one photo to another many times over. Today there is little difference in the performance of color film emulsions between major vendors. Today's color films have excellent color rendition, contrast, and density range that exceed by far the ability to reproduce it.

Cost is a factor in the digital camera world, and as the saying goes, "you get what you pay for." Digital cameras vary in price, which can be directly related to output results. Today there are digital cameras or camera recording backs that cost anywhere from under $1,000 dollars to well over $80,000 when all the peripheral gear is added. Prices are sure to come down as major players attempt to enter the consumer market. Prices in the $300 to $400

Figure 6-5 Logitech's Fotoman Pixtura. *Courtesy of Logitech*

range can be anticipated in the low-end cameras. One example of a low-end camera is Logitech's Fotoman Pixtura (Figure 6-5) that ports into a PC with a 486/25 or higher processor. This unit captures 24 bit color images at 786 x 512 pixels. Other digital cameras are made by Sony, Kodak, and Casio, to name a few.

Megavision's T2 digital camera back (Figure 6-6) is designed to fit most 5 x 7 view cameras or to attach to Nikkor or Hasselblad lens adapters. With 2000 pixel resolution and a focal plane shutter connected to an Intel "Plato" motherboard, this digital receptor represents the high end of digital photography with a price tag of $40,000 or more. Leaf, Canon, and others have equipment in this price range.

The higher the cost, the better the results. The decision that has to be made is what end results do you want? How good do you need or want it to be? There is a big difference between input requirements for reproduction when you compare a 2¼" x 2¼" 65 line color reproduction in your local newspaper, with a two-page spread of a food advertisement using 150 line color reproduction in a quality magazine.

Figure 6-6 Megavision – T2. *Courtesy of Megavision*

As with conventional color photography, the rules of optics, lighting, color, tonal range, sensitivity, contrast, color response, dynamic range, speed, and resolution need to be considered.

There are differences between using film and using CCD arrays. These differences have to be understood and mastered. Almost all the differences are related to the CCD arrays and the pattern of pixels arrayed on the sensor. Many of these problems are unique to digital imaging and terms

such as signal-to-noise ratio, aliasing, color fringing, bleeding, and blooming will create new vocabulary. As the digital camera produces the graphic signal it is necessary to judge the result on some output device. So the total system, camera and computer are a unit and the problems come in the movement of data within this system, and how well the camera input relates to the output viewing conditions.

Digital photography has a number of advantages that will increase its continued acceptance into the creative sector of the graphic arts. It is fast, creating and viewing images in seconds rather than hours in normal chemical-based color photography. The real assets, though not camera related, come from the fact that the picture has now been separated into a red, green, and blue signal that can be transmitted, manipulated, blended, viewed, and stored on a wide variety of digital equipment from the Mac's and PCs used in the preliminary color creative field to the high-end color electronic prepress equipment. This places more of the manipulative movements upstream closer to the originator of the idea. Faster?, (yes); better?, (depends); easier?, (in many areas); cheaper? (probably not); but, all of these still require the human interface to make the decisions. So, as with conventional photography, experience and knowledge of the digital process will be the determining factor on degree of print customer satisfaction.

For More Information

The following sources will provide you with the additional information necessary to better understand the concepts introduced in this chapter. The best sources for digital photography and current camera technology are the major manufacturers such as Sony, Kodak, Casio, and others.

AGFA. *An Introduction to Digital Photo Imaging.* AGFA Prepress Education Resources, Mt. Prospect, IL, 1996.

AGFA. *Working with Prepress and Printing Suppliers.* AGFA Prepress Education Resources, Mt. Prospect, IL, 1996.

Billmeyer and Saltzman. *Principles of Color Technology,* New York: John Wiley & Sons, 1981.

Graphic Technology. *View Guide,* Inc. September 15, 1994.

Hunt, R. W. G. *The Reproduction of Colour in Photography Printing and Television.* Fountain Press, Tolworth, England, 1987.

Kodak Bulletin for the Graphic Arts. *Standard Viewing Conditions for Reproduction.* Eastman/Kodak Company, 1970.

Section V

Color Separation for the Reproduction Processes

Electronic Color Scanning

Systems of Color Separation

Over many years of reproducing color, the industry has developed several systems of color separation. These systems produced color separations using different techniques and production equipment. The three most common systems of color separation were the direct screen method, the indirect method, and the electronic scanning method. The first two systems of color separation were used primarily for generating analog separations, or separations that were produced by photomechanical techniques. The third system of color separation, electronic scanning, remains the current system of choice. Scanning is an image capture technique that creates a digital file that can be manipulated and stored.

It should be noted that when each of these systems were in use by industry, given skilled technicians and enough time, each process delivered an excellent end result. In the past, the choice of color separation system depended on the following considerations.

1. Initial capital expenditure or cost of equipment

2. Type of original copy, either reflective or transparent

3. Size format of the original copy and output size (Ganged copy or individual originals)

4. Turnaround time expected by customers

5. Level of quality, to include color correction

6. Cost that a customer was willing to pay for the final separation and proof

To put modern electronic separation techniques in perspective, a brief discussion of the three systems is important. The conventional systems of color separation are fading quickly, but are still available is selected locations. The evolution of electronic scanning was accomplished by providing features not available in the direct or indirect systems.

The *direct system* of color separation included camera back separations which delivered screened separation negative films. Camera back separations were considered to be a fast and efficient method of separation. Photographic masks were used for color correction. Photographic masking included split filter masks created by partial exposures through different primary filters on pan masking films. The direct system could be done on a process camera, direct screen enlarger, a contact frame, or on a third generation contact screen electronic scanner.

The *indirect system* of color separation involved additional generations of film exposures because a continuous tone separation was made on pan film through the complementary color filter. The continuous tone or con tone separation was then contacted to a film positive which was later contacted to ortho film using a halftone screen. The advantage of these additional film steps was the ability to continue to alter size, or to make retouches to every generation of film. The process was time consuming, but could use the inexpensive contact frame for many of the production sequences.

The third system of separation, *electronic scanning,* is the fastest method, and ultimately the easiest method of color separation. The electronic scanner was capital intensive in its early days. The third generation of scanner included either transparent or reflective formats, the ability to change reproduction size, negative or positive output, change scan direction, and many other improvements over the first two generations. The fourth generation of scanners included electronic dot generation (no contact screen) and the ability to store digital data for manipulation and output at a later time. The technological advancements of the fourth generation of scanners reduced the need for the

direct and indirect systems of separation. Ultimately, the desktop or CCD scanner was developed, and the cost of the electronic scanner was reduced significantly. The acceptance of PostScript imaging was instrumental in the acceptance of low-end and mid-range scanners.

Analog Separations

Analog separations are commonly classified as photomechanical or color separations produced from devices that use nondiscrete values or continuous values. An example of an analog control is the volume control on a television set. On the electronic scanner, analog control is a potentiometer. Older scanners used analog controls or adjustments, and progressed to the combination of analog and digital color computers. The newest generation of scanners are considered to be totally digital.

Analog separations can be referred to as film output from temporary memory. When the older scanners were shut off all data was lost, or the camera exposures generated a single film image. Color proofs were also generated by analog technology, and if the image needed major correction the process had to be redone. The advantage of digital separation files is the ability to store the image data, manipulate data, and archive the data.

Digital Separations

The *digital separation* is created by devices that assign discrete values for the image data, such as 0/1, or on/off binary code. The digital data creates a separation file that can be stored, manipulated, and archived for future use. Modern electronic scanners adjust output size, tone reproduction, electronic dot generation (EDG), and other functions with digital data.

The future direction of all color separation processes is to close the digital loop. When the digital loop is closed there will be no need to output to film. By creating digital separations, *direct digital color proofing (DDCP)* and direct-to-plate or direct-to-press technology can be utilized.

Production Equipment

During the 1950s to the early 1980s, there were four distinct pieces of production equipment used for color separation. The *process camera* was a dominant piece of equipment used in the production of direct screen camera back separations, as well as in the indirect method of generating continuous tone separations. The process camera is used very little today, primarily for large format rigid copy. The horizontal process camera was commonly used with photographic masking done on register pins, in a totally dark environment.

Another traditional piece of color separation production equipment that has become extinct is the direct screen enlarger. Used by newspapers and color houses for many years, the direct screen enlarger utilized transparencies mounted in the head of a large format enlarger that projected the enlargement onto the vacuum easel. The direct screen enlarger typically used a circular screen for halftone separations and had a color filter turret under different lenses. The flash exposures utilized a low-level auxiliary light source that swung over the screen and film on the vacuum easel. Direct screen enlargers often required total darkness or a dark green safelight.

The third piece of separation equipment was the *contact frame,* which was limited to making one-to-one size reproductions. The contact frame required pin register, total darkness for separation films, and a rotating filter rack that used a point light source for the different exposures. The contact frame was often used to screen continuous tone separations for the indirect method, thus freeing up the process camera for production of the first generation separation and masks. The contact frame was either an open face or closed glass vacuum frame. The contact frame is still used for many applications in the industry, primarily for creating composite films rather than color separations.

The fourth piece of production equipment used for separations is the electronic scanner, which has become a mature technology and affordable for many applications.

Classifications of Scanners

Since the 1950s, electronic scanners have been evolving in sophistication, while at the same time, reducing in cost. The traditional scanner required commercial quality output, the ability to handle different format sizes, negative or positive film orientation, and other attributes found only in expensive high-end electronic prepress equipment. Since the late 1980s, a variety of electronic color scanners have evolved from different manufacturers, to compete with the traditional color electronic prepress systems.

During the 1970s and 1980s, electronic color scanners were classified by their output. Scanners were considered to be either continuous tone, contact screen halftone, or electronic dot generated. Today scanners are classified as either drum or flatbed, photomultiplier (PMT) or charged couple device (CCD), or high-end, mid-range, and low-end. The basic concept, "you get what you pay for" still exists today. Different priced scanners produce different results, but the lines that differentiate scanner classifications are becoming blurry.

High-End Scanners

The high-end scanner remains the production tool of choice because it is capable of larger format variations, and it delivers the greatest control over the reproduction variables. The question becomes whether separators or printing companies need to pay for the entire spectrum of technology and capital investment in the neighborhood of $40,000 to $100,000. The major manufacturers of high-end equipment are beginning to offer mid-range equipment to compete with low-end choices. The fact remains that the majority of commercial color printing done today is produced from high-end scanner technology. The dependability and speed of the high-end scanner offers consistency and customer satisfaction under demanding production deadlines (Figure 7-1).

The majority of high-end scanners were considered an integral part of the color electronic prepress system (CEPS). Because these scanners were part of a dedicated system,

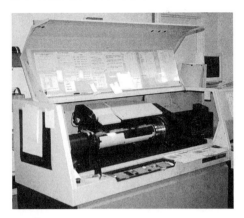

Figure 7-1
A high-end scanner used for production in the industry. *Courtesy of American Color*

they were often considered to be proprietary in nature and part of a closed system. The introduction of PostScript played an important role in the advancement of the open imaging system, with a choice of equipment interfaces.

Mid-Range Scanners

The mid-range technology and hardware seems to be where a lot of the action is during the 1990s. Many people in the industry who experimented with desktop and low-end scanners have discovered the need for better quality and more dependability in commercial production. The mid-range scanners fall into a broad price range of between $4,000 to $40,000, and offer many of the advantages of the high-end scanner at a lower cost.

The mid-range scanner is usually designed to work in the PostScript imaging environment. Typically, the mid-range scanner is either a drum scanner that has the same features as a high-end scanner, but with smaller input and output parts, or a high resolution CCD array flatbed scanner. Many of the commercial printing companies are discovering that they cannot serve their customer base with low-end scanners, but they do not want the capital investment of the high-end. The mid-range scanner will become more and more popular in the production environment (Figure 7-2).

Figure 7-2 A mid-range scanner used for production in the industry. *Courtesy of Heritage Graphics*

Low-End Scanners

The desktop publishing movement that began in the mid 1980s helped to create low-end scanner technology. The low-end scanner was affordable and was typically a flatbed or handheld charged couple device (CCD). The resolution of the low-end scanner was unsatisfactory, but allowed the average person to capture black and white or color images in nearly any environment. Software that drives the low-end technology tends to lack the robust features found in higher-end scanner software. Scan time and image enhancement are limited on the low-end devices, but they are designed for PostScript output.

Most of the low-end scanners are either CCD flatbed devices or slide scanners. The newer low-end scanners offer higher resolution and a refined CCD array technology (Figure 7-3). The low-end scanner usually starts at around $300 and will go up to about $4,000. When buying a low-end scanner it is wise to avoid the lowest priced devices.

Figure 7-3 A low-end scanner that has application for some commercial color separations. *Courtesy of American Color*

Many individuals or small imaging houses end up purchasing another scanner with additional features. Some low-end scanners are bundled with a computer workstation and software. Bundled scanner hardware can often be an indicator of a product that did not sell well, or that has to be updated, coming from some old inventory. The same is true with bundled software, the program is either in the process of being updated or had difficulty in its original marketing.

Electronic Sensor Technology for Color Scanners

Electronic color scanners use light sensitive photocells to record the light reflected from, or the light transmitted through the original copy. The sensor in the color scanner converts the photocell energy into an electronic signal. The scanner converts the light energy recorded as an analog signal into a digital data stream. There are two major types of sensor technology available, the traditional *photo multiplier tubes (PMT)* and *charged couple devices (CCD)*. There are other sensor technologies being used on desktop scanners, but for commercial color separations the choice of PMT or CCD scanners is the primary consideration.

CCD Scanners

Recent developments with the CCD have significantly enhanced this sensor technology for imaging. The CCDs are typically used in flatbed scanners and consist of an

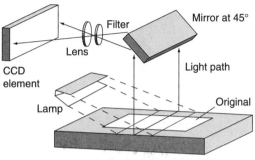

Scanning table for reflective copy

Figure 7-4 Charged coupled device (CCD) scanner.

array of light sensitive elements. The number and density of CCD elements determine the resolution and quality of the scanner (Figure 7-4).

The resolution capability of a CCD scanner refers to the finest increments that the scanner is capable of sampling from the original image. The majority of operators refer to resolution as *dpi* or the number of dots per inch, others prefer to use *ppi* or pixels per inch, which means the same. A CCD scanner is rated using its native resolution, or the maximum sensor capability in dpi. Many low-end CCD scanners provide interpolation software that mathematically creates more pixel data between the actual native data points. Caution must be applied when using interpolation factors because too much artificial data can compromise the image quality.

Another attribute of electronic scanners is dynamic range. The dynamic range of a scanner is measured by its ability to reproduce tonal range or density range. Some scanners, such as PMT scanners, can reproduce a density range of between 2.70 and 3.20. The density range is the difference between highlights and shadows. The dynamic range is also affected by the bits of data per pixel. The higher the bits per pixel, the better the tonal range of the reproduction. The better scanners can capture 24 to 32 bits per pixel.

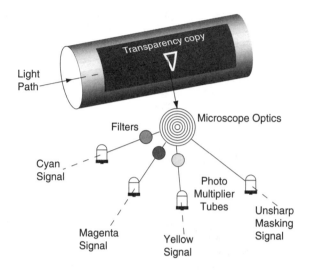

Figure 7-5 Photo multiplier tube (PMT) scanner.

The majority of desktop scanners use 24-bit color which represents the primary red, green, and blue colors with an 8-bit brightness range. This technology provides for 256 variations for each primary color or 16,777,216 total colors. The 32-bit system provides an additional 8 bits of data for the 256 levels of transparency, or the difference between opaque and clear color images.

Flatbed scanners can either be a single-pass scanner or a three-pass scanner. The three-pass scanner was developed and marketed first. The three-pass scanner required a pass for each of the primary colors of red, green, and blue. Early three-pass scanners caused misregister of the RGB images. Newer three-pass scanners are more accurate. The current trend is to use a single-pass color scanner.

PMT Scanners

The traditional electronic scanner is the drum scanner, which typically uses photo multiplier tubes (PMT) as the sensor technology (Figure 7-5). The photo multiplier tube is

sensitive to different wavelengths of the light spectrum. While not as sensitive as the CCD, the PMT is capable of amplifying the signal, which ultimately produces greater tone throughout the reproduction. The difference between PMT scans and CCD scans can be seen in the shadows of the reproduction.

The majority of commercial color separations produced are accomplished on PMT drum scanners. Recent developments in the CCD array technology are beginning to impact on the amount of commercial separations produced by traditional drum scanners.

The major advantage of the high-end color scanner is its ability to enlarge and reduce extreme sizes accurately. The drum scanner usually accepts larger format originals and can output larger film sizes very efficiently. Desktop scanners are usually limited to small platens. Most drum scanners are horizontal in design, but a couple of manufacturers have developed vertical drum scanners.

Linearization Procedures

Electronic imaging devices, including electronic color scanners and imagesetters, must have a linear output, or in simple terms, a controlled density increase for each exposure increase of the laser. The need for repeatable and predictable film output is a necessity for commercial color reproduction. Several major manufacturers have developed software for linearization testing. The *linearization* test for an electronic scanner involves measuring the output of a laser light source for a specific film emulsion, under controlled processing conditions, as evaluated by a transmission densitometer. Exposure and calibration of an imagesetter are very similar in that for every measured increase in exposure there should yield a proportionate increase in density.

At the beginning of any production shift, a scanner operator should test for linearization. The linearization

tests have become very simple over the years, and require little film, chemistry, and time. The purpose of the test is to make your results predictable, and thus consistent. In a production environment, usually more than one operator works on a color scanner. The concern is for production results that do not deviate from one operator's work to another.

Image Adjustments for the Electronic Color Scanner

The typical mistake made in the process of color separation on an electronic scanner is to rely on the manufacturer default settings. Previous generations of the electronic scanner required skilled operators who played the complicated control panel like a piano. The analog scanners or analog/digital scanners required manual adjustments that were not preprogrammed.

Preprogrammed default settings include resolution, screen ruling, tone reproduction aim points, gray component replacement, and many other imaging considerations. Insofar as default settings are used, it has never been more imperative that we do not disregard the learning curve industry has created over the last thirty years of color reproduction.

The three most critical imaging concerns for color reproduction are tone reproduction, gray balance, and color correction, to include global and local. Other considerations in color separation include cast removal, detail enhancement, and under color removal (UCR) or gray component replacement (GCR).

Cast Removal

There are occasions when the original transparency or copy has an overall tint, such as green or blue. This cast can be caused by several factors, including the use of

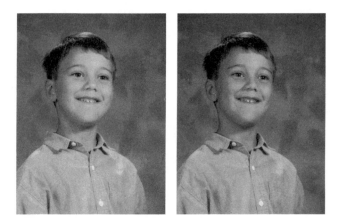

Figure 7-6 A green cast original and a color separation that was adjusted with cast removal. See color insert. *Courtesy of T.C.*

the wrong film for the available light conditions, or heat exposure. The electronic scanner affords the opportunity to adjust the overall cast and to correct the color gamut (Figure 7-6).

Detail Enhancement

When laser scanners became popular, individuals sold laser art because the image was extremely sharp and it appeared to be three dimensional. Another term more common to desktop and Photoshop users is sharpening through the use of sharpen and sharpen more filters. The sharpen filters found in the submenu of Photoshop sharpen blurry images by increasing the contrast of adjacent pixels. The high-end drum scanner has a feature that allows for adding a fine white line around the shadow details, and a fine black line around the highlight details. This feature is adjustable and works best for highly intricate artwork. Extensive detail enhancement should be limited on

soft, subtle images such as skin tones in a portrait. The starting point for detail enhancement should be adjusted for each picture.

Under Color Removal

As far back as the 1950s, under color removal was performed to reduce the yellow, magenta, and cyan ink densities in the neutral gray shadows of the image, and to replace the density with a full range black printer. Some of the key advantages of UCR in offset lithographic printing include reduced dot gain and wet trapping. In gravure printing and offset printing, another advantage is the reduction in cost for expensive pigments, with black ink providing the replacement density. With reduced ink on the press sheet, drying time can be reduced.

UCR was the early predecessor to gray component replacement. UCR is quantified as a percentage of the density removed from the maximum shadow.

The use of UCR can sometimes cause gray balance problems in the neutral shadows. The use of under color addition is required to compensate for color deficiencies. Under color addition is also expressed as a percentage.

Gray Component Replacement

The use of gray component replacement (GCR) is a refinement and more sophisticated variation of under color removal. Often called achromatic color reduction, GCR affects the entire image and is not limited to the neutral shadows as in the use of under color removal. GCR is based on the idea that any color or hue is made up of varying amounts of overprinted cyan, magenta, and yellow. The color being reproduced is predominately made up of two of the primary subtractive colors, and the third is considered a graying contaminate. The graying contaminate or weakest color ink could be reduced or removed in proportion to the other two pigments, and be replaced with black ink (Figure 7-7).

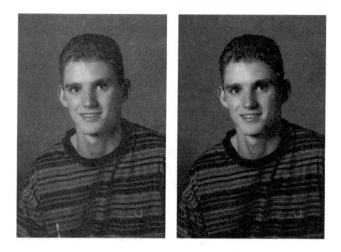

Figure 7-7 60% GCR with the three-color yellow, magenta, and cyan on the left and the final four-color sepaation on the right. See color insert. *Courtesy of David R. Dudas*

Because GCR affects the entire image, it is controlled by software, and the software will vary slightly from different manufacturers. Gray component replacement is often a standard default on image manipulation software, and is applied on Adobe Photoshop. GCR is the generic name for this process, and encompasses many of the various trade names such as Integrated Color Removal (ICR) from Dainippon Screen, Crosfield's Polychromatic Color Removal (PCR), and Linotype/Hell's Complementary Color Reduction (CCR).

Some advantages of GCR are:

- Less total ink coverage

- Faster drying times

- Improved ink trapping

- Improved dot gain

- Cost savings of ink when using 50% or more GCR

During the last decade, customer acceptance of GCR has increased, and SWOP guidelines have improved. Too much GCR in a color separation can cause variation in color from the original, and at nearly 100% GCR, fine white lines become visible if there is any misregistration during the press run.

The electronic scanner represents the current system of choice for color separation in the industry. The technology behind the scanner continues to provide increased capability with a reduction in price. Scanning for commercial applications requires an understanding of image manipulation specific to the different reproduction processes.

For More Information

The following sources will provide you with the additional information necessary to better understand the concepts introduced in this chapter.

AGFA. *A Guide to Color Separation.* Agfa Prepress Education Resources, Illinois, 1993.

AGFA. *An Introduction to Digital Color Prepress* (Fifth Printing). Agfa Prepress Education Resources, Illinois, 1993.

AGFA. *An Introduction to Digital Scanning.* Agfa Prepress Education Resources, Illinois, 1994.

AGFA. *Digital Color Prepress: Interactive CD-ROM.* Agfa Prepress Education Resources, Illinois, 1996.

Field, G. G. *Color Scanning and Imaging Systems.* Pittsburgh: Graphic Arts Technical Foundation, 1990.

The Desktop Color Book. Verbum Books, Inc., San Diego, CA, 1992.

Preparation of the Color Separation

The reproduction of a color original requires the entire spectrum of color in the image to be separated into the primary subtractive colors of yellow, magenta, and cyan, along with a black printer. The application of the separation process limits the spectrum of color in the reproduction process. The limitation is due to variables such as the spectral sensitivity of the film and of the scanning device, ink impurities, ink and substrate relationship, and reduction in original density.

A successful separation facility can control many of these variables by proper evaluation of the original and by careful attention to some of the major factors such as: tone reproduction, gray balance, color correction, and halftone screening. What makes a separator successful is an awareness that each continuous tone color original is different, and that the standard software defaults or cookbook procedures will not always apply. A successful separator is not a button pusher, but rather an individual who analyzes, problem solves, and composes facsimile reproduction of an original. It took industry the last three decades to properly separate color images for the different reproduction processes. This learning curve must still be applied to the newer digital technology, including desktop separations.

Tone Reproduction

One of the most important considerations in the faithful reproduction of a continuous tone color original is tonal reproduction. There have been several books written on the subject of tone reproduction, but in its simplest form,

tone reproduction is the manipulation of the printable dot range for the purposes of facsimile reproduction. This means that depending on the printing process to be used and the type of press for that process, the range of halftone dots that can be reproduced will change. For example, a good commercial sheetfed offset press can carry a range of halftone dots from a 3% highlight to a 97% shadow dot. A non-heatset web offset press can only carry a range from a 15% highlight to a 85% shadow dot without losing or plugging the dot geometry.

It is critical that the range of tone in the original be compressed to the reproduction characteristics of the particular printing process and press configuration that will be used to reproduce it. This is not difficult with the use of aim points for highlights, midtones, and shadows.

The first concern for tone reproduction in the color separation process is the evaluation of the original image. Regardless of copy format, either transparency, reflective, or digital image, the density range must be identified—usually through densitometry. Digital files can be opened in color manipulation software such as Adobe Photoshop (among others), and examined with the in-line densitometer tool. After the highlight and shadow have been defined, the image is evaluated for contrast characteristics with respect to various picture elements.

Original continuous tone copy is classified as either high-key, low-key, or average contrast. By definition, high-key copy contains all of the major picture elements in the highlight to mid-tone area.

An example of high-key copy would be a white cat on a cream colored carpet with off-white walls in the background (a slight exaggeration, but in this business anything is more than possible). The graphic information contained in this color original is primarily contained in the highlights and midtones, with the exception of the shadows in the cat's eyes. The importance of tone in this picture is to faithfully reproduce the highlights and midtones, with the shadows becoming a secondary concern.

An example of low-key copy includes a color original that is perhaps a night shot of a car accident on a wet high-

way, where the only highlights are the two headlights and the emergency lights on top of a police squad car. The major picture elements that provide necessary graphic information are contained in the midtones and shadows.

The most desirable of all original continuous tone color copy is one with good contrast range. This means that there are defined highlights, midtones, and shadows, with pleasing contrast between each.

Tone reproduction allows for the selective manipulation of density values in an image to accentuate picture elements. For example, a color transparency is delivered from the customer and a model who has blond hair and was wearing a light gold blazer with dark brown slacks. The separator must know what is important in the picture, perhaps the picture was meant to sell clothing (gold blazer), or perhaps the photo is meant to sell hair coloring (blond hair). The ability to adjust midtone placement can accentuate either the hair or the blazer in this example. The important thing is that the customer is expecting a good facsimile of the original in the critical picture elements.

Gray Balance

The term *gray balance* refers to the ability to reproduce neutral gray values in a color reproduction using only the yellow, magenta, and cyan process inks. The term gray balance is a misnomer, because it is the precise imbalance of the dot sizes for each of the process color inks that create neutral grays. The imbalance is due in large part to ink impurities. In theory, if pure process yellow, magenta, and cyan overlapped in 25% dot sizes, the result would be a light gray that is free from a warm (red) or cold (blue) color bias. In actual production, ink impurities would require the light gray to be produced with slightly different dot sizes (plus or minus 3% or 4%) due to the different pigment contaminants.

The cyan ink is usually the most contaminated with a major impurity of magenta and a minor impurity of yellow. For this reason, it is critical to reduce the amount of ma-

	Pure Color Theory			**Actual Gray Balance Adjustment**		
Table 8-1 Example of Gray Balance						
	Light Gray	Medium Gray	Dark Gray	Light Gray	Medium Gray	Dark Gray
Yellow	25%	50%	75%	20%	48%	69%
Magenta	25%	50%	75%	22%	50%	71%
Cyan	25%	50%	75%	26%	60%	79%

genta ink where it overlaps the cyan, and likewise, to reduce the yellow ink where it may overlap the cyan. The fact that cyan has these impurities means that the color correction or adjustment of dot sizes for gray balance is required in the yellow and magenta, so that a balanced amount of process color may produce equal reflection of red, green, and blue primary light.

Gray balance can be determined by careful evaluation of a full set of tint charts printed with the process colors used on press (see Table 8-1). Selecting a neutral gray scale from the different tint percentages will indicate the correct compensation in dot sizes to correct for the ink impurities.

Another technique for determining gray balance for a given set of inks requires the color separation production of six different neutral gray scales. The difference in these separations is that only the yellow, magenta, and cyan are produced using six different gray balance settings on the electronic scanner. After the three-color separations of the neutral gray scale have been printed, they must be compared to the six different scales on the press sheet. A rainbow effect of a warm red gray scale to the cold blue gray scale will be observed. The proper electronic scanner settings for gray balance should fall somewhere in the middle. All future color separations produced with those inks will require a similar gray balance setting on the scanner.

Color Correction and Manipulation

The purpose of color separation is to faithfully reproduce the colors found in the original with the four process colors of ink. There are times when a customer requires color to be modified, either to make a color match a sample product, or to exaggerate the quality of memory colors, such as blue skies and green grass. The ability to match colors or to enhance colors requires color correction.

Color correction can be either global or local in nature. Global correction involves a modification to the entire image. In comparison, local color correction relates to an isolated location or object in the image, such as a blouse or pair of pants.

Color correction is often done digitally, but can be accomplished in several ways, including traditional wet dot etching or dry dot etching for either global or local correction. Near obsolete, the wet dot etching involved the use of acid etch to reduce the halftone dot made from silver halide crystals in the film emulsion. Dry dot etching is more common today and more environmentally friendly. Dry dot etch involves the creation of a duplicate film in the contact frame, with the use of diffusion sheeting and dodging or burning of selective areas of the image with different light exposures. Many digital color files are output onto film with the use of imagesetters, these films may require minor modification and dot etching may still be available in select locations.

The use of photographic or electronic masking to modify the image involves global color changes. Traditional photographic masking was used with process camera back separations, contact frames, and direct screen enlargers. The electronic scanner is capable of electronic masking to achieve the same results. Masking simply uses converse imagery or inverted signals to reduce inks that are contaminants of other process colors, where they overlap those process colors in the image. Photographic masking was difficult because it required additional film images, punched in register, that had a diffused focus to soften the transition between colors.

Table 8-2

Color of Ink	Wanted Colors	Unwanted Colors
yellow	yellow, red, green	magenta, cyan, blue
magenta	magenta, red, blue	yellow, cyan, green
cyan	cyan, blue, green	magenta, yellow, red

Electronic masking allows for manipulation of both wanted and unwanted colors. Conventional color masking utilized the GATF rule of thirds, where for every primary color of ink there were three wanted colors synonymous with ink, and three unwanted colors synonymous with paper white. On the electronic scanner the wanted colors are called black colors and the unwanted colors are called white colors. The manipulation of wanted (black colors) and unwanted (white colors) provides the necessary adjustments for electronic masking. The wanted colors and unwanted colors are listed in Table 8-2, and wanted colors will equal the color of ink and the two primary colors of light that make the primary color of ink.

Halftone Screening

The ability to reproduce a continuous tone image on a printing press that has the ability to print only one color at a time, and one density of that color at one time, requires a geometric dot pattern of varying size that creates an optical illusion of tone gradation to the eye. In the earlier days of continuous tone reproduction, the artist used a handcrafted rendering that was based on no tone, quarter tone, halftone, three-quarter tone values, plus total density. Over the years, the term halftone was retained, but the imaging process became photo-mechanical versus handcrafted.

The geometric dot structure used in today's halftone screen technology comes in different shapes or basic configurations. Regardless of the many variations of dot shapes listed in some desktop imaging software, there are

three basic dot shapes or configurations. Many other names for dot shapes are built as variations of these three major configurations. Image manipulation software such as Photoshop, can produce the different dot configurations required of specialized printing conditions.

The first dot shape or configuration is the square dot or what is sometimes called the conventional dot shape. The square dot is the traditional shape based on the invention of the crossline screen. Back in the 1880s, the Levy brothers created a crossline screen by scribing lines into a glass plate, filling the groove with dye and placing two glass plates on top of one another with the lines oriented perpendicular to one another. The result of this invention was a square dot structure that creates a checkerboard pattern in the midtones.

The second dot shape or configuration is the elliptical dot which provides a football shaped dot. This elongated dot shape provides for a more pleasing midtone dot transition than the checkerboard pattern of the square dot. An excellent example of the elliptical dot's more pleasing appearance over the square dot is in a picture of a model's face. The flesh tones in the picture will almost always translate to midtones. The subtle transition of tone in the checkbones of the model are more pleasing with the elliptical dot than with the square dot. It is for this reason that the elliptical dot has become one of the most popular halftone dot shapes. In Japan and Europe, another name for the elliptical dot is the chain dot.

The third halftone dot configuration is the round dot. The advantage of the round dot shape over the elliptical and square dot is that it will not plug up the shadow details on a high-speed web press. Both the elliptical and square dot patterns will plug the shadow details starting at about the 70% dot range on a high-speed wet web press. The shape of the elliptical and square dot becomes elongated and distorted at high press speeds. The round dot will tend to produce better shadow details by not plugging or distorting the shadow copy until the 80% or higher dot range (Figure 8-1).

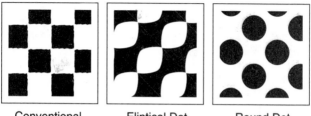

Conventional (suare) Dot Eliptical Dot Round Dot

Figure 8-1 Three popular halftone dot configurations. *Illustration by Dot Lestar*

A new dot configuration has been developed for the platesetters using direct digital technology. The Euclidean dot shape is created digitally, and provides the best of both worlds. For example, the Euclidean dot structure can utilize a conventional highlight, with an elliptical midtone, and a round shadow dot.

Screen Rulings

The screen ruling used in the reproduction of color separations on a printing press is determined primarily by ink and paper relationship, the ability of the press to reproduce fine detail, and the desired level of image rendition. Often the publisher or printer will determine the screen ruling based on production limitations. The objective is to select as fine a screen ruling as possible, to assist the eye in the illusion of fine geometric dot patterns appearing as continuous tone. The finer the screen ruling, the less obvious the dot structure (less white paper will show in the background of the color separation). Fine screen rulings with more rows of dots per inch, will yield a richer or denser color saturation due to the fact that more of the paper surface area is covered with process pigments.

Because the eye has been trained over many years to see on a horizontal or vertical orientation, the rows of

halftone dots created by the halftone screen are rotated to assist in the illusion. The eye can tell if a picture is hanging straight on a wall or if type on a page is square with the edge. The eye would not have great difficulty in visibly picking up the rows of dots that make up a black and white halftone if they were not at 45°. The dominant pigment, or black in this example should always be placed at an angle such as 45°.

The halftone screen ruling typically refers to the number of rows of halftone dots on the diagonal of the square inch. This means that for a 45°, 133 line halftone screen, there should be 133 rows of dots along the 45° angle of a square inch. Standard screen rulings include the following:

Screen Ruling	Purpose
65 line screen	Newsprint or Absorbent Stock
85 line screen	Some Flexo and Screen Process Printing
100 line screen	Newsprint/Flexo/Screen Printing/Quick Print
120 line screen	Newsprint/Flexo/Screen Printing/Quick Print
133 line screen	Standard Screen Ruling for Offset
150 line screen	Commercial Sheet-fed Offset/Gravure Standard
175 line screen	High Resolution
200 line screen	Premium Printing
300 line screen	High Resolution/Dry Offset/Gravure

Scanning Resolution

When scanning on a digital desktop scanner, the need to identify resolution becomes a function of screen frequency in lines per inch. The industry standard indicates that there should be at least two scan lines for each line of the halftone screen to be printed. This means that when scanning an original image at 100% using a 133 line screen, the scanner resolution should be set at 266 ppi or rounded to approximately 300 pixels per inch. Another name for pixels per inch is dots per inch (dpi). The scanning resolution ensures that all the fine details of the original image are captured faithfully. Caution should be used not to make the resolution too great, or the digital file size will become much larger than necessary.

Figure 8-2 A moiré pattern. *Courtesy of LaVerne Harris*

When enlargements and reductions are required during the scan, the percentage or scaling factor must be included in the equation. As an example, to enlarge a scan 300% or by a factor of 3, to be printed using a 150 line screen, the resolution equation would look like this.

Scanning resolution = 2 x screen ruling (lpi)
x percentage or scaling factor

900 = 2 x 150 lpi x 3

Some scanner operators do not include the scaling factor or percentage of enlargement/reduction in the equation and images still look good. The multiple of two times the screen ruling in lines per inch provides enough image sampling to minimize loss of detail or sharpness.

Screen Angles

The placement of four different geometric dot structures, one on top of another in tight alignment or register, creates a new, more complex geometric structure or image. If the four-color process image is made of halftones that are rotated so that the row of screen dots are at least 30 degrees apart, the final geometric dot pattern will produce a tight rosette pattern. The *rosette pattern* blends into the original image, creating the illusion of a continuous tone color image. If the four-color process image does not have the screen angles rotated, a *moiré pattern* is produced, which will create a geometric dot pattern that distorts the original image (Figure 8-2).

There are two types of moiré patterns. The primary or first order moiré is created when the proper screen angle ro-

tation is not followed in production. Screen angle rotations may vary slightly, but the following suggested screen angles are typical for offset lithography and gravure printing.

Offset Lithography
 90° = Yellow
 75° = Magenta
 105° = Cyan
 90° = Black

Gravure
 60° = Yellow
 75° = Magenta (Red)
 105° = Cyan (Blue)
 90° = Black

Exceptions to these standards are often based on images that have significant flesh tones and wood grains. A second order moiré occurs when the image contains an object that is a geometric pattern or screen structure. For example, a separator may properly scan a catalog image that contains a herringbone sports coat, but when it is proofed a localized moiré appears in the sports jacket only. The secondary moiré can be adjusted by rotating screen angles for the different colors.

Because different manufacturers' prepress equipment use different halftoning techniques, the screen rulings and angles may vary, based on screening algorithms. The control of screen angles in a digital environment requires trigonometry and must ultimately be based on a given output device. Halftone dots must be built on a grid, with the center of the halftone dot where two lines of the grid intersect. Manufacturers have a choice of rational and irrational halftone screen techniques. The rational halftone technique involves an angle of dot creation where the opposite and adjacent legs of the triangle are either positive or negative whole numbers (integers). Rational screening techniques have difficulty with 15° and 75° angles commonly used in color separation. The Hell Company, led by Dr. -Ing Rudolf Hell, (currently Linotype-Hell) created and patented a refinement to this screen angle problem for color separation. The Hell solution involved using different screen rulings and angles to create a near rosette pattern. Later, the Linotype-Hell Company created the Supercell rational tangent by subdividing a larger halftone cell into smaller

cells. This refinement is used by other manufacturers to better refine the screen angle problem.

A newer halftone screen technique uses irrational angles that do not use integers, cells or even super cells. In irrational screening, each halftone dot is calculated or created separately, rather than in a system of cells. This technology involves massive calculations and number crunching.

Digital halftone screening is often said to be device dependent because the individual characteristics of one output device differ from others. These characteristics include addressability and resolution.

Stochastic Screening

The concept of *stochastic screening* is not new. After World War II, there was an effort in Europe to print with fine resolution patterns that would appear screenless. The fine resolution patterns tried to create a tiny dot pattern that was random in placement. The early Italian screens made in Russia lacked the ability to create a true randomization of dot pattern. The computer-generated randomization of dots has increased the use of this technology.

Traditional halftone screen techniques created dots of uniform density that varied in size, but were equally spaced. Another name for this type of screening is Amplitude Modulation (AM). The dot sizes of conventional halftones vary in size proportionally to the amount of light reflected from the original tones through a vignetted dot structure on the contact screen. The soft fringe of density on the vignetted dot allowed differing amounts of light energy to create different size halftone dots on the film.

The stochastic screening method in comparison, uses halftone dots that are all the same very small size, but the number of dots or tiny spots of image vary. The halftone dots used in stochastic screening are so small that they are often classified by the spot size of the digital imaging device. The spot size is the smallest image that can be created by the laser light source. Another name for halftone

dots used in stochastic screening is microdots or laser spots. The fact that the tiny microdots in stochastic screening vary in number and location, as based on the original image density, the term frequency modulation, or FM screening, is used.

Some of the advantages for stochastic screening technology are listed below.

- There are no align screen angles because of the random placement of the tiny microdots. This also assists in image registration.

- Stochastic is applicable to direct-to-plate or direct-to-press imaging technologies.

- Stochastic screening works with existing offset presses and prepress equipment, but good housekeeping is required. Vacuum frames must achieve proper draw down for imaging.

- Higher quality images are possible for commercial sheet-fed offset, web offset, and in selected cases, newsprint. The quality of image rivals gravure printing.

- Hi-fi color or bump plates may be utilized without concern for moiré.

Stochastic screening technology has created a niche market within the industry that is growing.

High-Fidelity Color

There has been considerable effort over a period of time to improve the gamut of color possible with conventional four-color process printing. Mills Davis has been credited with the most comprehensive study of high-fidelity color or hi-fi color. The work of Davis, Inc. was funded by different industry concerns and manufacturers, and provided potential growth markets and direction for future technologies.

Mills Davis developed a diagram similar to Figure 8-3 which illustrates the visual limitations of print media.

| Electromagnetic Spectrum |
| Human Vision |
| Hi-fi Color Printing & Imaging |
| Color Photography |
| Display, Vidio, HDTV |
| Pantone & Toyo Colors |
| Four-Color Process |

Figure 8-3 Visual limitations of print media.

Hi-fi color involves the use of additional color separations, stochastic screening, and additional process color ink pigments, typically totaling seven colors. The common process color scheme includes yellow, magenta, cyan, orange, green, violet, and black. The advantage of high-fidelity printing is the increase in color space or gamut. The difference in visible image between conventional four-color process work and hi-fi color is significant. The hexachrome technology by Pantone is gaining acceptance for the application of hi-fi color.

The use of hi-fi color applies to all of the major reproduction/printing processes. Perhaps the most common printing process application is offset lithography, including sheetfed and web products. One of the highest quality applications of hi-fi color technology is waterless lithography, where premium inks, plates, screening resolutions, and papers are used. Gravure printing, flexography and screen process printing all benefit from hi-fi color applications.

Examples of products that have been produced using hi-fi color technology include:

Premium brochures and commercial advertising

Annual reports

Catalogs

Corporate identity literature

Fine art reproductions

Premium packaging

Hi-fi color can also utilize spot color plates, touch plates, or bump plates in an effort to expand the color gamut. The bump plate is designed to apply more pigment in an effort to increase density. The spot color is used for pre-mixed pigments that can represent standard colors, for example corporate identity. The touch plate is used for localized color enhancement within the color image.

The Pantone company has developed a six-color set called the hexachrome system. The Pantone hexachrome system allows for color matches with the Pantone matching system (PMS). The hexachrome system takes full advantage of the numerous six-color presses available in industry. The Pantone system is supported by Adobe products for the desktop.

Proofing requirements for hi-fi color include a system that has resolution capability for stochastic images, dot gain for FM screening, and availability of special process color pigments. Several manufacturers support hi-fi color technology and proofing systems are available to emulate the final product.

New digital printing presses are also addressing the future applications of hi-fi color by manufacturing equipment that has room for optional ink colors beyond the primary four process colors. Future applications of hi-fi color remain to be seen, but there is growing interest in this technology.

For More Information:

The following sources will provide you with additional information to better understand the concepts in this chapter.

AGFA. *A Guide to Color Separation.* Agfa Prepress Education Resources, Illinois, 1993.

Field, G. G. *Color and Its Reproduction,* Pittsburgh: Graphic Arts Technical Foundation, 1988.

High Fidelity Color. Davis, Inc., Washington DC.

Parsons, Bill. *Electronic Prepress: A Hands-on Introduction.* Delmar Publishers, Albany, NY, 1995.

Scitex. *The Story of a Color Picture.* Bedford, Massachusetts, 1992. Videotape.

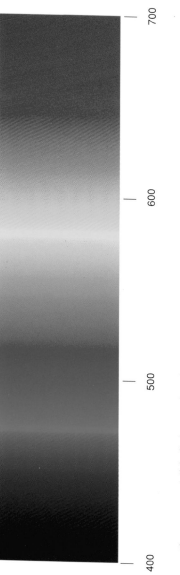

Figure 1-1 Visible light on the electromagnetic energy spectrum. *Illustration by LaVerne Harris*

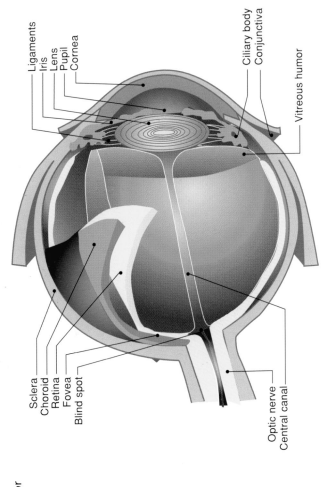

Figure 1-2 The major parts of the human eye. *Illustration by LaVerne Harris*

Ligaments
Iris
Lens
Pupil
Cornea

Ciliary body
Conjunctiva

Vitreous humor

Sclera
Choroid
Retina
Fovea
Blind spot

Optic nerve
Central canal

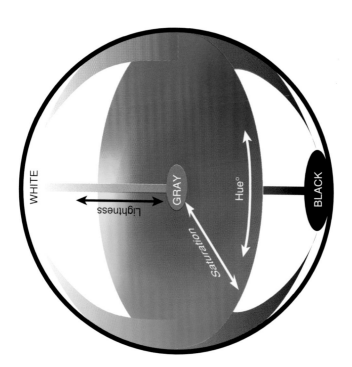

Figure 2-1 The three-dimensional color model illustrates the hue positioned around the color circle with saturation of a hue changing as it moves toward the center. The third dimension of lightness is a vertical orientation with white at the top and black at the bottom. *Courtesy of X-Rite*

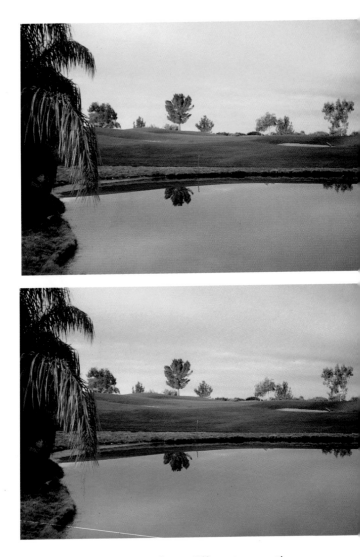

Figure 2-2 An example of two different separation adjustments of a color original that may be based on differences in memory color.

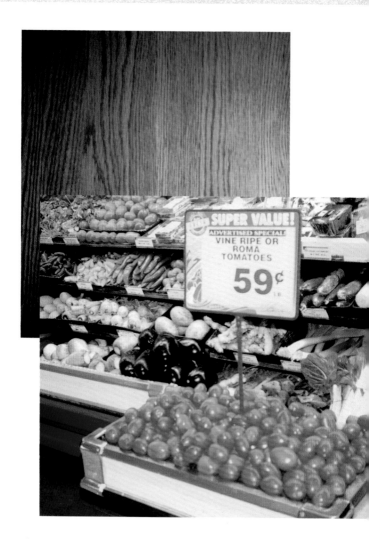

Figure 2-3 An example of original artwork, where memory of colors assist in the image identification.

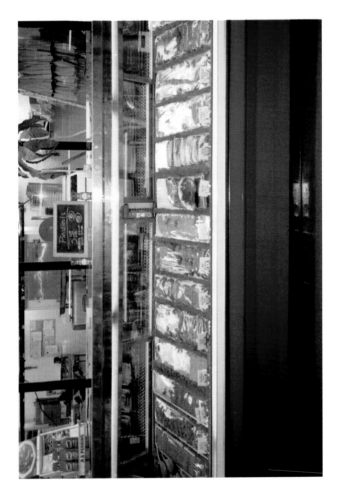

Figure 2-4 An example of products in a store that have been enhanced by the use of color as a marketing tool.

Figure 4-3 Three process color overprint of yellow, magenta, and cyan produces a dark brown value in the center, top. The four color overprint on the bottom shows the visual contrast of black.

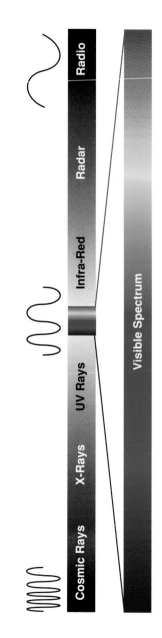

Figure 5-1 Color models differ in their ability to reproduce the visible gamut. *Courtesy of X-Rite*

Figure 5-2 The Munsell color tree system *Courtesy of X-Rite*

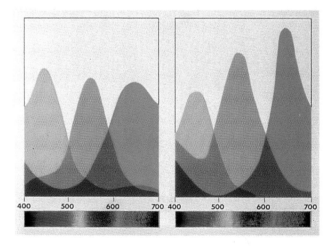

Figure 6-4 Two typical color transparency dye systems *Courtesy of Frank Benham*

Figure 7-6
A green cast
original and a
color separation
that was adjusted
with cast removal
Courtesy of T.C.

Figure 7-7
60% GCR with the three color Yellow, Magenta, and Cyan on the left and the final four color separation on the right. *Courtesy of David R. Dudas*

Figure 11-6 Examples of image resolution for different reproduction processes. *Courtesy of Indigo*

Section VI
Digital Work Flow for Color Reproduction

Color Applications in a Digital Work Flow

In the past, customers delivered art boards with neatly marked cover sheets containing the necessary information for production. Today, the printer must deal with computer disks, mysterious little "black boxes" containing postscript errors, font conflicts, and other enigmas. Traditionally, a job could be stored as film flats occupying less than two inches of shelf space. Today, the same job consumes gigabytes of hard disk space. Moving, trapping, imposing, imaging, and archiving these monstrous files are increasingly complex and time consuming. The prepress work flow of the 1990s must have a flexible architecture that can accommodate the customer's needs, as well as changes in the technology. The printer must be able to produce high quality, efficient products that can compete in an expanding marketplace. This chapter will examine some of the critical work flow issues facing the printer, such as: file storage, networks, scanning, color management, trapping, imposition, and the trend toward direct-to-plate and digital printing.

Designing an effective system of work flow in this ever-changing world of electronics requires first that we establish the goals of the system and the boundaries for its operation. The goal of the printer has always been to produce a product that meets or exceeds the customer's expectations of quality, in a timely fashion, at a cost the customer is willing to pay. The goal of the customer is to have their "vision" transformed from idea to paper, as quickly, inexpensively, and accurately as possible. A secondary goal of the modern printer, and one that is often customer driven, is to be state-of-the-art. To compete in

existing and new markets print shops must operate like well-oiled machines, reducing waste and inefficiencies wherever possible.

The new term "Direct to…" is a catchall to describe the general trend in the industry to be more efficient by going direct-to-imposed film, direct-to-plate, and direct-to-press. Whether the goal is film, plate, or press, achieving the goal of "direct to…" will require that the printer develop a strong infrastructure and work flow. This chapter will attempt to look at the following major components necessary for a strong and efficient work flow:

- Receiving a job

- Preflighting

- File servers/networks

- High-res scans

- Electronic stripping

- Proofing and imaging

- Data storage

Receiving a Job

In 1995, based on PIA information, more than 84% of printers accept jobs in a digital format, with this number increasing rapidly. For larger shops (those with twenty or more employees) as many as 72% of the incoming jobs are digital. That still leaves 28% or more as conventional art. In our efforts to pursue direct-to-plate and digital press technology, the prepress work flow will have to accommodate both digital and conventional art (at least for the present).

Conventional Art

If a job is received all or in part as paste-ups or as furnished film it can be handled in one of two ways—the printer can process the job in the traditional way or convert it to a digital form. Chances are the printer still employs

qualified strippers and has the cameras, vacuum frames, and light tables necessary to strip the job. This process often seems like the most sensible approach. The disadvantages, at least early in the transition to a total digital work flow are minimal. However, as the need for space squeezes the conventional stripping departments, there will be less room for large and cumbersome cameras and light tables. As the work force shifts to the digital world there will be fewer strippers who can manage a complicated job. There is an additional expense in maintaining all of this equipment. The alternative is to invest in copy dot scanners and other high-end capturing devices that could be employed to bridge the gap. This equipment is useful but expensive and it will need to be amortized over a very short period of time since traditional jobs are rapidly decreasing in number.

Digital Art

Digitally prepared jobs have become an integral part of most printers' work flow. The major work flow issue for a digital file is the method of transportation. Today 58% of files arrive on floppy diskettes, the rest are distributed among optical, SyQuests, Bernolli disks, DAT tape, Zip disks, and MO cartridges (Figure 9-1). It sometimes seems that a new storage media or size is introduced monthly. The problem for the printer is how to control equipment costs while still maximizing the ability to accept customer files. Since turning away jobs would not be wise, and requiring customers to transport their drives is impractical, another solution must be found.

One such solution is a front door system. In this approach a single computer can be used as a doorway to the network. A single version of each drive required by the printer's customers can be attached to one computer. This method will reduce cost by reducing the need for multiple drives of the same type. With current mail order houses providing overnight services and competitive pricing, it is rarely necessary to purchase drives in advance of receiving a job. Currently drive prices range from as low as $150 to as

Figure 9-1 A Zip drive is a moveable, inexpensive storage device. *Courtesy of Heritage Graphics*

much as $1500 and more, depending on the device. The average drive is between $400 and $700. Printers should budget for these expenses as they would for film and plates, and include the prices as a direct cost or in overhead as part of estimating job costs.

Telecommunications

Currently only about 7% of digital jobs are received via telecommunications. Most printers expect to see this number increase rapidly in the next few years. There are basically two methods of telecommunications in use today—a dedicated (point-to-point connection) or a dial-up service to which both parties subscribe.

A point-to-point connection can be as simple and inexpensive as a direct modem connection, in which the customer calls a waiting system via modem and simply downloads the file. Some printers have even experimented with electronic bulletin boards as a convenience for customers. Although this is an inexpensive solution it requires the printer to have a modem and computer sitting and waiting for the customer to call. At current modem speeds of 28.8 kbps it would be very time consuming to use this

method for large files. It is, however, excellent for type changes and missing fonts.

An inexpensive alternative to an idle computer waiting for the telephone to ring, is a dial-up service such as America Online or CompuServe. With such a system in place, the customer sends the file to the server and then the printer can download the file when it is convenient. Download time is still a problem and now the file would be transferred twice, which also increases the risk of its being damaged. Many printers are investigating the possibilities for using the Internet to transmit files to and from customers. This will likely prove to be too slow, since it uses standard modem speeds, and there are also security issues that have yet to be resolved.

Dedicated lines or dial-up services utilizing ISDN, Switched 56, ATM, or other high-speed systems can greatly increase the throughput time of large files. The prices of these systems while currently high are dropping rapidly.

For a printer to service its customers effectively it will be necessary to have an open and flexible "port of entry" into the plant, capable of receiving both conventional and digital data in many forms. The key will be to be realistic about costs and budget for changing equipment needs.

Preflighting

Verifying job readiness, often referred to as *preflighting,* is one of the most critical steps in a successful digital work flow. In general, preflighting refers to analyzing PostScript files for any defects that will cause problems during ripping and imaging. Preflighting can also serve as "revenue protection." Files can be checked to see if they match the quote in size, number of colors, and other critical cost elements. The critical questions for a plant, when adding a pre-flighting step to the production process are:

1. When in the process should preflighting occur?

2. What information should preflighting reveal?

3. Who should perform the preflighting?

When Should Preflighting Occur?

Nothing sends a worse message to the customer than to insist on five day turnaround for a job and then call them on day three to explain that you are missing a font or image. The customer will now assume the first two days were unnecessary and give you less time on the next job. With printing cycles being squeezed at all ends, it is important to make the customer feel that their job is getting immediate attention.

"It is our goal to preflight each job within eight business hours of its arrival in the plant," (Roberto DiPaolo, Collins, Miller & Hutchings, a division of Wace Corporation).

Many small printers will preflight a job while the customer waits. This provides an opportunity for real time information and decision making.

What Should We Check For?

Pareto's theory (sometimes referred to as the 80/20 rule) when applied to the preflighting process would postulate that 80% of the actual problems a printer has with customers' files are caused by only 20% of the possible problems. What this means is that although there are many things that can go wrong with a job, the most likely things will be: missing fonts, missing or low resolution graphics, and incorrect specifications of colors. Preflighting attempts to look for and correct all the possible problems a job might encounter. If instead the solution attempts to address only the most common and easy to remedy problems, it can be performed by a less skilled person. It is important that preflighting not be so complex that it introduces more problems than it solves.

Preflighting software is now available to aid in the process. This software can be system independent such as FlightCheck by Markzware or system specific such as Scitex's preflighting software. These types of programs attempt to analyze the files to determine problem areas. The software will generally produce a report that includes information such as font utilization, placed images, colors,

document size, and configuration. These elements can then be cross checked with the job ticket or information sheet submitted by the customer. Errors or discrepancies can be immediately reported to the salesperson or client.

The last step in preflighting should be "revenue protection." Now that the job is in hand, it is time to check it against the quote and/or ticket to verify that it can be produced in budget and on time.

Who Should Perform the Preflight?

In some plants, preflighting is performed by a production person. Using production staff has many disadvantages. These disadvantages derive from the fact that preflighting should be done instantly and production staff should be doing production. Constantly being interrupted to preflight is disruptive to the staff's train-of-thought and the production schedule. It is not possible to effectively schedule preflight into the production schedule since it is not possible to predict when or how many jobs will need preflighting on a given day. When production is very busy it is tempting to postpone preflighting on jobs that are not due immediately. This would destroy one of the basic reasons for preflighting in the first place—giving the job immediate attention.

According to Terry Nagi, "The debate continues as to where preflighting should be organized, but most successful printers are now placing it in the hands of qualified and well-educated customer service representatives."

Preflighting should be performed by either customer service representatives (CSRs) or a dedicated preflighter. CSRs are responsible for job tracking, customer interface, and problem solving. They have contact with the job nearly as soon as it appears in the plant. CSRs should be trained in basic pre-press skills in order to expedite jobs. Preflighting is not difficult to learn and perform.

Preflighting should be performed on all new files as early in the production cycle as possible. It is not necessary or possible for a good system to find all the problems a job may encounter. Rather the system should simply identify and fix the most common problems. CSRs or an equivalent

sales assistant should perform the check, freeing up production personnel to do their jobs.

The preflighter can serve one more important function. The preflight workstation can serve as a "front door" to the work flow and network. Jobs can be loaded into the file server during the preflight process, which will save time later in production. If the customer has provided high-res scans, then this is a perfect opportunity to send them through the OPI generator. At the time the job enters the system and is preflighted, it should be cleaned of unnecessary files. All of the necessary files should be transferred into the system for production.

File Servers and Networks

A *file server* and network are the backbone of any electronic prepress system. They provide storage for all the active jobs and a means of transporting the files around the system. File storage and data transfer have evolved slowly with the changing needs of the printer into a variety of options:

- Store jobs on individual workstations

- Shuttle storage ("sneaker net")

- Centralized storage

Storing Jobs on Individual Workstations

Loading a file into a computer, working on all the components of that job on that computer, and then printing from the same machine direct-to-the proofer and imagesetter are relatively common ways to do business, even for plants with a network in place. In fact, most printers started out using this method of job distribution.

"In the early days, we didn't really need to move files around much. They came in on disk or SyQuest, we loaded them into one of our two computers, did a little manipulation and imaged film," (John Morton, President, Heritage Graphics, Phoenix, Arizona).

If there are a limited number of workstations and a limited number of operators this system works quite well. Problems arise when two jobs needing immediate attention are stored on the same computer. Either they will have to be worked on sequentially or one job must be moved to another computer.

Sneaker Net

Sneaker net (loading a job onto a movable storage system and transporting it manually from one location to another) may sound odd but it is an extremely fast system for file movement. Although it can be based on a system of SyQuest, Optical, or other removable cartridges, it works best using a shuttle system. Shuttles are hard disk docking systems. Each computer gets a dock and several shuttles are purchased to "float" around the production environment.

The advantage to shuttles is that they have exceptional transfer rates because they use the SCSI port. A job can be loaded on a shuttle and moved easily from machine to machine. Most offices are small and it only takes a few seconds to cross the room and insert the drive. A shuttle could start in preflighting where it is loaded with a new job, transferred to the scanner for high resolution scans to be loaded, then to a stripping station for trapping, imposing, and printing. Shuttle systems offer the printer excellent flexibility. When more storage space is needed, just purchase more shuttles (which are generally less expensive that a stand alone drive). After the job is complete, the shuttle can be docked to a low-end computer for archive to tape or CD. Shuttles are an excellent redundant system to keep things moving in the event the LAN goes down.

The disadvantage is the cost. Currently, docking stations range in price from $600 to $900 each, depending on whether one chooses a single bay or double bay. Shuttles do not replace local area network (LAN). You still need a LAN to access a laser printer, proofers, imagesetters, and E-mail.

Centralized Storage

Centralized storage of files is the general direction the industry is heading. This system involves dedicating a computer that has a large capacity for storage. Such a computer is referred to as a "file server." File servers give all computers in the system equal access to all jobs, thus making jobs, computer, and operator independent of each other and will reduce the time spent hunting for jobs in larger offices.

A file server can be a simple computer that does nothing more than hold jobs, or it can serve as a print spooler and as the high-res swapping device for automatic picture replacement (APR) and open prepress interface (OPI).

OPI/APR

Open prepress interface (OPI) and *automatic picture replacement (APR)* allow the user to generate two copies of an image, one high-resolution which will be used for imaging the final piece, and one low-resolution which will be used as an FPO (for position only) while the file moves through the system. The low-res file will save time when imposing and trapping files. OPI/APR is generally accomplished by software on the server or the scanning computer. A product such as Adobe's Color Central will run on both Mac and PC and is free from links to proprietary systems. Hardware/system manufacturers such as Linotype-Hell or Scitex have OPI/APR software built into their systems.

FPO generation is generally accomplished when the file is scanned and transferred to the server. This works well for printers with in-house scanners, but what about customer-provided scans and those purchased at service bureaus? The preflighting/front door system would solve these problems. The OPI software does not distinguish where the file was generated. The preflighter could send any scans generated outside the plant through the software just as the in-plant scanner operator would. Files would already have low-res scans waiting when trapping and imposing begin.

Electronic Job Tracking

Many new file servers are coming equipped with electronic job tracking software, and companies such as Adobe are developing platform independent job tracking software. This software is designed to automatically move jobs around the system by copying low-res images into job folders, transferring jobs to the trapping and imposing stations, and then to an archiving station when the job is completed. These systems can help automate redundant tasks and relieve the pressure of job tracking.

Local Area Networks (LAN)

Local area networks (LANs) consist of a system that connects all of the computers and printers within a given facility. Networks can be used simply to print data or they can be used to exchange data between computers. A network is clearly the preferred method of data movement for most offices, and printshops are no exception.

Network speed is of critical importance to printers because of the large size of image files. Early entries in the electronic prepress arena used thin coax or Thinnet as the backbone of their network. As file sizes increased with the advent of desktop color Thinnet is proving to be too slow. The major problem with Thinnet is collisions. Collisions occur on a network when two or more machines are transmitting information simultaneously. The data can become garbled and must be resent. Collisions increase as the load or number of users on the network increases. All of this means that, even though Thinnet theoretically performs at 10 mbps, its actual speeds are considerably lower.

An alternative to Thinnet is 10baseT which can offer users a substantial increase in throughput even though its theoretical speeds are equal to Thinnet. The speed increase comes from adding a switched hub to the system. Network hubs can act as traffic cops and direct the data flow through the network in an orderly fashion. The hub allows each device to have a dedicated line to the other devices on the system. The 10baseT can reduce the number of

collisions substantially and therefore increase data throughput.

Although 10baseT is a substantial increase over Thinnet, data transfer of large files is still quite time consuming. There are several alternatives emerging in the market. Examples are ATM, FDDI, and 100baseT. The last seems to be the most likely to become the standard for local area networks in the near future. 100baseT functions the same as 10baseT but at ten times the transfer rate. The major cost associated with either of these network types is the hub itself. The cost of a hub ranges from a few thousand dollars to thirty thousand or more, depending on the number of devices and their configurations.

The most important issues to consider when upgrading or adding a new network today is whether to run wires capable of handling high speed data transmission (category 5 wiring). A 10baseT switched hub with a high-speed port is necessary to control the older computers and laser printers. High-speed ports can be used to connect to a 100baseT hub. The 100baseT switched hubs are still rather expensive but the price is dropping and the technology is improving. The fast lines can be used to connect a file server to newer computers achieving near SCSI data transfer speeds.

One other major consideration when installing a network is the need to connect to other sites, either other divisions of the same company or customers. Many newer hubs offer an open architecture that will allow the addition of cards for ATM or ISDN hookups.

Network and server solutions must be customized for each printer's special needs. The critical features are to maximize efficiency and leave room for the future. Combining a file server for storing high-res images with powerful workstations to process the job can reduce the load on the network and improve performance.

High-Res Scans

As desktop color has improved and become more available, printers have seen a dramatic increase in the amount

of color they must acquire and print. Digital files have become the norm for transporting files from scanner to press. A printer can acquire digital high-res scans three ways. The customer can provide them, they can be purchased from an outside service bureau, or the printer can scan them itself.

Customer-Provided Scans

Customer-provided scans often can be very problematic. Frequently the customer uses low quality desktop scanners to create the scans and does not fully understand the requirement of the press and imagesetter. Many customers lack adequate proofing devices with which to evaluate the scans before sending them. These problems must be addressed in preflighting and headed off by customer education.

Outside Purchases

Many printers buy their scans from a color house or service bureau. This avoids the need to purchase a high-end scanner. For printers who do very little photographic reproduction this is probably the best choice. The printer does not need to maintain the equipment or employee scanner operator (a highly skilled and highly paid artisan). The printer can also avoid some of the responsibility for color reproduction by putting the burden of numerous color correction back on the supplier. The disadvantage is the lack of control over the system and slow turnaround times. To improve turnaround time on jobs, printers should consider partnering with one or two color houses. Partnering will increase the printer's leverage over the color house. It will also make it possible to install high-speed direct lines between the scanner and the printer. This will allow for faster transfer of files once they are scanned. Files can then be received over the lines and the job tracking software can send the files straight to the OPI server.

In-house Scanning

Many printers are implementing in-house scanning services. This allows them greater control over the process and it is another value added service they can offer the client. As with all computer technology, the cost of equipment has fallen dramatically and the ease of use has increased. For a printer considering in-house scanning the major decisions are, whether there is enough work to justify the equipment costs and what level of quality is required by their customers.

Electronic Stripping

Traditionally cameras, vacuum frames, and light tables were the tools of the trade. Today a Macintosh with a large screen and enough RAM is rapidly replacing the old favorites. The goal of stripping has not changed—a product capable of creating a printing plate. The major tasks for the stripper is to compose the pieces necessary to form a page, trap those elements if necessary, and then impose the pages in a manner that will maximize the press sheet usage and minimize bindery operations. Electronic stripping like traditional stripping is mainly trapping and imposing.

Trapping

Trapping has long been a contentious issue in the electronic prepress world. There is a growing group of designers who believe that trapping is no longer a concern with the new accurate production equipment. Many different solutions have surfaced and none of them seems to be able to solve all the problems quickly and easily. There are three main approaches to trapping that are used in the industry today.

- Trapping in native software
- Trapping software
- Systems software at the RIP

Trapping in Native Software

Using the program that created an image to trap the image is the original approach to trapping. This can be extremely quick and easy or extremely difficult and time consuming. Text and graphics created in page layout software are generally easy to trap. Imported graphics such as an illustration must be returned to its native program to be trapped. Although this method does not require extra hardware or software it does require a highly skilled software user and a great amount of time.

Trapping Software

Trapping software such as Adobe's TrapWise, or Island Graphic's IslandTrapper offers a solution that will handle many of the problems of trapping complex illustrations, vignettes, and continuous tone images. The problem is that, in most cases, a PostScript file must be created before trapping can occur. Writing to PostScript adds another time consuming step, especially with complex jobs containing many high-res images. OPI reduces PostScript writing time because the high-res images are not included. Either way, once the file is written to PostScript, it is difficult to make changes.

Quark XPress and PageMaker are both capable of doing a good deal of trapping on their own. These features are ignored when trapping complete pages with trapping software or on a system. Another approach, and one that has a great deal of merit, is to trap only the elements that cannot be handled by the page layout software. Programs such as TrapWise can be used to trap individual images and save the trapped file as a placeable EPS. The new file can be imported to replace the untrapped version. This approach is much faster and more flexible than trapping the entire page.

System Solutions

System solutions, such as Scitex or Linotype-Hell, can provide an alternative. Files are sent to the software RIP

where they are trapped. The files can then be imposed and imaged. These solutions generally offer some correction capabilities. Post-RIP trapping is generally accepted as the optimum solution.

Imposition

In order to go direct-to-plate or plate-ready-film, a printer must be able to produce a plate ready file with all the items in place for a single pass through the imagesetter. The file must include all of the pages, continuous tone images, printer's marks, and control strips, such as color bars. Imposition is much like trapping, it can be slow and tedious and many of the necessary features are lacking in the available solutions. Again there are two solutions, software and system. Software solutions, such as PressWise, generally require the files to be converted to PostScript before they can be manipulated. With an OPI/APR system in place conversion should not be excessively time consuming. A much larger problem is ripping time. Once the files are imposed, the completed image, i.e., the eight-page spread, must be ripped to the imaging device. At this point the high-res images are introduced. Ripping times for large files can be very long. However, the initial ripping time is not the real problem because ripping time is unavoidable. The real problem is the proofing and correction cycle. These spreads will have to be ripped at least once to be proofed and once to be imaged and that is only if there are no changes. If there are two or three passes through the correction cycle, the time spent is tremendous.

The solution is post-rip imposition. In other words, ripping each page individually and then imposing the ripped pages. If there is a type change to one page it will be possible to re-rip only that page, dramatically reducing the re-ripping time.

Proofing and Imaging

In a direct-to-plate, direct-to-press world there is no film to proof. Digital proofing is mandatory for the produc-

tion of a quality product. Both the printer and the customer must become comfortable with digital proofs. Ink jet and dye sublimation techniques are the most popular digital proofs available today, although they both fall short in their ability to show traps and moirés. The Kodak Approval system is generally credited as being the best digital proof on the market but it is quite expensive.

The major concern with a digital proof is that it might not match the final product. The big problems are with colors not matching expectations and text and images shifting from proof to press. Color management software and improved ripping should solve most of these problems.

Color Management

"When a customer says '...I don't understand, it looked great on my screen,' I know we are in trouble," (Mike Chiricuzio, Manager of Sequel, an all-digital printing company in Phoenix, Arizona).

Customers today are taking more and more control over the products they design. More and more are purchasing their own in-house scanners and producing their own high-res scans. Most customers, however, do not invest in high-quality digital proofing systems. The fact is they rely heavily on their monitor and their desktop ink jets for color evaluation. In a totally digital world we need a way to produce and view consistent and accurate color from the customer's monitor all the way to press.

Color management software has been around for a while. Quark integrated EFI Color into its page layout software. Kodak has its own color management software and there are others. Until recently these systems have fallen short of what is needed in the graphic arts industry. There are two main requirements for a good color management system: a consistent and objective way of measuring and comparing the color reproduction capabilities of various output devices, and a way of calibrating those devices to produce color that approximates the press sheet.

Apple's Color Sync has been widely praised for addressing these issues. It is distributed with the Macintosh

operating system, operates in the background, and allows for the user to create their own profiles for equipment that is not supported by the pre-made profiles. Color Sync uses CIE color spaces as its standard for comparing color. CIE color space provides two important elements. One, it can be read by a spectrophotometer, and two, it is an established standard for describing color. Using a spectrophotometer, test patterns from various output devices (including a monitor) can be read. The information can be recorded into a central controller. This controller will manipulate the output of these devices to more closely match the press sheet (i.e., it calibrates the monitor and proofer).

Customers are going to continue to produce more and more of their own color in-house. It is essential for printer and client to come together and mutually define color. The successful printer will need to embrace color management and educate the customer. Purchasing a spectrophotometer and volunteering to fingerprint the customer's monitors and printers is an excellent way to improve quality and develop strong alliances.

Ripping

Manufacturers of *raster image processors (RIPs)* and imagesetters are continuously working to improve the time it takes to RIP and image a file. Reducing the ripping time is critical to improving throughput speeds, but even more important than general ripping time is "re-ripping" time. In general a file will rip once to proof and once to image. This is of course if there are no corrections. If there are corrections, it may have to be ripped over and over again. Additionally, the file is frequently ripped to several devices such as color proofers, black and white proofers, and imagesetters, each of which requires its own rip. The secret to reducing production time is to reduce the number of times the file must be ripped.

Systems that can rip the file and print it to a variety of devices such as proofers, imagesetters, and platesetters will dramatically improve throughput times. The success for such a RIP will be controlled by the number of output

devices it can support and how well it can compress the data for storage. (Keep in mind ripped files are very large and to reuse them one must store them.)

Consider the following: A printshop is equipped with a laser printer, a Rainbow, an Iris, a digital press such as the Indigo (12" x 18" sheet size), and a 20 inch and a 40 inch press. A job enters the shop and is planned for the 40 inch press. While the file is being composed and proofs are being sent to the laser and Rainbow (single page or reader spreads) the customer has a sudden need for 100 copies for a trade show tomorrow: impose the file 2-up and print it to the Indigo. Then re-impose the job for the 40 inch press and proof using the large format Iris. As the press date arrives, the 40 inch press is tied up with a different job. The job must now be re-imposed for the 20 inch press. At each proof or change the entire job must be re-ripped. Not including the corrections cycle, this job was ripped five times.

Considering the time it currently takes to impose and rip files, these types of changes are very expensive and time consuming for the printer. With a system that ripped individual pages and then stored them, imaging could be accomplished using imposition templates designed for each press.

Unfortunately there are very few RIPs that offer this type of service. Currently, Linotype-Hell has been working feverishly toward this goal and has offered to license its "Delta list" to anyone who wants to create printer drivers. As printers move toward the digital world they will need to use a variety of output devices, each with its own requirements. A central ripping system that can service them all will dramatically improve throughput and reduce the problems caused by multiple RIPs.

Data Storage

Data storage can be divided into two basic categories: production storage and archiving storage. Individual storage devices can be classified by their accessibility as online, near-line and off-line storage (Cross 1996). On-line storage is readily accessible by the system. It is primarily comprised of hard disks but could also include on-line CD

arrays. Near-line storage, such as SyQuest, CDs, and other removable media, is not left continuously on-line but can be accessed easily. Off-line storage such as tape systems compress and store large amounts of data. Retrieval generally requires additional software and some user interface.

Production Storage

Production storage is necessary to store jobs while they are in progress. The two most important features of production storage are accessibility and capacity. Accessibility refers to the ease with which a user can store and retrieve the data. Because it is necessary to have instant access to job data, production storage is always on-line or near-line.

Typically, production storage would comprise a combination of the built-in hard disks from each production computer and a centralized hard disk (or group of hard disks) attached to the files server. Local hard disks could be used to hold system software, applications and jobs that are currently in production on that workstation. The file server would hold the high-res portion of the scans, jobs waiting to be archived, jobs waiting assignment to a person or workstation, and jobs that are on hold.

Local hard disks can vary in size but generally are 1 to 2 gigabytes. File servers are another matter. Storage at the file server must be sufficient to hold all the high-res images that would be in some stage of production for one week. This includes all jobs that are currently being worked on, out on proof, on hold, and on press. It is impossible to make blanket statements on exactly how much storage is the right amount. Each plant should conduct an internal audit to make that decision.

It is possible to generalize about types of storage systems for file servers. One of the more popular systems is a RAID (redundant array of independent disks). This system is popular because it provides an internal backup for its own system. A RAID system is divided into segments. Approximately two-thirds is used for data storage, and the remaining one-third is used as a backup of the first section.

The system is designed to monitor itself and reload in the event of data loss. RAID is considered a safe, fast method of data storage and retrieval in the case of data loss. RAID drives are, however, considerably more expensive than a standard array with equivalent usable storage space.

A standard array provides the users with a large pool of storage space, but no backup protection. Backups can be performed using a conventional tape system. Both RAID and conventional arrays offer the user access to large amounts of expandable storage to meet both current and future needs.

Archiving

Archiving is the process of saving completed jobs for future use. Archived files can also be used to access files such as missing logos or reused hi-res images for new jobs.

Any of the removable media can be used to archive. The printer should, however, give careful consideration to the shelf-life, cost per megabyte, and ease of use when choosing a method of archiving. Archiving media needs to be able to store large amounts of information on a stable format that is cost effective. Traditionally DAT and opticals were the two main choices. DAT was inexpensive but slow and somewhat unreliable. Opticals are considerably more stable, but they generally store less information and cost more per megabyte. With the advent of low cost CD writers, it has become more practical to use CDs for long-term storage.

The primary reason for archiving is retrieval. Retrieval requires two things—a stable storage media and a good filing system. It is the filing system that is most often overlooked.

Almost all printshops use a numbering system and/or customer name to track their jobs, so filing using this information makes sense. Assigning a disk or part of a disk to each customer is one way to allocate storage space. This method has its problems. It is often difficult to decide who the customer is—the organization that paid for the job (i.e., the designer) or the organization that will use the job (the designer's client). New customers are also problematic.

Should they get their own disk or share one with others? How much work will they provide in the future? (Remember, you cannot remove information from a CD, only add to it.)

Job numbers seem a more sensible method of storage. However, jobs rarely are completed in the same order that they are started. Jobs stored sequentially are the easiest to retrieve. One possible solution to the problem is to do short-term and long-term archival on two separate media. Using optical for short-term storage will allow quick transfer of data without regard to sequencing. When a sufficient amount of time has transpired for all (or most) jobs in a given sequence to be completed, then the jobs can be transferred to CD. The primary disadvantage to this system is the duplicate effort when transferring files from optical to CD.

Filing by name or job number does not aid in finding subfiles. Suppose the customer forgot to send a copy of their logo with the job. It would be easier to find the logo from an old job using the "by name system." Still, unless you know the exact job, it might take some time to find. A database can be used to track files and jobs that are archived irrelevant of the filing method. Archive database programs allow for scanning of the archive disks and cataloging of all the files stored on them. Text searches can then be performed to find a job or an individual file. If properly maintained, a good archive database can improve productivity tremendously.

Considerations for Digital Work Flow

Printers must become proactive in educating their customers to the requirements of the printing press and the limitations of the hardware and software available.

Perfecting an efficient work flow is critical to success in an all-digital world. Printers will need to implement many changes in their equipment, processes, and culture to implement these changes effectively. Direct-to-imposed film is an ideal stepping stone to future direct-to-plate and press technology. To attempt direct-to-plate or press before implementing the necessary changes in work flow would be disastrous. Imposed prepunched film that can be laid to

jig, tacked to clear base, and exposed to the plate will accomplish most of the cost savings of direct-to-plate and still give the printer their currency of choice—film.

Whether the goal is direct-to-imposed film, plate or press, a solid, well-planned work flow will dramatically improve throughput, increase customer satisfaction, and reduce job cost. Though this book touched on many areas of concern, the most critical step to improved work flow is probably the least expensive to implement—preflighting. Most, if not all, large plants and trade shops have already implemented preflighting but most smaller shops have only attempted it haphazardly. Preflighting is essential to quick turnaround times and to revenue protection. Printers who embrace the changes and make the internal adjustment quickly will surely outperform those who do not.

For More Information

The following sources will provide you with the additional information necessary to better understand the concepts introduced in this chapter.

Cross, Lisa. Computer-to-plate: Long Wait, Hot Issue. *Graphic Arts Monthly,* 36-42, February 1996.

Cross, Lisa. Building the Digital Infrastructure. *Graphic Arts Monthly,* 38-42, January 1996.

Cross, Lisa. Storage Solutions Rise in Importance. *Graphic Arts Monthly,* 80, March 1996.

LANs, WANs, & Servers Link the Network. *Graphic Arts Monthly,* 50-54, February 1996.

Linotype-Hell Corporation. *Digital Advertising,* Number 7039, 1994.

Nagi, Terry. Preflight: Customer Service, Customer Satisfaction. *HVP.* 30-31, October 1995.

PIA. *Technology Benchmarks, Printers' Awareness, Use and Assessment of New Graphic Communications Technology.* Virginia: Printing Industries of America, Inc., 1995.

Romano, Frank. Computer-to-Plate: Hot Technology. *Electronic Publishing.* 12-13, March 1996.

Romano, Frank. *Pocket Guide to Digital Prepress.* Albany, NY: Delmar Publishers, 1996.

Section VII
Color Proofing

Color Proofing Systems

Introduction

Proofing is utilized at various stages in the reproduction cycle to determine if the work performed at any given step is acceptable for use in subsequent operations. Different criteria are utilized to judge a proof's acceptance at various stages, but in general there are two basic concerns. First, are the mechanical aspects correct, and second, does the proof predict the end printed result from a visual standpoint? These two principles are requirements of any proofing system regardless of process, technique, or method. Virtually all color proofing methods and products produce satisfactory results for judging the mechanical aspects of a printed product, but are not necessarily acceptable for critical color judgment. In many cases they can only be used as indicating color. In most circumstances, once agreement has been reached on color between the buyer of color and the manufacturer of the proof, the color is very rarely altered. The sooner in the reproduction cycle that this color approval is obtained, the less costly the process. This is not the case in the mechanical aspects of proofing, as these include type changes, heading and banner shifts, removal or replacement of picture content, changes in gutters, trim, and register marks. Many of the mechanical changes are made throughout the entire reproduction manufacturing cycle right up to platemaking.

Most type, design layouts, engineering drawings, matrix printers, and other images utilize black and white proofing products, and are by far the largest producers of proofs. Color proofing is generally associated with pictorial content, but it also applies to designs, banners, brochures,

or other jobs that are in effect color line work, spot color, and mechanical color (fake color using tints).

When one considers the various production techniques and quality demands that are needed to fulfill the many needs, it is easy to understand why there are well over fifty different color proofing products available. The array seems almost endless, with more people entering the market, especially in the lower quality digital proofing area.

Color proofing of pictorial information is a subjective process that requires experience in interpreting the differences that exist between a particular proofing process, and the finished printed results. The printing process is made up of a number of compromises, one of which is proofing. It is important to know and understand these compromises, as proofing provides the unwritten contract of approval between the various stages of reproduction. As people work with various proofing methods and materials, they build a confidence level on their ability to predict end results. This takes time and experience. For this reason changes in proofing products or techniques come slowly, and only after all concerned reach an agreement on acceptability.

History of Proofing

Up until the mid 1950s most proofing was done from the finished printing plate or cylinder, utilizing either flat bed or rotary presses. In many instances proofing was done on the production presses, because the best proofing is accomplished under the exact conditions that the finished job will be produced.

In the mid 1950s the Ozalid Corporation introduced an ammonia developed color overlay product for the color printing market. This product was an offshoot of material made for the engineering and drawing reproduction market. This was the first commercial attempt at an off-press proofing material. This was doomed to fail, as the colors utilized were different to a significant degree from the normal four-color process inks used in either letter press or lithography, and Ozalid had no presence in the commercial print-

ing market. It was a good idea, but one with product and distribution problems.

In the mid 1950s the 3M Company entered the pre-sensitized litho plate market and became a dominant factor very quickly. The need to easily proof the final litho films prior to platemaking became obvious, and so in the early 1960s 3M introduced an alcohol developed overlay color proofing product to the offset printing market.

Press proofing was at that time the method of choice and the acceptance of this new method was very slow in coming. The small offset color trade shops were the first to move as they operated generally in the less color sensitive market. Products improved, customer acceptance increased slowly until by 1980 off-press proofing products in the color reproduction market equaled film usage costs in the manufacturing cycle of color separations.

The proofing method whereby proofs are made from halftone films is referred to as "analog." This covers a wide variety of products, single sheet overlays, laminated transfer systems, positive or negative working, colored photographic materials, and others. The analog market was promoted most strongly by 3M and DuPont in the 1980s even going so far as to establish a cadre of technical representatives, whose sole purpose was to influence print and color separation buyers in specifying specific off-press proofing materials.

The improvements in the off-press proofing products came fast, starting in 1980. A wider selection of products, automation of the production cycle, and greatly improved technical support and service were available. Most of these improvements were aimed at the offset printing market; however, the introduction of halftone gravure techniques in the latter part of the 1980s started a trend toward offset proofing techniques that allowed the gravure industry to utilize off-press proofing in much the same way as the litho industry. By 1992 the gravure process was closing the digital loop, and the gravure proof press was becoming either obsolete or used for production work.

Today, most manufacturers of graphic arts film also sell an analog color proofing product. These manufacturers

cater to virtually every need trying to simulate the output of offset, gravure, flexo, and to a lesser degree screen process printing. The needs become complicated for each process. For example, offset printing is either sheet fed or web, coated or uncoated paper stocks, and a multitude of inks and numerous variations of dot gain. The choice of the proper proofing system requires an in-depth knowledge and understanding of the requirements for a specific set of final production criteria. The term, "buyer beware" fits very well in the selection of a proofing system.

Starting in the late 1980s digital information started moving upstream in the reproduction cycle toward the creative area. The Mac's and PCs entered the so called "desktop publishing" stage and the beginning of the need for digital preproofing emerged.

The use of digital color information started in the commercial world in the mid 1980s with the high-end color electronic prepress system going digital, and moved toward the creative people in one direction, followed by image assembly, plate and cylinder manufacturing, and finally to the digital color printing presses. Today it is possible to go from concept to printed page in an all-digital mode, in both offset and gravure.

As the digital transfer of information moved into the graphic arts reproduction cycle, so did the need for digital proofing products. The race was on to duplicate the major existing analog proofing products with a digital product, using the proper combination of consumable product, hardware and software. The key word is duplicate, as the analog products and methods were and are the current benchmark. Customers want an analog backup available if the digital system goes down. In time this concern will be reduced, as digital direct technology is fully accepted.

In the mid 1980s Iris was selling a color ink jet printer for commercial color proofing. In the mid 1980s heat transfer desktop color printers for use with the minicomputers were in full force, being used for preliminary looks at design and layout. By 1990 the proliferation was well on its way. Both Kodak and 3M announced high quality digital color proofing systems that could be used for final cus-

Figure 10-1 Kodak Approval PS digital color proofing system

tomer approval (contract color). These are expensive, each starting at $250,000, and were targeted at the largest color prepress installations (Figure 10-1).

The Japanese were showing dye sublimation in the late 1980s as an improvement over heat transfer, and by 1990, 3M, Kodak, and DuPont had entered the dye sublimation digital market (Figure 10-2). In the late 1980s Canon demonstrated the ability to drive a Canon color copier with digital data, as well as copy directly from color copy. Xerox, Kodak, Canon and many others entered the color market early on with the ability to produce color duplicates. Some have adapted their equipment color toners to more closely replicate printing inks. The transition is now complete. Digital products for proofing have duplicated the analog products, and in many cases exceeded the old system. Considering that it took twenty to twenty-five years for analog products to be the major choice of proofing needs, it seems possible that digital proofing products will win acceptance in less than ten years (Figure 10-3).

Figure 10-2 Kodak Digital Science desktop color proofer (DCP) 9000

Figure 10-3 3M (Imation) Rainbow Color Proofing System.

Press proofing will not go the way of letterpress. Some of the major advertising firms still desire press proofs but the numbers are slowly diminishing. In packaging, where up to eight colors or more can be utilized, press proofing provides the needed information. Specialized products such as fabric printing, and wall and floor coverings are other areas where press proofing has certain advantages. When customers require partial runs of color work for preliminary distribution, such as for a national sales force, press proofs are more economical than off-press proofs. Producing 200 Matchprints or Cromalins would not be as economical or as consistent as the press proof.

Analog proofing will slowly diminish as digital proofing expands. It will not go away as long as films are supplied for platemaking, not only in the United States, but the rest of the world as well. Off-press proofing is most pronounced and accepted in the United States and Canada. China still uses flatbed proofing presses as does India. The rest of the world is somewhere in between.

Under the heading of "nothing is new," The digital color printing press has been added to the color proofing process. With the availability of stored color information in digital form at the printers, where every turn of the press can produce a modified image, it is now possible to once again proof on the production press, but this time in a more timely and cost effective fashion. What impact this will have on the proofing market is uncertain, but it will certainly have a place in the proofing of short run color, as will the color electrostatic copiers and/or duplicators and presses. One wonders where copiers end and presses begin.

No matter what the technology, proofing will always be around, as someone will want to see something specific before they spend their money.

Role of Proofing

The final goal of all proofing is to assure that a printed piece meets the "agreed-to" specifications and customer expectations. There are times when provided specifications and customer expectations are not in harmony. Specifica-

tions are normally objective and measurable, while customer expectations can be subjective, and therefore open to interpretation. Proofs provide a visual method of evaluating the various production steps in the reproduction chain.

Mechanical layout, text, and graphics are proofed both individually, and together at various stages, until the customer agrees that the work is correct. A majority of the proofing done is utilized within the production chain prior to presentation for customer approval. Mechanical layout proofs are produced using mostly black and white materials, and show placement of the various elements, such as: type, banners, headings, graphics, and others. It also must take into account printing requirements such as gutters, trim, registration, and bleeds.

The mechanical aspects of a job can change continually throughout the job cycle as editors redo copy, picture content is shifted or changes size, printing conditions are shifted, or bindery methods are altered.

Text proofing is done from the very first rough draft right through the final editing process, and is usually the result of either photographic typesetting, or the output of various digital printers fed by minicomputers. Here again black and white materials are the norm, but with the ease of moving text with minicomputers, the use of colors in text is much more pronounced today, and thus the lower end of color proofing is sometimes utilized. This is especially true if tint blocks are being incorporated, such as with digital heat transfer.

Colored text in banners or headlines are color proofed sometimes by themselves, but generally with the graphics, and a higher quality proofing product is utilized, as the main desire is to evaluate the pictures. Graphics (pictures) are proofed for color as early in the color separation process as is possible. The initial proofing evaluates such things as size change or cropping, along with color evaluation against input copy. The quality of the color separation system, the expertise of the operators, and the person judging color decides what additional color changes (if any) are required prior to submitting the graphics proof to the customer. The closer the production cycle gets to the customer

approval stage, the more care is required that the proofing material will provide a "de facto" contract, and that it represents the ability of the printing process to reproduce that proof in a timely and cost effective manner. Proofing at each stage of the process assures that as the work is passed through the system each stage is performing its function satisfactorily.

Proofing, if done correctly, accomplishes two things:

1. There is no attempt to color correct on the printing press.

2. The proof that is utilized is acceptable and in line with the customer's expectations.

This role is to provide a guide that represents how the finished printed product will look. It assumes the following three specific needs have been met:

1. The proof is reproducible in most attributes on press (no proofing system can match all press conditions all the time).

2. The proof is acceptable to the customer.

3. All judgment of color was understood and viewed in exactly the same manner by the customer, printer, and color separator.

Proofing at its best is a guide. The judgment of color is a subjective process and for that reason, interpretation is required between the original concept, creation of art, proofs, and the printed page. Experience in color judgment and an understanding of the limitations of the entire process is a requirement, if the multitude of color relationships is to be understood and utilized in a positive manner. Interpretation is the name of the game in proofing.

Proofing Stages

As previously stated most proofing is an internal prepress activity, and it is only at the later stages of job completion that the various elements are submitted to the

customer for approval or changes from job specifications. The assessment of production conditions starts early in the reproduction process and in some cases no hard copy proof is utilized. The proofing process includes:

- The creative and production people visually evaluate the input copy to determine which is best suited for their clients' needs, not only from the creative side, but also from the technical. In production, is there compatibility between the input copy and the printing process, and is the information in suitable form for reproduction?

- Input copy is evaluated both visually and by densitometer to determine scanner setup requirements based upon tonal range, film type, cropping, size change, high and low densities, contrast, color shifts and requested customer changes. All these factors are relative to printing needs such as printing ink specifications, paper type, type of printing, screen angles, screening techniques, register, and overall quality.

- Some electronic scanners provide a visual color CRT evaluation system that allows for overall color shift determination in scanning, if required. This is the first area of soft proofing, but can also be related to CRT evaluation systems, used in conjunction with digital color cameras that are within themselves color separation systems.

- Films produced directly from the scanner operations are evaluated utilizing so-called hard copy "scatter proofs" or random proofs. This requires a color proofing product that closely resembles the expected printed results. Digital data is viewed in many cases on a color CRT device utilized in color electronic prepress systems to determine if changes need to be made prior to the making of films for proofing. This is the second area where soft proofing is utilized.

- After the initial evaluation of the first hard copy color proof, the proof is either shown to the customer for

comments or approval, or it is used to make judgment calls for additional color corrections to satisfy the initial requested specifications.

- The film or digital data used to make the films, or information for proofing, is modified by either re-scanning, dot etching, or data manipulation, and is output again on color proofing materials. This is again evaluated and modified, if necessary, until the stage is reached for customer evaluation. In many cases the customer will request changes after viewing the color proof, and the whole cycle is repeated until the customer accepts the results. It is not unusual that three or four color proofs are utilized before the so-called "contract" proof is customer approved.

 At the image assembly stage where all the elements come together, both color and black and white proofing are utilized, depending on need to check for: color breaks, cropping, crossovers, overlays, overprints, register, reversals, sizing, screen angles, text and graphics placement, and bleeds.

- The finished, plate ready films, or plate, or press ready digital data, are proofed prior to either making printing plates, cylinders, or being input into digital printing presses. This can be either a color, or noncolored proofing material, depending on the circumstances. This is the final check prior to turning on the printing press.

- Printing plates and cylinders are examined visually to make sure all the information has been transferred to the printing surface. This is not an option in digital printing.

- Initial press sheets from the production run are compared visually and with instrumentation, to the approved color proofs, supplied by the customer or color separator. This is the final proofing step. Approval of the press sheet, even if different from the proof, signals the beginning of the production run.

- Proofing continues throughout the press run by comparing press production results at various times to the approved press sheet. Uniformity is the desired attribute.

The proofing of text, and the many mechanical steps, have not been discussed in great detail because color proofing is not usually a major factor in line applications. However, there is a trend toward the use of more noncritical color proofing in these stages as color expands into more text and line art applications. This is not an insignificant area of concern.

Analog Proofing

Analog off-press color proofing systems utilize a high intensity exposing device, and record information from either line, or halftone black and white film negatives or positives. They come in two forms, either an overlay system of single sheets or a laminated layered system. Most are available in positive or negative versions, and can be processed either manually or by automated processors.

Overlay Systems

The earliest of off-press proofing materials were initially introduced by the Ozalid Corp. in the late 1950s followed by 3M in the early 1960s. In these systems, each color is a separate colored film transparency. The films are combined in register, and backed with paper (usually the paper to be printed on), to produce a composite color proof. The films can be used singly or in combination to provide progressive proofs.

Overlay system colors come in a wide variety (3M offers over thirty colors) including normal four-color process ink colors in at least two varieties. This system found widespread use in the offset non critical color market, and became a staple of proofing in offset printing, as well as the design and layout areas of the creative people.

Overlay systems today are generally used as internal quality checks, rather than for customer approval. The advantages of overlay systems are: fast, simple to produce,

and relatively low product costs. Overlay systems provide the ability to look at single or overlay color combinations, similar to single- and two-color presses. Laminate proofs reduce light refraction problems and appear more like the press sheet, but you cannot lift and examine the individual colors after lamination.

In the North American market three manufacturers are dominant with specific product lines:

3M (Imation)—Color Key

DuPont—Chromacheck (dry system)

AGFA (Enco)—Naps and Paps

Overlay systems are in wide use and form a sizable portion of the color proofing market. GAMIS/PIA estimate the overlay systems to be around 20% of the color proofing market in dollars spent. This market will diminish as the digital data stream expands. Every digital installation in either the creative, or prepress area, replaces analog with digital proofing as internal color check. Overlay systems are the most vulnerable for replacement by digital proofing.

Single Sheet Systems
(Laminated Layered Systems)

This system is also referred to as integral systems, transfer systems, or laminated systems. In single sheet systems, all color films are put together by either laminating or transferring films one at a time to a single base sheet, and are normally viewed in total, not as individual colors.

These systems generally produce an image in one of two ways:

1. Layers of ink or dye are placed on a stable substrate.

2. Toner images normally on a paper substrate.

A number of single sheet systems are regularly accepted as final customer approval proofs. As this acceptance has increased, the use of press proofs has diminished, except in those areas where multiple proofs

and progressives are needed, and the cost of supplying single sheet systems is not cost effective. Single sheet systems are used by most prepress color service businesses, as well as most printers. Considerable effort by major film and proofing manufacturers has produced a proliferation of products to reasonably match a majority of printing conditions. A variety of colors are available both in process as well as specialty colors. In an attempt to match print conditions, various density, dot gain, and paper surface conditions have been made available.

In the quality color printing market the single sheet process is used not only as the final proof, but also as the internal color check in order to maintain color continuity, both at the prepress level as well as for the printer. This relationship is very important, and is one of the major reasons why the changing of proofing process is very difficult. Everyone from creative, through the printer, to the customer, is involved in evaluating proofing materials.

It should be noted that in the single sheet proofing market, not only are a variety of color proofing products available to simulate a wide variety of printing conditions, but also products have been altered to compensate for ethnic preprogrammed physiological differences. For reasons not exactly understood, Asians prefer colors differently from the Europeans, who are also different from the U.S. market. This of course adds to the proliferation of manufacturers, distributors, and product.

There are well over ten major companies in the single sheet process market offering a wide variety of methods, processes, and materials, many of which duplicate each other.

Listed are the current, major North American companies and their major single sheet product line:

DuPont—Cromalin

3M (Imation)—Transfer Key and Match Print

AGFA (Enco)—Trans-Naps

Fuji—Color Art

Agfa—Agfa proof

Photographic, Electrostatic, and Electrophotographic

Not specifically mentioned, but worthy of note, are additional processes that provide a single base sheet proof that are viewed in total, and not available as individual colors:

- Photographic color papers are used in a variety of ways—from diffusion transfer, through self-developed products. Some work from continuous tone information, and others from halftone color separations. Kodak, Polaroid, DS America, and Konica, are just a few of the entries in this area. Thus far they have not found wide acceptance, but are utilized in certain specific circumstances.

- Electrophotographic systems originated in Australia with the Remak System, and later by Coulter Systems, and more recently by Eastman Kodak Company. This process is an automated electrophotographic system with high resolution, adjustable density, and dot gain, with the ability to transfer to a wide variety of printing papers. This process is the most expensive of the single sheet systems, and is utilized normally for only final customer approval proofs. This process has found limited acceptance due to its high cost, but is considered by many to be the most desirable of all single sheet proofing systems for the highest quality of color work (especially in advertising agencies).

- Electrostatic color proofing utilizing color art or film is being used for color comps, and early on color checks of color breaks, etc. A number of color copiers exist that can perform this function. Many can change size, have overall color shift ability, and will proof on more than one type substrate. Color copiers or color duplicators have been improving in quality, and in effect have entered the lower quality short run printing market. Kodak and Xerox are well known in the color electrostatic market, but others such as Canon, have more closely targeted the graphic arts market and even offer color output from either analog or digital data input.

The single sheet laminate products are the dominant off-press color proofing method today, estimated at approximately 60% by GAMIS/PIA. It is expected that they will remain dominant up until the year 2000 or later, when digital color proofing will either match or exceed its use in the North American market. Well into the next century the printer will be using single sheet laminate products for a final color check prior to making printing plates.

Digital Proofing

Digital proofing is the generation of a hard copy color proof, or soft color proof (CRT), from a digital data stream. This system normally generates hard copy color proofs in either a continuous tone, or nonconventional dot form. Only in one instance at the very highest end of digital proofing are conventional halftone dots generated.

As in other proofing systems the objectives are either internal control to verify the accuracy of the individual production or creative steps, as well as obtaining customer approval prior to printing. In digital proofing the ultimate goal is not to proof the digital data per se, but to proof what the digital data will look like when printed. Digital proofing differs from other color proofing only in its techniques. It does not change the requirements or needs of color proofing at any step in the process. As color digital data use has moved upstream into the creative area, as well as downstream to the digital platemaking and direct digital printing process, so has the need for digital color proofing progressed, and the required products followed.

This trend has created a digital proofing need that duplicates the analog uses. For this reason a large variety of products and processes have come into being. Here, as in analog markets, there are many duplicate products. The suppliers of digital proofing products are expanding at a rapid rate, and the number of vendors already exceeds the analog product availability. In the digital color proofing systems, color hard copy proofing on paper is the preferred system. Soft proofing is gaining acceptance especially as an internal check both in the creative and early production stages.

Digital proofing has proven to be somewhat faster and somewhat less costly than analog proofing. How fast and at what cost depends on the level of quality desired for a particular need. In the digital ink jet process and dye sublimation process, the ultimate quality goals are to emulate the most successful of the analog color proofing products. The degree to which this is accomplished will determine acceptability of digital proofs as a customer approval system.

A major shift in thinking is required for the acceptance of preproofs (no halftone dots) as a final contract proof. This will come about as three things are happening that will hasten the use of mid- to high-end quality digital hard copy color proofs.

1. The products are being improved on a continuing basis, and some are already challenging the analog laminated products in the mid-quality color printing market.

2. The newer print buyers, and those in the creative and design field, are not so-called "dot worshipers," and seem more interested in the visual match of proof to printed product, rather than the technical ramifications of the process.

3. The cost to the consumer is generally less for digital color proofs, and this is being promoted in certain areas. So cost versus value becomes a critical factor, especially if you are generating the proofs for your own use.

Hard Copy Digital Color Proofing

There are a number of technologies involved in the digital color proofing market, such as: electrophotography, laser, mechanical ink plotters, ink jet, dye sublimation, xerographic, photographic, thermal wax transfer, ion deposition, photo encapsulation, and others. Most of these technologies are not new and have been adapted to the graphic arts market. In the digital market, the users and

sometimes the manufacturers have been quicker to recognize needs and adapt, rather than the vendors. Since 1990 when the digital proofing market expanded, there have been three general technologies that have come to the forefront, and are the major categories in the digital market. They are divided primarily by quality levels as perceived by the users and buyers of color proofs.

The thermal transfer products dominate the lower end of the color hard copy proofing market, and are used in the lower quality market for such things as design, layout, low resolution graphics, and color type. A wide proliferation of products and equipment are available.

At a somewhat improved quality level are the color laser printers that augment the black and white laser printers, such as those made by Hewlett Packard. Color copiers such as the Canon CLC and Xerox Majestik can be driven by digital input, as well as accept continuous tone or line art originals. These are used mostly for comps and mechanical color proofing, especially where multiple proofs for distribution are required. Advertising agencies were the first to recognize the applications of this method.

Dye sublimation digital color proofing has started to challenge analog proofing for internal color checks, as well as having continued to gain acceptance as a customer approval product. Many of the dye sublimation systems on the market utilize common engines in a different box. Quality levels of dye sublimation output vary considerably in resolution color rendition and predictability. The 3M (Imation), Kodak, DuPont and others all offer high-end dye sublimation proofing products, with 3M's Rainbow system being popular. As indicated there are many others in this market at various levels of resolution, speed, color rendition, and cost, such as Tektronix, Radius, and SuperMac. Due to this proliferation, it can be expected that cost will come down, and there will eventually be more losers than winners in the vendors' circle.

Inkjet digital color proofing, like dye sublimation, is not a new technology, but new to the color prepress proofing

Figure 10-4 Kodak Digital Science 1000 PS large format inkjet printer.

market in the past 10 years (Figure 10-4). The inkjet systems are more expensive than dye sublimation systems, but are also more versatile in width of paper proof, and the variety of substrates upon which it can imprint a color image. IRIS is the current major supplier of color inkjet systems for graphic arts. Others will follow suit due to market acceptance. DuPont for example had entered the market using modified stork equipment from Europe. Kodak is certainly in a position to enter the market as they

have a whole division concentrating on inkjet for coding and mailing information. Both inkjet and dye sublimation will no doubt improve to the point where they could open the door for hard copy remote digital color proofing.

At the very high end of digital color proofing are the digital systems that produce contract proofs with conventional dots. These systems operate somewhat as do the analog systems that utilize four or more color layers that are laminated to a substrate for a finished product. Both Kodak and 3M offer products and equipment at this level. The users are primarily large color separation house and high volume color printers. The initial total costs are substantial—well over $250,000—which limits the number of installations. Also most of these systems are interfaced to the very high-end Color Electronic Prepress System (CEPS) operations. It is expected that in the near future a standard PostScript interface will be available, which may expand the use of these types of systems. There are a few digital color proofing systems that produce conventional dots on photographic paper. Konica and D.S. America are two of these but the acceptance of this type of a system as a contract proof has not been significant to date.

Soft Proofing

As users begin to find soft proofing systems that provide satisfactory results, and experience teaches us how to interpret form from the CRT to the printed page, cost savings in internal proofing can be realized.

The use of soft proofing in the graphic arts goes back to the early 1970s, when the color separation systems used CRT devices to judge and evaluate color manipulation in the high-end CEPS equipment.

Much has been done to establish systems of calibration and control of soft proofing CRT devices. The most successful are those software and hardware packages that link the input color separated data to the viewer, to the output device and proofing system in a closed loop method. Until ANSI Standards are established in this area there will be much frustration, and seeming lack of predictability.

The key words are calibration, reliability, and software. The biggest problem area will be the human mind that is the observer and judge, in a system totally subjective by nature with the normal human failings. There will be no substitute for experienced color judgment in a successful soft proofing color system.

In the digital proofing systems market the need for standards is a must. Some color targets and aim points for calibration are being offered in a digital form. It is only recently that SWOP acknowledged the use of analog proofing products, much less digital.

With the growth of digital data, and as a result digital proofing, the need for accurate, predictable, reproducible, calibrated color data is an absolute requirement. Software, not hardware, will be the ultimate solution. Those who are involved in digital color proofing should spend 80% of their time evaluating software, and 20% on equipment and consumable.

Soft proofing is utilized by viewing CRT devices that are either stand-alone equipment, or incorporated into hardware that serves multipurposes. All the high-end CEPS systems have soft proofing devices incorporated as do all the color Mac's, PCs, and UNIX systems. All of the color separation systems, either high- or low-end utilize soft proofing either directly or indirectly as a major part of their color system.

Stand-alone systems operate as either independent stations, or are remote slave units dedicated to direct connects to a CEPS system, or other host color evaluation system. Such CRT previewers are available from Barco, DuPont, Kodak, Linotype Hell, Scitex, Toppan, 3M, Dai Nippon Screen, and many others.

The CRT devices work with RGB color information, while printing and proofing systems work in the CMYK color space. The transforms contained in the software utilized in soft proofing are extremely complex, as the variation of input copy, proofing products, printing conditions, and the viewing conditions must all be factored in. In other words, "is what you see – what you get?" The answer is "not exactly." This is the same answer you get in all proof-

ing systems. Experience and interpretation are still necessary ingredients for success.

Most digital transformation software incorporate the following information:

- Calibration of the press, that most closely resembles the actual press run.

- Color conversion, accommodates the color specifications of photograph dyes, paper and ink relationships, and/or color differences between original, color proof, and color printed product.

- Linearization, coordinates the illuminate to the characteristics of the input copy.

This software is an extremely complex and a most important part of the color evaluation process. Those who are the most successful in this software race need an outstanding understanding of the entire printing process (copy through finished product), colorimetry, and spectrophotometry. This is no easy task, thus it produces a wide variety of software programs that go from very good to the not so good. Practical evaluation with a variety of test objects is the only current practical way to evaluate software quality. Eventually ANSI will have standards in this area, as it is recognized that this is one of the more important cogs in the reproduction chain.

Viewing Standards for Soft Proofing

In the digital data world much of the color data is viewed on color monitors, especially in the creative and color separation areas of the graphic arts. Such equipment first came on the market when Hell, Scitex, and Crosfield went beyond scanners and entered the color data manipulation area with high-end color electronic prepress systems that utilized colored cathode ray tubes for color judgment. As the so-called "desktop publishing" entered the market, the colored CRTs in Mac's and PCs proliferated until it is now a given that somewhere within the chain of the movement of color digital data, at least two of the judgment calls

on color are made looking at a CRT color device or its equivalent.

There is a degree of continuity between these color CRTs mainly because the number of manufacturers is very limited. The major market for color CRTs is commercial television receivers. Their needs and specifications are a function of the Society of Motion Picture and Television Engineers. As the commercial television CRTs are the largest market, it is not surprising that the graphic arts market's needs are not paramount in the eyes of CRT manufacturers. Low- or high-definition equipment is not the main factor, but the phosphorus utilized in CRT manufacturing. Their aim is pretty pictures, not color accurate pictures. They know what the motion picture and amateur film manufactures found out long ago. No one wants accurate color, they want pleasing pictures. Unfortunately this is not the objective of the graphic arts.

In order to bring the color as seen on the monitor as close as possible to the printed page a group called the "International Color Consortium" has been formed in the United States to work with the ISO/TC 130 standards working group II to establish a color management system that addresses the problem. There are methods in place to measure the colors on a color CRT device. By analyzing the color space available on a color CRT, utilizing RGB color space, and comparing that to the CMYK color space in normal four-color process printing, an intermediate colorimetric space can be devised that modifies incoming data to the color CRT devices that help simulate a soft proof of the printed page. Their efforts are directed at software modifications that eventually will be installed in new equipment or utilized to modify older systems. All of this will be done keeping in mind that 5000°K viewing conditions are the aim.

A word of caution, as the color phosphorus in CRT devices will not exactly match all colors produced by printing ink pigments, interpretation between the two mediums will always be required to some degree.

Evaluation of Color Proofing

Color proofing occurs throughout the entire design, prepress, and printing stages. Proofing serves two basic purposes that revolves around its basic need as a communications tool.

1. Color proofs confirm the progress of a job and the performance of the producers at the various production stages.

2. Color proofing provides the information required to make the final judgment of job acceptability. In effect it is an unwritten contract between all concerned that the proof is a reasonable prediction of the finished printed job.

The ultimate goal of proofing users is to obtain job acceptance by the print buyer as early in the process as possible. Proofing is costly and time consuming. The goal of both suppliers and buyers of proofing is to obtain early agreement on both the mechanical and color aspects of a color job. Early agreement means lower production costs and faster turnaround. Once agreement has been reached on color requirements they are very rarely altered. This is not the case in mechanical requirements where the layout, positioning, and other factors can change as the job progresses, even up to press time. Furthermore, a job may shift from one production press to another, and finishing or press configurations can change, thus changing the mechanics of the job.

Proofing is used in two basic areas and attempts to serve two masters. This is no easy task, and it is one where many subjective judgments come into play, which in turn produces undesirable variables. Proofing is used to compare original copy to the proofs, as well as proofs to the printed sheet. On one hand, you have the creative people evaluating how well the proof represents the original copy, while the client and printer compare the press sheet to the proof for accuracy of reproduction. Matching the proof is the given objective.

For many years the proofing market was mostly influenced by the creative people, the objective being proofs that matched the original copy as closely as possible. This was a reasonable task in the day when hard copy input was the norm, such as: wash drawings, paintings, and line art, but as color photographic transparency film became an acceptable input in the mid 1930s, the situation changed. All of a sudden the input was beyond the capabilities of the printing process. The introduction of Kodachrome by Kodak opened the doors for a color reproduction revolution, not one necessarily looked at favorably by the printing community.

Color proofing now faced a dilemma. They could not duplicate the density, purity of color, or tonal range, of a color transparency. Many techniques were devised in an attempt to improve the visual impression of a proof. Keep in mind that press proofing was the approved proofing method. In an attempt to more closely match proof to transparency, the proofing paper was upgraded, cleaner inks were utilized, tone scales of proofing separations were altered to improve high light tonal separation, and total ink densities were increased.

All of this did improve the visual look, and was a step closer to matching the color transparency, but it was a lost cause from the beginning as the conventional four-color printing process physically cannot duplicate many of the attributes of color transparencies. This pleasing of the creative people, however, created a monster in printing. The proofs were much better in quality than could be produced on most production printing presses. This created endless hours of debate, letters, and reports between clients, creative people, color separators, and printers. So-called "make goods" became a fact of life. A whole cadre of quality control people evolved to do no more than evaluate and debate the problem.

This of course called major attention to the problem, and as offset and off-press proofing came into being, the entire industry started to move toward a more sensible approach of having the proof emulate the printing process.

This was a long and tedious road helped along by the formation of the SWOP committee, which became a moving body to obtain continuity on printer input color separation material supplied by different vendors, with realistic physical aim points that were acceptable to the printers. All of this took between forty and fifty years. This indicates how firmly proofing procedures become a basis for color communications, and changes are done most reluctantly, and justifiably so.

The users of proofs today expect that color proofs reasonably represent how that job will look when finished on a printing press. The move from pleasing the creative people to pleasing the printers and client did not happen without much education on the part of all involved in the reproduction chain.

The print people in production, as well as photographers, color separators and others, now understand and accept the differences between color proofs and color transparency input. Most understand it and acquire the background to interpret the differences.

The interpretation of proofs relies on mostly subjective judgment, experience, viewing conditions, and a good understanding of the variations and idiosyncrasies of the reproduction chain. Physical measurements are utilized on certain parameters that relate to printing, for example: trap, density, tonal range, dot size, basic color hues, but in the end it is the human eye and/or brain that makes the final judgment. Is it what you want, do you like it, is it acceptable?

When you hear someone say "Match the Chrome," you know someone does not understand the process. There are three words that sum up the needs in the evaluation of proofing—"Interpretation, Interpretation, Interpretation".

Proofing Trends

In the color proofing area there are three criteria that will continue to have a direct effect on utilization of color proofing systems.

1. The use of any proofing method will continue to be based upon the work being produced, and the specific purpose for proofing.

2. There will be no relaxation in proofing requirements. If anything, a more stable and repeatable process will evolve due to the establishment of color standards and color management systems.

3. Better quality color demands will drive the development of improved products that are more cost effective on a per proof basis. The medium to lower quality color proofing needs will expand most rapidly at the expense of black and white proofing. It will be reinforced by the continued evolution of digital reproduction systems.

Print buyers and others who judge color have a wide variety of backgrounds. Increasingly these people come from nontechnical backgrounds such as the business or computer world. This changes the perceived needs of proofing. Proofing systems will be expected to operate in office environments with the ease of office copiers. Low maintenance, excellent reproducibility, and automatic calibration will be the watch words. Cost and versatility are also a consideration. The day of having a proofing system committed to one specific set of printing circumstances will certainly be reduced.

There is no question that the "all-digital world" will increase the use of digital color proofing. With digital color cameras coming onstream, digital plate and cylinder making, coupled with the increased usage of digital printing systems, there will be expanded needs for color proofing. The ease of obtaining a digital proof unto itself will increase the number of color proofs manufactured. It is anticipated that color proofing will become faster and more economical. A natural trend would then be to use certain digital proofing systems as a finished product for short run color printing, as well as for proofing. The digital printing presses certainly afford an opportunity to explore that

market. The digital proofing systems, both hard and soft copy, eventually will be accepted for remote proofing uses. As land line transmission systems improve in capacity, quality, and availability, large consumers of proofs will look toward on-site color evaluation. The availability of color management systems coupled with automatic calibration to a host computer, will be the key to move this need along.

By the year 2000 analog systems will constitute less than 50% of the color proofing market, and will continue to diminish with the printers being the last to change for a variety of reasons. The use of color proofs will expand by 8-10% a year as costs come down and speed and ease of manufacturing increase.

For More Information:

The following sources will provide you with the additional information necessary to better understand the concepts introduced in this chapter. Manufacturers of color proofing equipment provide an excellent source of real time information.

Bann, David, and Gargon, John. *How to Check and Correct Color Proofs.* North Light Books, 1990.

Bruno, Michael. *Principles of Color Proofing.* GAMA Communications: Salem, NH, 1986.

GAMIS/PIA. *An Analysis of the Graphic Arts Prepress Color Proofing Market.*

Graphic Arts Technical Foundation. *Standards for The Graphic Arts.* 1995 Technology Forecast. Pittsburgh, PA, 1995.

Graphic Arts Technical Foundation. *Trends in Color Proofing.* Forecast Number 30. Pittsburgh, PA, 1995.

Kodak Bulletin for the Graphic Arts. *Standard Viewing Conditions for Reproduction.* Eastman/Kodak Company, 1970.

McDowell, Dave. Eastman Kodak Co., *Color Standards Activity In The Graphic Arts.* SPIE Symposium February 9, 1994.

NPES. *Standards for the Printing & Publishing Industry.* January 1995.

Research and Engineering Council of the Graphic Arts Industry, Inc. *Critical Trends,* 1994.

Standards Specifications and Trade Practices. *"Pre" Magazine,* March 1992.

View Guide, Inc. *Graphic Technology,* September 15, 1994.

Section VIII

Characteristics of the Major Printing Processes

Understanding the Major Printing Processes

Preparing separations for printing multiple reproductions of color originals requires a basic knowledge of the major printing processes. This chapter addresses the technical aspects of each process, but most importantly, it will present advantages and disadvantages for each major method of printing. It is generally accepted that there are five major methods of printing, each utilizing a different image carrier configuration for the application of ink to a substrate. Within these major printing processes are many different variations such as: sheet-fed, web, heatset, and waterless or dryography. The five major printing processes are:

1. Offset lithography

2. Gravure

3. Flexography (Letterpress)

4. Screen process printing

5. Digital printing

Offset lithography and gravure remain the two dominant printing processes used in the high-volume reproduction of process color. The first four major printing processes have experienced a growth in color reproduction over the last ten years. The fifth, or digital printing process has only been available for the last four or five years. The digital printing technology was developed specifically for short run color printing. The short run color market represents a major portion of all printing.

Each color separation must be made to fit the limitations inherent to the different printing processes. Not only must a set of separations conform to a printing process, the films or digital files must be sensitive to the differences in press configurations. This means that in preparing films or files for offset printing, they will have slightly different aim points for tone reproduction than those required for gravure printing. Furthermore, the separations prepared for sheet-fed commercial offset will differ from those prepared for web offset. The separation requirements for heatset web offset will also be different than for non-heatset or cold web offset.

Trade specifications and standards for each of the different printing processes often include the inspection of separation films or digital files. This inspection process tends to identify and indicate potential reproduction problems prior to press. The intention of creating a generic film or file format for the different printing processes is not new, and has been met with some success. Establishing generic formats for reproduction aim points that are tolerant of differences in the printing processes is an ongoing effort. As a customer needs to create color separations for an advertisement that may be reproduced in different magazines, using different printing processes, generic formats become an economic necessity.

The digital control or manipulation of graphic data allows for significant improvements in proofing and preparation of image carriers (plates and cylinders). Finally, there is the ability to proof color separations for non-heatset web offset (SNAP), that accurately represents the quarter tone values that differ from heatset or commercial offset. Digital proofing has the ability to better match different press environments. This digital manipulation allows for tone reproduction differences that may be caused by ink and substrate differences encountered in the different printing processes.

Offset Lithography

Offset lithography is the most popular of all the major printing processes. This remains true for both the United States and the world. Lithography is the forerunner to the offset lithographic process, and is still used in fine art applications and some industrial direct printing. Offset lithography takes advantage of the direct lithographic process invented by Alois Senefelder in 1796, but uses a resilient rubber blanket to enhance the quality of printing and to extend the life of the image carrier. Offset lithographic plates use a right reading image, whereas the straight litho plate is wrong reading because it transfers the image directly to the substrate.

The terms offset or lithography are generally used by industry to represent offset lithography. Care should be taken as to the context of the discussion, so as not to confuse the less utilized direct lithographic plate with offset lithography. Furthermore, the term offset can be applied to some of the other printing processes. For example, gravure printing can be offset when the gravure cylinder transfers the inked image to a very soft blanket, which in turn prints to a substrate.

Offset lithography uses a simple principle that grease or ink will not mix with water or fountain solution on a flat image carrier or printing plate. The planographic plate or two-dimensional offset plate uses a hydrophilic surface to attract water and an oillophilic surface to attract the ink. The non-image and image area of the plate are defined by either the water-loving or ink-loving surface. The fountain solution or water is always applied first to the offset plate, and later followed by the ink.

The lithographic principle seems simple at first, but in a high-speed, high-quality industrial environment, the process becomes a complicated science. The fountain solution must maintain a specific pH value during the length of the press run. The acidic nature of the fountain solution defines the image and non-image area by cutting the image edge where ink adheres. One of the more difficult aspects of process color offset printing is to maintain consistent ink

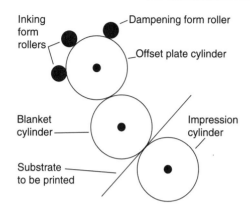

Figure 11-1 Offset lithographic press configuration.

densities while not scumming the non-image areas. Too much water washes away ink density or color saturation.

The offset lithographic process has many advantages that keep it the dominant process, but the press configuration of printing image and maintaining non-image areas from a two-dimensional surface makes offset a more complex operation. The driving force that keeps offset the process of choice by many people is the simpler, quicker, and inexpensive prep operations, along with one of the least costly image carriers (printing plates). Because of offset's ability to use photographic, and now digital, imaging, there is very little limitation to the original copy.

Reproducing Process Color on Commercial Sheet-fed Presses

Some of the very best process color printing can be produced on the sheet-fed offset lithographic press (Figure 11-1). Several factors contribute to the sheet-fed quality when compared to the web offset or gravure environments. The first advantage of sheet-fed is the lower speed as compared to web presses. The lower speed assists in better register, less plugging of details and shadow dots in the

separations, and better control of dot gain. A second advantage is the finer screen rulings used in the separations. Sheet-fed offset separations are often produced at 150 or finer screen rulings. The industry average for offset screen rulings still remains at 133 line screen for the reason that some presses cannot print the finer rulings without plugging the screened image with ink. The commercial sheet-fed offset industry can even work with 300 and 500 line screens in select cases. The use of stochastic screening is most popular in the sheet-fed markets. Commercial sheet-fed offset inks can produce excellent density and if desired, a high gloss image.

Reproducing Process Color on Web-fed Presses

Process color printing that is completed in a web offset environment is classified as either heatset or non-heatset. This means that there are two different ink formulations, which require different methods of drying, and will produce distinctly different image results. The heatset offset press and inks will produce a higher gloss and greater image density. The heatset offset process is more expensive and must be better monitored for environmental concerns. In the heatset process, the offset ink is transferred from the blanket to the substrate which then must pass through a drier to heat the ink, and then is set on chill rollers that have a descending temperature sequence. Most offset driers have a gas flame that provides a temperature of about 400° to 550°, and use chilled water to maintain cooler temperatures in the chill rollers. The chill rollers set the ink, which provides some of the gloss.

Non-heatset or cold web offset presses have reduced image density and usually print on cheaper more absorbent stocks. Specifications for Non-heatset Advertising Printing (SNAP) provides recommendations for separation aim points and screen rulings. High volume inexpensive color printing may be produced by the non-heatset press. Conventional halftone screening is recommended with rulings not to exceed 133 lines.

Reproducing Process Color on Waterless Offset

While not new, the waterless offset printing process is gaining popularity in selected print markets. Waterless offset is best suited for high quality, short to medium length sheet-fed printing. Product brochures, annual reports, and corporate identity brochures are some of the typical products produced by this technology. Waterless offset utilizes a different printing plate and set of inks. The pressroom environment must adhere to strict temperature and particulate controls.

Waterless offset has also been called Dryography, and is capable of extremely fine screen rulings. Dryography is a trademark for a hybrid proprietary system. Waterless offset can print 500 or finer conventional screen rulings or stochastic screens with limited plugging of the image. There is a trade organization dedicated to the waterless offset process called Waterless Printing Association (WPA), and it is located in Chicago, Illinois. The WPA is sponsored by prepress, ink, roller and blanket, temperature control, press, and substrate manufacturers. Some waterless printers consider their process different from offset lithography, but the fact remains that the process uses modified offset presses.

Advantages to the Offset Lithographic Printing Process

1. Relatively inexpensive prepress operations—Offset lithography is the one printing process that can readily accept all forms of original copy for reproduction purposes. Continuous tone copy is converted into a halftone image or geometric dot structure, and line copy is reproduced directly to the image carrier as a high contrast image. Since the early 1960s, offset has benefited from photomechanical off-press color proofing systems. It is possible to accept original copy, including continuous tone images, and have the plate on the offset press for production in a matter of hours. Line copy can be plated and on press within an hour.

2. Low cost of image carrier/printing plate—The offset lithographic plate is one of the least expensive image carriers. The plate is for general purposes two dimensional, and lightweight for easy handling and storage. Depending on the size of the press, an offset plate can cost anywhere from $2 for duplicators to $60 for larger presses.

3. Short production lead times—On the average, production lead time for offset lithography is shorter than the other processes. The difference in lead time will continue to shorten as the digital prepress loop closes for all processes. Currently, gravure is the only printing process that enjoys a completely digital front end in the preparation of image carriers. The offset plate remains easier to produce than the gravure cylinder, and offset is using an ever-increasing amount of desktop prepress. Recent implementation of the platesetter for direct imaging of offset plates will keep offset lead times very competitive.

4. Prepress color proofing capability—Since the implementation of 3M Color Key into the commercial graphic arts market in the early 1960s, offset has benefited from many off-press proofing systems. The ability to accurately preview color separations prior to the production press run has made offset a very predictable printing process. Until recently, the gravure printing process required wet proofing for publication. This meant that the gravure production cylinders were printed on a proofing press for customer evaluation.

5. No limitations on original art and type—The original copy provided by a customer may include very fine line artwork or detailed serif structure in the type faces. Gravure, flexo, and screen process printing have greater difficulty in reproducing these copy elements without some loss of detail. Gravure is sensitive to reverse type below 10 points due to the fluid nature of

the ink. The cell structure of a gravure cylinder can cause very fine lines or serifs to appear broken. Screen stencils and raised flexo plates can plug very fine details. Preparation for the offset plate is simplified due to the ease in reproducing these copy elements.

6. High quality of printed image—The offset lithographic process has maintained the 133 line screen as a standard for general printing purposes. In the last decade, many offset printers are using 150 line screen rulings for production, and in select cases, 300, 500, and finer rulings are used. The 133 screen ruling refers to the fact that there are 133 rows of halftone dots across the diagonal of a square inch. New dry offset technology has consistently used 300, 500, or finer screen rulings for production color.

Disadvantages to the Offset Lithographic Printing Process

1. Limited life of the image carrier (1 to 1.5 million impressions), to include unpredictable wear patterns during the run—The offset printing plate has a very limited run life, the longest run plate will produce between 1 million to 1.5 million impressions with the proper post-exposure or bake time. The photopolymer coating or image area will begin to wear in an unpredictable manner. This means that the color image may begin to lose halftone dot structure in the highlights, midtones, or shadows of any process ink. One side of a plate may wear before the other side due to incorrect pressure settings. The life of waterless or dry offset plates will vary, but the average life of this plate is greatly reduced from traditional offset lithography.

2. Must balance ink and water during the length of the press run—Offset lithography requires a continuous balance between ink and fountain solution to define the image from the non-image areas. Press make

ready for offset will require a greater consumption of paper for the purpose of ink density and image integrity. The gravure, flexo, screen, and even digital technology provide full ink density within one revolution of the cylinder. Furthermore, as press speeds or room temperatures change during a run, the balance of ink and water must continue to be modified. The pH and conductivity of the fountain solution is also a factor that the other processes are not required to monitor during a run.

3. More expensive printing substrate required due to pH factors—Offset papers are traditional book papers that have a balanced pH value. Offset is a chemical balance that must be maintained for the definition of image and non-image areas. It should be expected that offset papers will cost more for the pH factor to be maintained. Because offset lithography introduces water or fountain solution into the printing process, offset web presses will typically run a slightly heavier paper to maintain tensile strength and control high speed web breaks.

4. Application of heat (400° to 550°) required to dry offset inks at high web speeds—High speed web offset presses often incorporate a gas drier to set the ink. The most common driers require a gas flame and produce temperatures in excess of the 400 to 550 degree range. Without heatset presses, offset presses run cold and thus require slower press speeds and different inks or papers to assist drying. Non-heatset web offset printing produces flat process color images. The reduced print contrast, and lack of maximum density in cold offset, often prompts clients to use the more expensive heatset inks. Gravure presses utilize steam driers and often require temperatures of only 180° to 220°F.

Gravure

The *gravure* printing process provides one of the highest, if not the highest quality, of process color printing. Furthermore, gravure printing can yield the highest quality results of all the printing processes while printing on inexpensive substrates at high press speeds. Gravure uses a fluid ink that is contained in a sunken image cell structure that, when transferred to the substrate, is absorbed in a continuous tone fashion. The offset lithographic process utilizes a paste ink that tends to hold halftone dot shapes when viewed under magnification. Some web-fed offset inks are pumped, but their viscosity is very thick in comparison to the gravure ink.

Gravure printing is considered synonymous with process color printing because of the fact that few customers print one or two color work on a gravure press. Overhead cost on a gravure press is considerably higher than any other presses, and the typical gravure configuration includes four over four, for printing process color on both sides of the sheet. Gravure printing can deliver a slightly higher density range of color on cheaper substrates, and is not bothered as significantly by trapping, dot gain, and other offset related problems. Most importantly, one revolution of the inked gravure cylinder against the doctor blade will produce full color (100%) density on the press sheet, and maintain that density throughout the run length.

Gravure produces rich color reproductions on many products other than publications and advertising. Gravure is used for process color applications on a wide variety of packaging and specialty or product printing. Floor coverings, decorative laminates, gift wrap, flexible packages, and many other gravure printed products involve process color on a wide variety of substrates. Always work with the gravure service house or printer to better understand the different substrate requirements for process color applications.

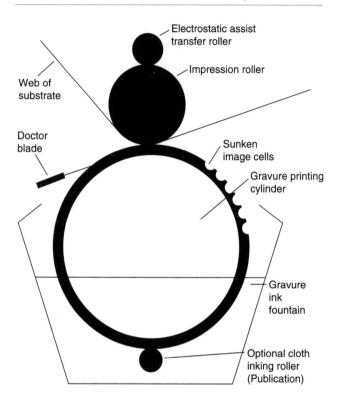

Figure 11-2 The gravure press unit configuration.

The gravure printing press is perhaps one of the simplest image transfer processes (Figure 11-2). Gravure relies heavily on the principle that the substrate will absorb the ink from the sunken image carrier. Only about 100 to 200 pounds of pressure are applied by the impression roller against the printing cylinder to transfer the image to the substrate. Other processes can require as much as 1,000 to 2,000 pounds of pressure for image transfer to select substrates. While solvent-based gravure inks are considered volatile, they dry faster and at lower temperatures than many other inks used by other printing processes.

Because some substrates do not absorb the ink as well as others, and the cell does not fully evacuate the ink, the Gravure Research Institute developed the Electrostatic Assist for gravure presses. The Electrostatic Assist (ESA) has been around since 1965, and has enhanced the quality of gravure printing. The process provides a low level negative charge to the metal cylinder which in turn charges the ink with a negative charge. Meanwhile, the rubber impression cylinder receives a positive charge from a transformer roller or other charged device. The negatively charged ink is attracted to the positively charged impression roller and must evacuate the cell into the substrate in an attempt to get to the impression roller. This ESA system is typical of all gravure production presses and delivers uniform ink coverage throughout the colored image.

Advantages to the Gravure Printing Process

1. Long life of the image carrier/cylinder—The gravure cylinder will produce 10 to 20 million impressions when properly chromed. The gravure cylinder can then be removed from the press, chemically dechromed and then re-chromed for further press runs. This represents run lengths that far exceed offset plates and some flexo plates.

2. Process color that has the appearance of continuous tone printing—The fluid inks used in the gravure process evacuate the cells and are absorbed into the substrate. Under magnification, the printed image appears continuous tone because the ink has spread into stock. The offset process uses paste ink, and under magnification it is visible that the image retains the halftone dot structure.

3. Exceptionally high press speeds—The gravure publication press is capable of running over 3,000 feet per minute (FPM). Even with cheaper substrates, it is common that the gravure press will run production speeds at or around 3,000 FPM. The fastest offset presses have only recently achieved the 3,000 FPM

range, but production speeds tend to remain around 2,000 FPM on the average.

4. Ability to print a seamless or continuous image design—The gravure image carrier is typically a cylinder and thus is capable of a never-ending image. This image capability is a major advantage in products such as gift wrap, floor and wall coverings, or any product that requires a continuous design. Flexo can butt images with sticky back or magnetic back plates.

5. Extremely fast drying inks ready for immediate handling (scuff proof) using only steam driers—Gravure publication inks use steam driers that operate at around 180 to 220 degrees. These temperatures are significantly less than heatset offset. Gravure solvent based inks use toluene solvent which evaporates very quickly and the ink also dries by absorption into the substrate. Gravure inks work well with high speed in-line finishing operations.

6. Excellent reproduction results on inexpensive printing substrates—Gravure has the ability to deliver the high quality process color images on the cheapest substrate. Gravure paper does not need pH balance like offset papers. Gravure can produce high speed work on lighter weight stock because there is no ink and water balance required. Offset requires a dampening solution that creates the potential for more web breaks.

7. Ability to do minor color correction to the image carrier (plus or minus cell corrections on the cylinder)—The gravure cylinder may cost more to produce, but it is the only image carrier that affords color and tone correction to the image. The use of burnishing and lacquers create minus correction by reducing the cell cavity and thus ink capacity. The use of hand tooling, or local/global re-etching will increase the cell capacity and color density. Corrections can be done on chromed cylinders, but most service houses or printers prefer correction on copper.

8. The first printing process that totally closed the digital loop (produced commercially acceptable product without film images)—During 1993, the gravure industry began producing cylinders without film. The use of digital data directly from customer files and digital proofing, allowed the gravure printer to reduce production cycle times. In the past, an average gravure publication cylinder may have used more than $120 of raw film for imaging, and it took four cylinders for process color work.

Disadvantages to the Gravure Printing Process

1. The initial high cost of producing printing cylinders—Gravure publication cylinders can cost as much as $1,200 per cylinder. Some gravure printers do not make their own cylinders, which means that cylinders may be made in Chicago and shipped to Matron for printing purposes. Shipping gravure cylinders becomes an expensive venture.

2. Longer average lead times required of publications—Gravure production lead times average around two to four days as compared to offset at one to three days. Closing the digital loop will further reduce this difference, and there are currently exceptions to these averages.

3. Inability to make quick and easy cylinder changes. If a major part of the image is to be changed, the entire cylinder must be re-engraved or re-etched—Gravure cylinders, by virtue of weight and size are difficult to move around. If a color correction is too extreme, or damage occurs to the cylinder surface, it must be re-imaged. Again some printers do not produce their own cylinders, and this further complicates a production schedule.

4. More precision is often required to obtain high quality results—The gravure cylinder must maintain dimensional tolerance within 1/1000 of an inch over the length of the cylinder. Cells are measured in microns

which translate into 1/1000th of a millimeter. This process requires greater understanding of mathematics and chemical reactions during the electroplating and cylinder imaging, than do the other traditional image carriers.

5. Type matter smaller than 8 points should not be used unless necessary, and type faces should not contain hairline strokes (critical for the use of reverse type)—Gravure uses a fluid ink that soaks into the substrate during printing, this absorption spreads the image and plugs fine reverse images. Furthermore, fine line details in artwork or fine serif structure in type matter will be lost or broken due to the need for cells to create the image.

6. Volatile inks/solvents raise strict EPA considerations—Gravure uses a large percentage of solvent-based inks, predominately toluene. Solvent recovery has been around since 1973, but the need to reduce harmful emissions will continue. Gravure inks are very volatile and require extreme care in handling.

Flexography

Flexography is the modern day adaptation of letterpress printing. Both *flexography* and letterpress are considered relief methods of printing, or printing from a raised surface. Flexo utilizes a resilient photo polymer printing plate rather than the metal letterpress plate. The flexographic industry has been referred to as a sleeping giant. This reference is made because some of the quality issues are being resolved, and flexography is expected to recapture some of the traditional letterpress markets that were lost to offset or gravure.

The flexographic printing process was previously referred to as the aniline process, due to the aniline oils used in the inks. Flexography or the aniline process became pop-

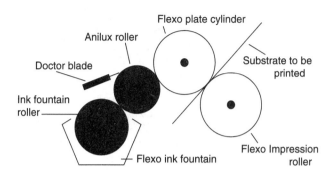

Figure 11-3 Configuration of the flexographic press unit

ular in the 1920s due to the French invention of cellophane for packaging. During the 1940s, the federal government banned some of the aniline inks for food packaging, and thus in the early 1950s the term flexography was adopted. Flexography is one of the simplest printing processes and appears to be most dominant in the packaging industry. In the last decade, there have been efforts to utilize flexography in the publication sector of the industry. Many newspapers are performing letterpress conversions or offset conversions to flexo.

Flexography has been using water-based inks since the 1950s. The early success of water-based flexo inks has made the process very popular with respect to environmental issues. Modern flexo plates are also aqueous and do not require acidic developers that were used in the past (Figure 11-3).

Advantages to the Flexographic Printing Process

1. Versatility and economy remain the principal advantages of the flexographic process—Flexography is considered to be one of the simplest printing processes, and uses rather inexpensive image carriers that can be used for many different substrates.

2. Prints on a wide variety of substrates—Flexography can print on paper, foil, cellophane, adhesive backed stock, or very abrasive substrates. Flexography does not require pH control of the substrate, and can run roll to roll when required.

3. Water based inks have limited pollution and hazardous waste problems—Flexography has been using water based inks in production environments since the early 1950s. Depending on the needs of the product, flexo inks can be opaque.

4. Quick make-ready and changeover of image carriers— Flexo plates can be prepared quickly, and can be mounted to the plate cylinder or platen press using either magnetic, sticky back (adhesive), or other methods. Flexo imprint units can run on gravure presses, and flexo plates can be changed during the gravure run to indicate different newspaper inserts. Flexo plates are very durable and easy to store.

5. Well suited for short or long runs (impressions up to 10 million)—Flexographic plates can be used over and over again. The cost of a flexo plate is less than a gravure cylinder, and can run up to 10 million impressions. Flexo plates are often used for imprint applications, or printing labels that will vary based on size, color, flavor, and/or other product factors.

6. Significant in-line die cutting or finishing operations— Flexographic presses are found in both commercial and in-plant printing operations. Because flexo is dominant in the packaging sector of the industry, many presses have custom in-line finishing operations. It is common for the flexo press to print the bag or package, then glue, sew, fold, die-cut, or seal the container.

Most of the advantages related to flexography are experienced in the packaging sector of the industry.

Disadvantages to the Flexographic Printing Process

1. Quality of high resolution printed images—The flexo process has one major disadvantage when compared to the other processes: the quality of image is not as high. The inks used, substrates used, press speeds, plate material, and other factors contribute to lower quality results of process color images. Even though there has been improvement, four-color process separations remain coarse due to the lower screen rulings.

2. Limitation of fine screen rulings or type sizes—Flexo printing plates are manufactured by rubber and tire companies such as Uniroyal. The plates have very unique capabilities, but often require coarse screen rulings such as 100 to 120 lines per inch. Flexo inks can be either fluid or paste, but high volume flexography often uses a fluid ink that will plug fine details or halftone images.

3. Limitations placed on some categories of original art—Similar to the gravure process, flexography has difficulty in the reproduction of very fine line artwork or detailed serif structure in some type styles. The fluid ink and substrate interactions often distort these images.

4. Lint buildup on plates—Flexographic printing on high speed presses can create a lint buildup from paper dust in the details of the relief plate. Typographical features, screens or artwork can become plugged, and the press must be stopped to clean the image carrier.

Screen Process Printing

Screen process printing is the one process that competes the least with the other processes. *Screen process printing* was originally known as silk screen and/or stencil printing. Unlike the other processes, screen printing push-

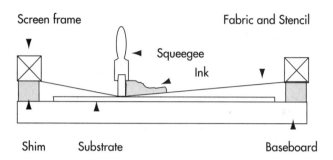

Figure 11-4 Major components used in screen process printing

es a full bodied ink through a stencil opening onto a substrate. Though screen printing is used to print on paper or board stock, quite often the process is used to print other substrates such as wood, plastic, glass, and cloth. Because of its broad applications, screen printing is typically considered to be a specialty process (Figure 11-4).

Screen process printing is used for many applications including process color separations. The difficulty in using screen printing for separations is that the stencil is mounted on a fabric that also represents another screen value. Separations/stencils must be rotated on the fabric to avoid moiré patterns. Process color work that is done by the screen process printing is often done wet on wet, and uses a coarse screen ruling. The rule of thumb for halftone stencils is that the fabric mesh count needs to be three-and-one-half to four times finer than the halftone screen ruling.

Screen process printing is very popular with the textile industry, and is used to print either directly to the fabric, or printed to transfer sheets that are heat transferred. Many t-shirts and popular sportswear are decorated by screen printing. Some decorative images can be ironed on with transfers using tensile inks or transfer sheets that have been printed with sublimation dyes.

Advantages to Screen Process Printing

1. Ability to print on either a two- or three-dimensional surface—Screen printing frames may be ¼ inch flat aluminum that flex or conform to the shape of the object, such as a snow or water ski. A design such as a town emblem may be screen printed on the side of a police car door. Glasses, mugs, and china may by printed using certain shaped squeegees. The screen printing frame and stencil are portable and may be positioned for different production requirements.

2. Ability to lay down the thickest ink film on a substrate (1 to 2 mils)—Using a rounded squeegee blade a very thick deposit of ink may be laid down on the substrate. Braille books for the blind can be produced by this process. UV inks can dry regardless of the ink film thickness.

3. Great variety of inks and substrates to be printed on— Screen printing probably offers the greatest variety of inks due to ability to print on many substrates. Screen printing is a specialty process that often requires ink formulations to be created depending on the substrate. The drying capability of screen printing inks can be enhanced with the use of heat, moving air, and chemical catalysts.

4. Inexpensive image carrier stencils—The image carrier for screen process printing is a stencil that is mounted on the fabric or mesh. Most production stencils are photographically generated, and can be produced quickly and economically. Some stencils are water-based, while others are solvent-based. The choice of stencil depends on the inks used for production.

Disadvantages to Screen Process Printing

1. Slow drying inks and press speeds—Screen process printing is perhaps the slowest of all reproduction

processes. A fast drying screen ink takes between 5 seconds and 15 minutes to dry. A long drying air-set epoxy make take as much as seven days to fully cure. This limitation reduces the number of roll fed screen printing presses, and also limits the number of impressions that can be produced in an hour.

2. Limited resolution of fine details or process color separations—Screen process printing introduces other potential moiré problems due to the fact that the halftone stencil must be angled against the fabric, which also is a screen pattern. Furthermore, when reproducing color separations or halftone screens, the fabric mesh count should be three-and-one-half to four times that of the screen ruling. For example, a 100 line screen halftone would require a fabric with a 350 to 400 mesh count to ensure that the small halftone dots of the stencil are properly attached to the fabric.

3. Limited life of the average stencil material—Screen printing stencils have a relatively short image life. The squeegee action is hard on the stencil, and the screen printing ink will start to dry in the fabric. When ink dries in a multifilament fabric it will plug up the screen openings and begin to change the ink density or image resolution.

Digital Printing Presses

The new generation of digital printing presses provides for a new inked image with every revolution of the cylinder. The Indigo E-print and Xeikon DCP-1 are similar in image transfer to that of the offset press. The digital printing press transfers an inked image from the plate to the blanket, and from blanket to the substrate. There is a 100% ink transfer from the blanket to the press sheet or substrate.

The digital printing press technology was developed for short run color applications, which usually represents 10,000 impressions or less. There are very few digital printing engines available in the world, the Indigo and the Xeikon are the most popular. Xeikon is the marketing name for the original Agfa consortium effort that developed that digital engine. Several of the larger printing companies in the United States have created digital divisions. The digital division would be responsible for accepting electronic files that are expressed overnight, sent over the modem, dumped to their location via T-1 lines and other networks, or transmitted by satellite. The printing company would then route the digital data to an intelligent copier, or digital press for production and finishing. The job could then be sent by courier or overnight service to the customer for distribution. The digital imaging technology reduces the traditional cycle time and provides greater distribution capability.

This technology requires an extensive capital investment that few small printing companies can make. Personnel in charge of this digital printing require extensive electronic prepress background combined with a working knowledge of sheetfed offset operation and troubleshooting. This high technology digital printing has taken a traditional offset press, complete with paper handling difficulties, and combined it with one of the fastest digital imaging processors.

Digital printing presses should not be confused with color copiers. There are only a few manufacturers of the direct digital printing presses in the world. The most visible digital press manufacturers include:

AGFA Chromapress

Xeikon DCP-1

Heidelberg GTO-DI / Heidelberg QuickMaster

Indigo E-Print 1000 (Figure 11-5)

Figure 11-5 Indigo E-Print digital on-demand printing
Courtesy of Indigo

Efforts to increase digital press size, speed and overall
capacity is in progress. New features are being added to these
presses each year, including in-line finishing operations.

Advantages to the Digital Printing Press

1. Turnaround time of printed color images—The ability
 to create tabloid size four over four process color work
 in a matter of minutes makes this a popular choice for
 short run applications. Specialty color work such as
 menus, business cards, announcements, and adver-

Figure 11-6 Examples of image resolution for different reproduction processes. See color insert. *Courtesy of Indigo*

tisements can be produced in limited quantity directly from a desktop file. In select cases, partial runs for a customer who requires only a few hundred advanced copies of a long production run in gravure or offset.

2. Personalization of images on each revolution of the cylinder—Every revolution of the printing cylinder represents an opportunity for a new image. Type matter or artwork, including process color separations may be changed to meet specific requirements of the end user.

3. Excellent resolution and processing time—Both Xeikon and the Indigo E-Print have the ability to produce 150 line and 133 line screen rulings respectively. Technological improvements will enhance screen resolution and dots per inch output. Processing time is currently faster than normal desktop technology. The use of UNIX workstations with gigabytes of storage and massive amounts of RAM enhance the processing of color images. See Figure 11-6.

4. Instant gratification—Digital on-demand printing affords the user real time short run reproduction results that include in-line finishing operations. A complete book or folded product can be delivered off the press.

Disadvantages to the Digital Printing Press

1. High initial cost of equipment—The digital printing technology has been in development for several years, and the products offered reflect significant capital investment, in an effort to capture development costs. Some manufacturers have offered reduced prices on a second machine as incentive to expand the number of units in production, and to provide backup hardware support in the field. Some of the true digital presses were selling in a price range of $220,000 to $500,000. The production environment surrounding this technology requires one or two dedicated desktop prepress workstations.

2. High cost of expendables such as ink and papers—The sales price of digital color printing requires more expensive inks, and in some cases, pretreated paper. It is expected that the initial cost of the hardware will drop, but manufacturers of this technology will profit from the expendable products, which are currently dedicated to proprietary systems.

3. Preflight time requirements to check digital files prior to sending the image to the digital press—One major difference in digital printing is the fact that the operator cannot visualize the image carrier prior to production. The inability to examine a plate or cylinder requires that the digital file must be opened on a prepress workstation and examined for potential problems. This preflight of the digital file requires skilled operators and workstations.

4. Cost effective for only short run, quick turnaround work (niche markets)—Long run color applications are not cost effective on this current digital technology. The press format or size of image is limited to a tabloid or narrow web applications. Some traditional products involving extremely high quality color work cannot be produced.

For More Information:

The following sources will provide you with the additional information necessary to better understand the concepts introduced in this chapter. Due to the recent advancements in this area of technology, the manufacturers remain one of the best sources for training and technical information.

Adams, Mike, and Faux, David. *Printing Technology.* Albany, NY: Delmar Publishers, 1996.

Agfa. *ChromaPress Multimedia CD.* RidgeField Park, NJ, 1996.

Cost, Frank. *Pocket Guide to Digital Printing.* Albany, NY: Delmar Publishers, 1996.

Field, G. G. *Color and Its Reproduction.* Pittsburgh: Graphic Arts Technical Foundation, 1988.

Indigo America. *Indigo E-Print 1000.* Woburn, MA, 1995. Videotape.

The Lithographers Manual, 10th edition. Pittsburgh, PA: Graphic Arts Technical Foundation, 1995.

Evaluation and Control of Color in Printing

Perhaps one of the most difficult aspects of producing high quality printed color pages is in determining whether the color matches the desires of the print buyer. This evaluation or color approval process is often called the "color OK," and it involves representatives for the print buyer working with customer service and press personnel. Prior to this time the problems were in the hands of the creative artist and those individuals doing the film separations, the printer or others involved in the prepress stages of producing the page. It is now time to make whatever corrections can be made, if needed, on press. The stress comes from trying to organize all the steps that have been taken by a variety of other people, and give guidance to the printer that will produce a printed product that will please everyone.

Experienced industry personnel approach the color OK as an opportunity to communicate their thoughts to the press personnel in a way that allows the pressroom to deliver the best reproduction possible for their company and customer. Standing next to the press, or in a room designed to work on color OKs, the experienced sales representative or customer service representative wants to be surrounded by people who know and understand their requests. As one veteran color specialist stated, "I have always considered this a 'team' event where each of us have something to add to the end results."

Despite all of the production planning and organizing that occurs on a color job and the great deal of money on the line for the finished efforts, many production personnel approach the color OK with little preparation. As a result,

they give up much of the control they have had over the printed piece, and allow the printer to make vital decisions that can affect customer satisfaction. Good communication among all involved is a critical concern.

In order to communicate effectively, print buyers or their representatives need to prepare themselves in advance. There are several things that can be done prior to the OK that will help to eliminate the stress, and help your printer give you better results.

Many of the topics and concerns discussed in this chapter are provided by Bob Jose, who dedicated a large portion of his career to working with major companies and trade associations for a better understanding of the color reproduction process. From his early days in production, to the current seminars he provides, Bob Jose preaches the importance of training and better communication as the key to understanding what makes color reproduction acceptable.

How to do a Color Approval

Some color reproduction is acceptable without corrections or the need for a press check during production. These products, such as children's books, tool catalogs, and spot color brochures, utilize color in a less specific way. It is the high quality, and often high volume process color work that requires a press check to determine if the printed reproduction matches the needs of the print buyer. Clothing and jewelry catalogs, annual reports, and other highly descriptive color images must be critiqued and adjusted to match the original image, or the desired image of the print buyer.

Tour the Printing Facility

It is strongly suggested that a lasting relationship be cultivated and maintained with the printer. This relationship often provides timely and dedicated service. If this is a new printer, have them set up a plant tour before they print for you. Treat this as if you were making a major

purchase, which is exactly what quality color printing is. If you were buying a home you would bring along inspectors to help you better understand and build confidence in your transaction. If you were in the market for a new automobile you would want to drive it yourself, and have your mechanic inspect it. You would not make the purchase based solely on the comments of the sales person.

This same situation is true when you deal with a printer. You should get to know the people you will be working with, the facility they work in, and the routines they follow. Remember, when you buy printing, you are not buying an off-the-shelf product, such as you might in a grocery store, what you are buying is custom-made for your needs. Establishing a working relationship with a printer takes time and begins with a sincere effort to understand a printer's capability at a given location.

Prior to the color OK, dig into your files, or pull up your notes or files on your computer. Review the notes that you took during meetings with your creative people, or with those who prepared your digital files, film, and proofs, and re-familiarize yourself with the job. This may sound very basic, but over the time that has passed you can forget changes that were requested, type that was specified, and countless minor requests.

Due to time constraints, printers often have the final proofs with color corrections marked on them. Be sure to bring notes and the most recent proofs you have available. The term "color guidance" refers to the notes or marks on a proof that specify desired changes.

Always carry a magnifying lens or what is commonly called a loupe or linen tester. It is best to use at least an 8X or 10X lens, though some personnel prefer 12X and 20X. The magnification is important for register work, examination of dot geometry, or flaws in the image.

Basic Considerations

Make all your color corrections while viewing the printed piece and proof under 5000° Kelvin standard lighting. Do not compromise on this as no other light source is

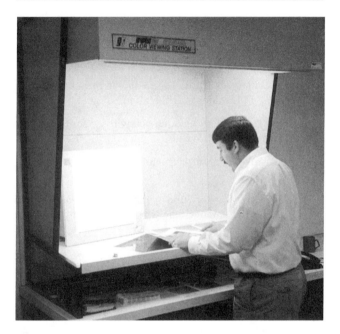

Figure 12-1 Example of a color OK conducted in a standard viewing booth. *Courtesy of American Color*

acceptable. For best results the lighting should be located in a booth that is painted a neutral gray, so that the surround colors do not give you false observations. It is recommended that you carry GATF/ RHEM Color Light Indicator strips to verify the light source as being a true 5000°Kelvin. Remember, if stripes are visible on the GATF/RHEM indicator, the light source is not 5000° Kelvin (Figure 12-1).

Directly in-line with the print job you are working on you should find a color control bar. It is made up of a variety of color and gray patches that can be measured to help maintain the printing and proofing process. Known as color bars, they are placed on the page to give you and your printer specific guidance.

It is not necessary that you become a technician, but you should know that the color bar contains test targets that the experienced press person can use to quickly find problems such as the following.

- Doubling—you actually see a double row of dots when looking at it under magnification.

- Slur—under magnification you will see that dots look like they have little tails.

- Ink trap—the ability for one ink to print wet over another.

- Sharpening—where under magnification you see that dot sizes are smaller than what you have on your color guidance.

- Dot gain—halftone dot geometry can increase in reproduction size based on the combination of optical and physical dot gain. The dot gain is measured by the 50% dot size, and the term total dot gain implies both optical and physical gain.

Talk to your printer about these things. It shows you care and it gives them a chance to show off their expertise.

The printer should be using a reflection densitometer to evaluate the color bar. The densitometer or a colorimeter, or even a spectrophotometer can be used to check the hue and color of the inks being used on press, and a variety of other measurements. The printer has many tools available that should be used before calling for your input or deciding on a compromise.

Press Forms

Press forms are laid out in various ways for the press so that when the printing is folded and finished, they are in proper page order. This is called *press imposition*. At times the way a form is laid out can become a serious problem for you and your color OK. If a very dark overall page is in-line on press with a very light coverage page it can prompt a conflict in color balance and the need to compromise.

Compromise is not a word that anyone, including the printer, wants to deal with, but it is a part of printing. You compromise when you save money by moving to a lower grade paper. You compromise for money's sake, when you accept an ad that is out of specs. With a press in-line compromise your objective is to re-create two pages that are acceptable, maybe not perfect, but acceptable.

Looking at the Press Form

Your job is printed with four plates: cyan, magenta, yellow, and black. The exact alignment of these plates, one on top of the other, is called *register*. This is a mechanical step in the process and even a minor misregister can shift the balance of tones and not allow you to get a good color match. The word minor could be misleading as we are talking in thousandths of an inch. If the printer has done his/her job and all things are in order in the platemaking stages and in putting the plates on press, getting exact register should not be a problem.

However, the quality standards of each printer are at different levels. If when looking at your job you see a misregister of one or more colors; bring it to the attention of the press person. If you are told: "Let's get the color now, and we can get that register problem corrected later on," you are working with the wrong printer. He or she is either trying to keep the press running or lacks the understanding of what that minor misregister can do to a print job. Keep it in mind that a minor correction of register can make a major change in color balance for print results. Register marks should be fine lines or cross hairs, and the images should not bounce during the run.

If you were forced to make color corrections due to production schedules after the release of the color proof to the printer, stop now and see if those corrections show up in the print job. An example of this might be that you had requested a certain area be increased, in tonal weight, by 25% in a certain color. Does it appear to be stronger? It is not necessary that you measure it to see if it is 25% stronger, but did it move in the direction you requested?

Check to see if all type is printing, and printing correctly. Often print buyers assume that this was done when they looked at the proof, or that they already approved the type changes some time back. This may be true, and each of those times were required observations, but there have been mechanical steps, the most recent of which was making the plates, where type can be deleted in processing and can be overlooked by the people in charge of such things. Through a human mistake, the wrong film made prior to a later correction can be picked up and used to make plates. No printer wants things like this to happen but they do. This is your last chance to make a correction, so use the time to give it that last check.

Examine the ink coverage of the type. Is it uniform overall or is it heavy in one area and light in another? This applies to other pages that may follow. To find one page in an article with strong ink coverage and others showing light coverage is not uncommon. Much depends on how focused a print buyer's personnel are to such things. The average reader will not pick up on this, but the print buyer's creative people might be very unhappy.

Looking closely at the color match of an individual page, focus on key areas of concern. Corporate logos should carry a high priority. Close-up flesh tones in a model's face, food displayed, furniture in a room scene, are all high on your priority list, as we all consider ourselves quality experts on flesh tones, food, and furniture. If you need to adjust color and make a compromise in balance, the background areas in most situations will carry the lowest priorities.

The Overall Balance of Color

One of the first mistakes that a novice buyer will make, when they first see their print job, is to zero in on a close examination of a certain subject, or a certain page without first looking at the overall color balance. If you stand away from the print job for a moment or two with the color guidance laying next to the printing, you will often see a dominant color that is too strong, or not strong enough.

For example, you see that overall it appears to be too red, or not red enough. Perhaps the image is too black, or not black enough. The pressman can make an overall correction that will move all pages closer to their color guidance. This is not out of the ordinary and over the years color experts have found that approximately 50% of the time they looked at OKs, that an overall correction at the start, would save many steps down the line as an effort was made to fine tune individual colors.

Tricks of the Trade

Making overall corrections is a fairly simple action on the part of the printer and involves a move to increase or decrease the overall ink flow on the rollers to the plates. In the gravure printing process the ink is mixed with solvents and varnishes prior to printing. Different amounts of a specific gravure ink and solvent will create overall color corrections for that press unit.

There is another action that can be taken for slight moves of color balance and it involves paper. Some paper manufacturers produce white paper with a slight yellow cast or with a slight red cast. Other white papers are manufactured with a slight blue cast. In fact, it is possible to layout twenty-five different papers, from different mills, and create a slight rainbow effect of white paper in a viewing booth.

An example of this would be a publisher who deals with cosmetic printing. This publisher would produce flesh tones, cosmetic products, and printing that require a very light subtle appearance to the overall print job. The publisher would do all the preliminary steps of getting color on a blue/white sheet of paper and get as close to color guidance as possible. If only slight moves were needed to warm up the skin tones the publisher could switch paper to a cream/white sheet. In making this trade of white papers the overall appearance of the cosmetic pages would improve greatly.

The same exchange of papers can be used in reverse. In printing an auto magazine, where colors need only to be

bright with good contrast, a color control expert would start up a new form on a cream white paper, make all the color corrections and adjustments to fine tune it as closely as possible, then switch to a blue/white paper. The average person could only see the changes when they are pointed out to them, but experienced personnel could see colors leap out, and improved contrast and detail. This focuses on the previous discussion about subtractive colors. Black is the absence of all color, and white is the presence of all color. All the color you will ever want to see is already in the paper, the inks are subtracting light reflected from the paper. So if you change that light reflected from the paper by changing to subtle differences in the white paper itself, you get an overall color correction.

Communication With the Press Operator

Unless you have a solid knowledge of color technology and the press itself, do not try to tell the press operator what to do on the press. Accept the fact that the operator is the expert. You are there to voice your opinions on the printed results, not how to get to those results. Rather, point out specific things that you like or dislike and voice your thoughts or comments.

When describing color try to avoid "arty" terms like, "It's too cold, warm it up," or the classic "give it more guts!" The press crew does not keep a bottle of guts handy to make that correction. They need to know what draws your comment. Give them detailed remarks. The terms warm and cold are commonly used in the trade, but understand that they may mean slightly different things. Cold may be blue to one person, paper white or green, to another person. Warm often means red to one person, and possibly yellow to another. From the standpoint of giving directions to the pressman, if you say "Warm it up!" and you are thinking to add red, the operator hears exactly what you said and gives the page more yellow (that is his warm color). When you are dealing with the same creative people you have dealt with for a long period of time, you learn to understand the art terms they use. The press operator seldom

talks directly to that artist. If you want fast, efficient actions on press that will give you the colors you want, stay away from vague art terms that get in the way of communications.

If you feel that the printed sheet looks better than the color guidance you gave the printer to follow, tell the pressman. For many years it was thought taboo to let the pressman know that the printed results were better than the color guidance provided. It was as if the work provided in getting the color guidance was not enough. Also, there seemed to be an unwritten law that the buyer was there to make corrections and must do so. According to Bob Jose, some of the best color OKs were great and needed only minor spot changes. In reference to a major printing plant in Indiana, Bob Jose was reminded of a very complicated four-color job that demanded precise color. After looking at the first press sheets, he signed off on the forms and indicated that the job was as good as it could be, and the press people had done an outstanding job. When the pressman questioned the fact that no changes had been made, he replied, "You did your job. I'm just here to critique it." A little side note was that the word spread in that plant, and it became a competitive thing to try to prepare press forms that needed no corrections.

If your job is printing on a sheet-fed press, ask for a ruled up sheet. Use this sheet to see final trim, page bleeds, check the pagination (are they in proper numerical order) and in general to see if the overall appearance is acceptable. If the final printed product is a folded signature off a web press, ask for a trimmed-out copy for the same reasons. If there are problems, this time was well spent, as it is better to make corrections now, rather than find them after the job is off press.

When you arrive at the point that you feel the printed job is as good as it will get, ask for ten copies off the press. Check them out, and compare them as there can be back-to-back variation. When you are satisfied sign your name and mark "OK to print" on two of them and give them to the printer, as this now becomes the guide for the remainder of the run.

At the conclusion of the press check, take a few minutes and thank the press crew for their efforts. Also if the plant management is available let them know how you felt the OK was handled by the press crew. If you had some problems, tell the production managers. If you felt it went well, also take the time to tell the management. Your participation in this current job is done, but your comments at this time can help the next job to be better.

Specific Concerns for Web Press Runs

The web presses run a great deal faster than commercial sheet fed presses, and for that reason you need to try to speed up the process of offering a color OK These presses must run faster to get proper ink feed through the ink train. Also they have problems with holding the paper in line, as well as drying the ink at slower speeds. The paper waste factor by itself provides major savings from expediting the OK process early in the run. Because of this you should try to establish, prior to the start-up, the maximum number of impressions allowed to reach color acceptability. In other words, how many impressions will be run (wasted ink and paper) to arrive at the OK? The other question is, what must take place if that figure is exceeded? You can reach an agreement on this with your printer as they will know how long it takes, on an average, to get to color. Again, this is not an exacting science, but a fair agreement can be made.

How Controls Work for You

At one time nearly every printer, publisher, ad agency, and film separation house in the country would issue their own printing standards to the rest of the industry. It was an impossible situation that made no sense.

Through organizations like the Graphic Communications Association (GCA), some technical people set up a series of studies that were performed in several major printing organizations. Tests were performed on ink, paper,

densities of ink coverage, dot gain, presses, plates, and other variables.

Keep in mind that all this data was being processed prior to computers, and had to be done at night and on weekends. The individuals dedicated to this cause had to maintain their jobs as they searched for answers. It took thousands of man-hours, thousands of telephone calls, and hundreds of large and small meetings.

As the information became available, it was clear that printers were not producing "dot for dot" (from film to finished results) color images. The facts indicated that even the best of them were getting major dot gain in their printing. Everyone was pointing at everyone else. Printers would on a regular basis, sharpen film before making plates covering up faults in their process, and blaming their problems on the film separators. Seeing what was taking place, film separators would pull their proofs and then sharpen their film (reduce the dot size) before sending it out to the printers. All of this was in an effort to add contrast to the print job, and get away from dull, flat, heavy looking print jobs. An effort to establish a common set of standards was finally working.

SWOP (Specifications for Web Offset Publications)

The Specifications for Web Offset Publications (SWOP) have provided guidelines for the measurement of original copy, film reproductions, proofs, plates, and press sheets. The real value of SWOP is experienced in the ability to assign responsibility for production work to the appropriate source, and hold that source accountable. Remember that the production of high quality color publications requires print buyers, ad agencies, photographers, separators, printers, publishers, and equipment/supply manufacturers.

Specifications for Web Offset Publications defined tolerances and/or ranges for the different production sequences. SWOP has provided a conceptual framework that advances the understanding of process limitations. The SWOP organization continues to update specifications as

technology changes and additional testing yields new data specific to improved color reproduction. It is recommended that all industry participants subscribe to the SWOP literature, and utilize the current edition of specifications.

What About Commercial Sheet-fed Printers?

Many commercial shops still profess their own standards, but if you look closely at those standards you will find enough SWOP standards in them. At first commercial sheet-fed shops rejected the concepts of SWOP or any other outside influences, but they too have benefited from all the work that was accomplished by the web end of the industry. The influence of SWOP on commercial sheet-fed offset has promoted an effort to establish new standards for this market of the industry. The major difficulty in commercial sheet-fed offset is the great variety of inks and substrates.

The number of major quality complaints has dropped significantly in the past twenty years. Furthermore, the quality of print has improved throughout the

industry, due in great part to the influence of SWOP requirements. Because human beings are still involved, the potential for error in judgment still exists.

Some Helpful Facts on the Psychology of Color

To this point color has been addressed as if it were an object that could always be controlled with simple measurements. In reality color is a subjective and sometimes fuzzy thing to study, as it more often than not, is something controlled by whims and habits, rather than by data and logic. The following information addresses some of the topics discussed in Chapter Two, but presented in the context of evaluating color reproductions.

Color by Region of the Country

People tend to believe that a color OK is a simple printed match to the color guidance that was provided. That is

true, but a color OK offered in California versus one in Minnesota, for the same page of printing, may be different.

It should be the same, and could be the same, but the problem is that people see color differently in different parts of the country. The clothing industry has known this for years. In delivering clothing to different parts of the country for sale they know that, on an average, in the sunbelt regions of the country people like bright reds and yellows. They like colors that are bright and clean with sharpness and detail. Why? Because they see those colors all the time and have become accustomed to seeing more brilliant colors in their everyday life.

This carries over into their work life. If they are in a position to influence color they want to move the color to areas they are most familiar with in their everyday life.

What about up north, or in the east? They get sunlight too, but they do not see it as much as the sunbelt people do. People in the north have more gray sky days. They live in a world of pastels, grays, flat dull color days. When they go in to work on a color OK, they too tend to try to make colors more natural based on day-to-day color experiences.

Walk up and down the streets of Milwaukee and you see that most people look like they are extremely conservative in color selection. Dresses, suits, and textile color in general, are less bright and tend to have less impact on the daily lives of people from the northern tiers of the country. Regardless of whether these people would like to argue this information, it is something that can add food for thought in the discussion concerning color differences.

In handling complaints for several major magazines over the years, Bob Jose would perplex the salesperson nuts when he or she called in asking for him to prepare information for an ad complaint. They always wanted to tell him how angry the customer was. They would push on how the customer was ready to pull out future insertions. They would reach a full head of steam by talking about how much of a rebate they might have to give the customer. After hearing them out and getting a few details about the

specifics of the complaint, he would always ask, " In what part of the country does your angry customer live?"

If the ad was one that had a lot of skin tones, and the person lived in Los Angeles, he knew that he should be looking for representative copies that tended to be stronger on red. Why? Because these people see a lot of warm reds and sunburned or suntanned people in their daily lives. If that same ad customer lived in Chicago, he knew that his copies should look more pale and washed out, as that is what people in Chicago see and have become accustomed to seeing in skin tones. It becomes a matter of what seems natural in a given environment.

Color by Time of Day

Now that you have the concepts of color by region of the country, let us refine it another step and go to color by time of day. For this you need to go back in time with Bob Jose, to Des Moines, Iowa where he was Quality Measurement Director for Meredith Printing. In his department there were fifteen people involved in picking up and grading press samples around the clock from twenty-six web presses and several sheet-fed presses. The technicians would pick up two sets of samples from each press, on a random table of times, 24 hours a day.

One set of samples would be graded for quality attributes. The other would be placed in Bob's office each day to aid him in his reports to management. The technicians would write the press number, the time of day, and any other pertinent facts like paper or ink changes on each sample.

This plant often employed quality technicians to view the quality attributes, for two main reasons.

1. Their observations were not only based on print quality, but also on things that they were very familiar with in their everyday life.

2. The quality technicians had made many "saves" for the publishing customers by simply doubting and ask-

ing questions about printing that looked fine to others involved.

Many of the quality technicians were women because several tests had shown that color perception holds some fifteen years longer in women than in men.

Women score better on a color blindness test by a ratio of at least eight to one over men. Women have been used in the paper making industry for quality assurance issues due to their sensitivity to touch, product details and visual inspection. Many industry supervisors have commented on the sensitivity of women to minor color shifts. In the area of quality assurance for color reproduction it is critical to utilize individuals that react to subtle image changes.

One morning, after some problems had been isolated on third shift, Bob Jose's supervisor asked to see copies of different samples. Without looking for any remarks, written by technicians about time of day, the samples were supplied. The questions raised to Bob Jose by his supervisor started a two-year study in the industry.

The questions asked by Bob's supervisor included, "How do you know those came from third shift? You did not even look at the notes on the sample." Bob's reply was, "Because they are blue." Until that moment he had not made that remark nor thought about the fact that third shift tended to run to stronger blues. His supervisor's next comment was, "What if they had been from second shift?" Bob's reply surprised him, "They would be more yellow." The supervisor's last question, "And what about first shift?" To which Bob's reply was "red."

After several dozen more questions they started talking to the technicians who verified what was said. There had to be a reason why three shifts of crews, following the same color guidance, using the same presses and supplies, tended to run to three different color balances. Understand that gravure printers, as well as a few offset people, refer to magenta as red, and cyan as blue. For gravure this is understandable because the magenta and cyan contain enough hue error to plot as red and blue.

Checking out their findings with printers, printing associations, and suppliers of graphic arts materials from around the country, the initial reply was they never heard of such a thing. But after a period of time, the different printers, associations, and suppliers made their own observations, and each one came back with the same results. During this time they gave color tests to everyone involved in setting color. They tried filtered glasses and lights. They even went so far as moving whole crews from one shift to another to see what might result. The press crews would take about two to three weeks before any changes would be seen, then they would start moving to the color of that shift. Remember we are talking overall tendency of a particular shift. One of the really interesting things was that as they gathered information, they put together visuals made up of the individual shift samples and showed them to the crews on each shift. The press crews could see the deviations on the other two shifts, but could not see the color tendency of their own shift samples. They could see the mistakes made by others in matching color guidance, but could not see differences in their own shift match.

About a year and a half into the observations a major meeting was called to include people from all parts of the graphic arts industry to study the phenomenon. At the end of the second week they had come to a conclusion that they were observing a psychological color experience, and drew the following conclusions:

- People who work the normal daylight first shift hours tend to like red. They see red fire engines, red roses, brilliant reds in their everyday lives. When they are working on color match on press, they are paid to match the color guidance as closely as they can. But, like any professional they like to add that little bit of themselves into the job. They are comfortable with red so they tend to add just a little more red.

- People who work the afternoon into evening second shift like yellow. They get up early in the morning and are outside working in the yard, playing golf, or performing daily activities under the exposure of warm

yellow sunlight. When the press crew go to work at 3:15 P.M., the first thing they find is the atrocity being performed by first shift with all that red. When they take over they start cutting red, and adding yellow.

- People who work the night shift like blue. Third shift people sleep all day and wander around in subtle darkness most of the time. They come into the brightly lit pressroom, and work with the same tools that first and second shifts used, but when they see that yellow-mush look of the second shift forms, they move quickly to darker images of blue. Why? Because that is the color that dominates their world.

This varied color between production shifts also answered some questions industry had about having customers in a plant to color OK forms. The customers tended to complain more about results when working with the two night crews. In going back to question these customers, their answers more often than not were about the lack of red in the print jobs. The printers had always known that red was one of the most critical colors they had to deal with, but the printers would hear things like "It is too yellow and they do not seem to want to fix it." Or the printers would hear "It is dark overall and no matter how I try to get them to warm it up, it still comes out dark." It finally became so obvious Bob Jose knew which shift they were talking about by just listening to their complaints.

So how did industry solve this problem? They did not, and it is still happening today. The response was to talk to the various crews and tell them, "If you are on first shift and you have a good match to color guidance, but feel it needs slightly more red, stop and wait for the customer to tell you to add more." On second shift, "Hold back on that move for more yellow." On the graveyard shift, " Watch yourself and be sure you do not add blue." In some plants, they held classes for each shift to explain the findings, and get the press crews input. Not all press crews agreed, but the effort was made to alert them to these color preferences, and in time it did help.

In other meetings with press crews, one of the discussions brought up the topic of customer color preferences. In one printing plant the press crews all knew 'The Purple Lady' who came in to approve color for a publisher who printed women's magazines. This woman always wore purple clothes of some sort, and she would talk about the color purple as if the press used purple ink. Her comment was often, "This area needs more purple!"

Furthermore, the crews had picked up on her preferences, and would prepare her forms by setting the color as close as they could to color guidance, and then add slight amounts of both blue and red, giving the printing a slight purple cast. Management was never told that this was taking place and after she left the plant, happy and content, sometimes the press crews would move the color back to better match the color guidance.

Black and White Forms

When talking about color approval one seldom thinks about black images. Black can be the most critical ink to go on paper as it is the ink that adds contrast to a four-color page of printing, and on its own is seldom accepted by those who approve it without changes being made. One printer worked for a publisher who published three different magazines on the west coast. With approximately 70% of the pages in those three magazines being black and white it should have been easy. The situation was that they had three different art directors; each requesting different levels of black ink coverage.

One of the art directors liked lots of "guts" in his coverage (Contrast and heavy blacks). Another art director liked to say "Give me standard coverage of black" (middle of the road black coverage). The third, a lady, liked it "A little flat."

Without question the most critical black and white printing is for magazines that print bridal gowns! They want to see light black coverage. They want to see delicate lace printing with fantastic detail. Uniform coverage over a

series of pages is an absolute necessity and they will hold the printers responsible for even the slightest variation.

Printers know this, but they also know their presses are great masses of steel that are fed new ink, new paper, and other supplies, on a regular schedule. This flow of materials brings variation into the printing, no matter how many quality procedures are used, or how many people are watching the print job.

Black and white printing is an excellent example of how preparing the film or digital files correctly, prior to going to press, can make a major difference in the levels of quality produced. However, far too often, black and white jobs get the least amount of attention by the buyers. This attitude carries over to those who produce their films or digital files, leaving the printer to try to make the job when it gets to press. That is the worst possible place in the graphic arts chain to try to make corrections. The press is the last chance to correct problems, and is the most expensive place to correct problems. The press has the least chance to correct those problems, as solutions are limited. Provide good film or digital data and you have every chance of getting a good print job. There is no more magic in a printing press than there is in that computer on your desk. It can only output what you put in it.

Clean and Bright is Always Right

Now that is not exactly true, and there are situations where clean and bright printing is not what the customer wants. Industry personnel, over a period of years of answering quality complaints, have established that over 90% of those complaints were due to dull, flat colors, or a simple dirty appearance to the mix of colors.

A sign went up for one printer in the area where quality technicians audited color, and it simply said, "Clean and bright is always right."

As you can imagine this would draw the attention of customers as they came through the offices. Remarks included, "Just match my color guidance," "I'm not always

looking for clean and bright." These comments from different customers would always open up communications. Many understood the complaints from their artists, or from an agency, and how many of them were for a dirty appearance, or for dull, flat looking colors. Few clients will complain because the results were too clean, or too bright.

One film separation house in Little Rock made up engravings and had that motto hanging all over the shop. Yet, with each new generation of customers where it is discussed, we have to go through the same dialogue.

All Good Printers Can Print Any Kind of Printing

You may be very satisfied with the printer you are currently dealing with, so you can just file this one away for some future date when you are looking for a new printer.

Everyone tends to think of printers, as just that, printers. You hear that ABC Printing is a great printer; they are smart, they have good people, they have new equipment, and they can get the job out quickly with few, if any problems. On top of that you have seen samples of their work, and it looked great. So what else is there to know?

You need to first know what kind of printing you are going to ask them to reproduce. You need to know what kind of printing they know how to reproduce. For example, a few years back one of the larger printers in the United States put in a bid and received a multiyear contract from one of the larger publishers in the United States. By all known measurements it was a perfect marriage. Everything went fine until it came time to print. Although this printer had contracts with dozens of other publishers who were happy with them, this new publishing giant was a major problem. After everything settled down it was determined that the printer had never printed the type of printing at the quality levels that the new publisher demanded.

This situation was created through past printing sales for publishers who were primarily interested in hardware

type printing, such as car magazines, hunting magazines, motorcycle magazines, sports magazines, and other publications where critical color was not a major problem. They still had to match color proofs, but they could err on the side of too much color, with no major problems.

The new publisher was bringing in publications that were primarily cosmetic in nature—flesh tones, food items, furniture, critical art, and subtle pastels. The difference between what the customer expected and what he or she received, was much the same as what you might expect and receive when going to a doctor. If you have a broken leg you would go to one doctor, but if you need brain surgery you go to another doctor. Both doctors are equal insofar as their titles, but their capabilities are far different.

The war that developed went on for several years with neither side really understanding the other. Over a period of time the printer learned that they could not just throw on more ink to solve problems. The printer learned that light coverage, with low contrast and smooth breaks in flesh tones, were needed to satisfy the customer. They nearly lost that multimillion dollar contract because they were a hardware printer, who just happened to get a cosmetic publisher's contract.

In this case, the problems were first uncovered by the publisher's representatives trying to get color OKs. They could not define exactly what was wrong at first, but they did know that the printer did not seem to know how to make the kinds of corrections that were requested. The truth was they had never been properly trained in cosmetic printing.

All this tells you that you can break nearly every page of printing down into one of those two groups, hardware or cosmetic. First you determine which group your type of print will fall into. Then you find a printer who has a history of printing your type of printing . Do not wait until you get a color OK to find these things out. Always do your homework first.

Trade Customs

The industry has long established business customs that should be practiced and understood by all who work in the collaborative effort of printing high quality color reproductions. These trade customs have been in existence since 1922, and address both the working relationship between the customer and the printer, as well as how technology applies to the specific job.

These trade customs are not considered laws, but rather daily business practices that will hold up in a court of law. The trade customs have been updated several times by the Printing Industries of America (PIA), with the most recent update being based on technological advancements. Most printers and trade shops will print the standard PIA trade customs on the back of quote sheets, and other customer-related documents. These customs address many topics including: due dates, property rights for creative work, and customer approvals for work in progress. The Graphic Arts Technical Foundation, in collaboration with other industry associations, has published a book that promotes these trade customs.

Conclusion

With the advent of computers over the past twenty years, the speed of the process has been multiplied many times over. Many links in the graphic arts chain that once were considered a "craft" position are now labeled a part of the science of printing, where all actions can be measured.

The requirement of a color OK in the process is one of the few things left that can be considered an art form or a craft. It can be measured after it is completed, but it is accomplished in the printing plant, with feelings and opinions. Your mind and your heart take over, and for that moment in time, mechanical measurements are set aside.

Color OKs are more a marriage of the minds between you and your printer. Again, you do not have to tell the printer how to make moves on press, they know how to do their job. You only need to be clear in telling them your thoughts about how you see the finished results in your mind's eye. Once this communication has taken place, the job becomes less stressful for both you and the printer. Your jobs print better, are more consistent, and are accomplished in less time.

There is no button you can push, no fast measurement you can take, that will speed things up. The whole thing is like a courtship between buyer and printer. If you start out by liking and trusting each other, the marriage of the minds will come. To put it very simply, this is a people-to-people collaboration to gain quality results and value for the printing dollars you are spending.

For More Information

The following sources will provide you with the additional information necessary to better understand the concepts introduced in this chapter.

Bann, David, and Gargon, John. *How to Check and Correct Color Proofs.* North Light Books, 1990.

GATF, NAPL, and PIA. *Graphic Communications Trade Customs/Business Practices.* Pittsburgh, PA, 1994.

Jose, Bob. *How to Do a Color OK.* Graphic Communications Association, 1988.

3M Company. *The Color of Your Business.* St. Paul, MN, 1992. Videotape.

Industry Standards

The development of significant standards in the graphic reproduction area is a relatively recent happening. The advent of the digital imaging in the prepress manufacturing cycle increases the need for the interchange of data in a free-flowing form between myriad available systems. As digital equipment moved upstream into the hands of the creators of information and downstream toward printing and platemaking, the need for standards quickly accelerated. It became apparent that more cost effective methods and faster data exchange needed to be accomplished to allow for integrated systems to increase productivity.

This need was recognized in 1985 by Dr. Tom Dunn of Dunn Technology, and out of his efforts came the various committees on Digital Data Exchange Standards that motivated the entire *Graphic Arts Standards* movement. The need to easily exchange digital data between various systems was the impetus not only for a renewed interest in graphic arts standards in the United States, but it also became the needed focal point for a rejuvenated international standards effort for graphic arts during 1989 in Berlin.

Today the standards movement in the graphic arts is strong and very active. Vendor participation and cooperation is a fact, and the customer and producers of graphic reproduction products are totally involved in the standards making activity, all within the last ten years. This is a remarkable achievement to say the very least, and a tribute to the few who have given so much so that so many can enjoy the fruits of their efforts.

Historical Perspective

In an effort to put the following standards in a user context, a brief historical perspective is provided. The American National Standards Institute (ANSI) standards that affect color print reproduction are of recent vintage. Specifications, the forerunner of standards, go back to the letterpress days in the mid-1930s. Input specifications for web printed publications had their origin in the 1930s when heatset web letterpress made possible the production of large circulation magazines on short production schedules. Since the finished advertising material in a film press ready form, was the product of a number of color photoengraving separators, some semblance of order was required to ensure a uniform film input within the mix of advertising pages in a magazine. Aim points or specifications for proofing of halftone films considering ink color, ink density, types of test targets, proofing paper, and so on, were discussed and implemented by committees representing the advertisers, publishers, and printers starting about 1936. It took until 1972 before committee activity resulted in a comprehensive set of specifications. Unfortunately these specifications were short-lived, as web offset printing supplanted web letterpress within just a few years.

The problems associated with input specifications for letterpress publication printing were found to be the same for offset web publication printing. So, in 1975, the representatives from the print production side of advertising in New York City formed a committee made up of printers, publishers, agencies, color separators, and a few interested suppliers, and Specifications for Web Offset Publications (SWOP) was born. Their major objective was to provide specifications for input films for the color separators of national advertising, printed by web offset (heatset). Over the years SWOP has been expanded to include some criteria for the printer, but the majority of the specifications are still aimed at the color separator and the suppliers.

The initial set of specifications was published in 1975. Updates have been published in 1976, 1977, 1978, 1981,

1986, 1988, and 1993. A basic feature of SWOP, from the first publication to the present is flexibility. The SWOP review committee meets on a regular basis to decide what, if anything, needs to be changed, added, or deleted to keep the specifications in line with the changing technologies and business conditions. In 1988 SWOP was incorporated into a "not for profit" corporation. SWOP is now a registered trademark. All participation is voluntary and unpaid. As SWOP has been for sometime the most visual attempt at standardization, it is often referred to as "standards," which it is not, and in many cases these specifications have been utilized as aims for input films to sheet-fed printing. Because there has been no other specification available within the printing world that has the backing of so many organizations, SWOP has almost taken on the aura of a universal aim point.

Specifications for Non-Heatset Advertising Printing (SNAP) is another organization that runs parallel to SWOP and serves the non-heatset web printers in the same vein. It is common for some industry personnel to make reference to SNAP as the specifications for newspaper advertising printing due to the substrates and cold web offset environment typical of the newspaper industry.

Many of the specifications in the SWOP booklet revolve around color and color measurement. The Committee for Graphic Arts Technical Standards (CGATS) of ANSI, in cooperation with SWOP is undertaking the task of moving those areas of SWOP that are appropriate into the official graphic arts standards mode. When adopted by ANSI in the United States, these standards will be proposed to the international ISO standard group which should be of great benefit to the advertising print media people who work in the global market.

Standards that affect color reproduction in printing are relatively new except for certain limited areas that really evolved outside the graphic arts industry but due to need were integrated into the graphic arts world. Two standards that evolved from photography and had a significant impact on color reproduction concerned itself with standard viewing conditions for color as well as the use of

black and white densitometry for evaluating continuous tone film color separations.

In 1953 a subcommittee of the ANSI Standards committee on photographic sensitometry was formed with the objective of formulating a viewing standard for the appraisal of color quality and uniformity, mostly with color photography in mind. This subcommittee known as ANSI PH2 presented an initial draft in 1968 that was published in final approved form in 1972. In 1972 standard PH2.30 came into being for the first time addressing color viewing standards in the graphic arts. This was really the first ANSI standard that had a direct bearing on color print reproduction. The standard for black and white densitometry came about at the same time and allowed numerical evaluation of continuous tone separation negatives. Both of these standards with some modifications are still in existence today.

In 1969 the International Standards Organization (ISO) founded Technical Committee 130 (TC-130). This committee was charged with developing international standards for graphic arts. At the time ANSI could not find an organization that would take on the task, and thus did not participate in the international graphic arts activity that affected color printing until 1989. What activity that did go on was done by the ISO/TC 142 photographic committee and if it had not been for the National Association of Photographic Manufacturers and one or two people in the graphic arts, the United States would have been totally left out of the international community. The lack of United States participation and the indifference of the global community caused the ISO TC-130 committee to go dormant in 1980. In 1976 at a TAGA meeting, Cal McCamy of The Macbeth Corp. presented a paper on the need for the United States to get involved in standards making, both domestically and internationally. Once again the interest was minimal.

In 1983, the Master Printers of America, a section of the Printing Industries of America, formed a committee on quality control and standards. Most of the major trade as-

sociations participated for a few meetings, but this committee went dormant for lack of interest.

The real standards movement in the United States began in 1985, when Dr. Tom Dunn of Dunn Technology formed the Digital Data Exchange Standards (DDES) group among the vendors of color electronic prepress systems. The need to exchange digital data between systems became evident in the mix-and-match world that the printer was faced with. This was the spark, or hot button, that motivated key people to start the movement toward an accredited ANSI standard. Thus was born the IT.8 ANSI Standards committee in 1987 that provided the standards infrastructure to open the gateway for accredited standards for the graphic arts. From this small beginning the standards movement caused the Committee for Graphic Arts Technical Standards (CGATS) to be formed in 1987 and accredited in 1989.

The IT.8 committee efforts on standards in digital data exchange awakened the International Standards Community interest by the ISO group from the United States. That group was reestablished in 1988 by Dave Mc Dowell of Kodak. In 1989 the United States sent a delegation to Berlin to rejuvenate world interest in digital data exchange standards. As a result the major developed countries in the world are now active participants with a few exceptions. The list of standards that affect color printing is growing every day. The movement is alive and well. User participation is the key to reduced costs and improved productivity.

A simple example of the need for standards was found in an article in a major European newspaper in May 1995. The article pointed out that the organization of European states, in trying to establish common economic grounds between participating countries, had agreed to establish one standard electrical wall plug in an attempt to replace the twenty-four different versions in existence then. This should sound familiar to those trying to move data from one computer manufacturer or system to another.

CGATS/IT-8/ISO TC-130

Prior to the mid-1980s, the standards movement in graphic arts was almost non-existent. Most of the American National Standards Institute (ANSI) standards that existed at that time impacted the traditional graphic arts industry in the areas of safety (mostly machinery), typography (identification of symbols), film measurement (B&W Densitometry), and color viewing conditions. Densitometry and viewing condition standards were actually within the realm of the photographic film manufacturers and were not concerned with the graphic arts applications in their original inception.

The International Organization for Standardization (ISO), Technical Committee 130, Graphic Technology, was established in 1969. This created a European effort toward standardization mostly aimed at packaging printing (testing inks for food contamination). A standard also evolved for publication inks that was utilized mostly in the United Kingdom. ISO activity declined in the late 1970s and early 1980s until it became dormant.

The United States was not a part of the ISO activity until the mid-1980s. The major reason for this lack of United States Graphic Arts standards activity comes from the fact that there was no recognizable standards group that represented the broad spectrum of graphic arts. Thus ANSI had no place to go to for specific graphic arts information or standards interest. One explanation for this is that we do not have a graphic technology industry. We have many industries producing graphic arts products by different processes. These industries operate in parallel, with their own procedures, trade associations, societies, and research organizations, thus creating fragmentation.

To turn this into a positive force that ultimately benefits the customer it is necessary to have a perspective on how standards are formed and used in the United States as well as internationally.

In the United States, The American National Standards Institute (ANSI) is the focal point for coordinating and publishing the type of standards with which the graphic arts industry is concerned. ANSI does not create standards. The ANSI accredited industry groups that create standards are the standards *"working groups."* ANSI does the coordinating and publishing of the working groups' efforts. It should also be noted that adherence to standards in the United States is voluntary. This is not the case in certain ISO countries.

ANSI has many subdivisions. The one under which the graphic arts industry operates is The Image Technology Standards Board (ITSB). ITSB covers television, motion picture, photography, and graphic arts, for domestic issues, as well as for international standards.

The division between office documentation, information and image management, information technology, computer graphics, and graphic arts is not very clear and getting darker by the moment. Various ANSI subcommittees are involved in establishing standards for information coding, office systems, and computer graphics—all of which interrelate to input into the graphic arts world and in some instances replacing or operating in parallel with prepress color electronic systems normally considered confined to the graphic arts industry. Close coordination is required between all standards groups dealing with generating, manipulating, or moving information. In the digital graphic arts world this means pictures, text, and graphics. If one considers all the interrelated activities in the digital reproduction cycle, it becomes difficult to comprehend how all facets will work in concert to satisfy the customer's needs without standards.

The standards that are either in existence today or are being worked on that directly affect the digital graphic arts world come under the following ANSI standards committees.

1. Committee for Graphic Arts Technology Standards (CGATS). This is the ANSI coordinating body for graphic arts that acts as an umbrella group to assist with graphic arts standards development. (Accredited by ANSI in 1989.)

2. Image Technology Committee #8 (IT-8). This group concerns itself with the exchange of digital data between color electronic systems and the peripherals that will feed or be fed by them. This group has now been integrated into CGATS as a subworking group in 1994. It is shown as a separate entity only for reference since many of the existing standards carry the IT-8 nomenclature.

3. International Standards Organization, Technical Advisory Group (TAG-130). This is the group that coordinates United States graphic arts standards with the international standards group through ANSI, coordinated with CGATS.

Committee for Graphic Arts Technologies Standards (CGATS)

CGATS has a dual standards role. It is charged with the overall coordination of graphic arts standard activities and the development of graphic arts standards where no applicable standards developer is available. In 1994, the work of the IT-8 Committee, which developed standards for the exchange of electronic data in graphic arts applications, was merged with the work of CGATS under the administration of CGATS. CGATS currently is composed of an executive committee responsible for planning and coordination, and eight subcommittees. The responsibilities of the subcommittees are divided in the following manner:

- SC1 Terminology—SC1 is developing a standard graphic arts vocabulary and terminology reference.

- SC2 Plates—SC2 develops standards relating to the physical dimensions and characteristics of printing plates.

- SC3 Densitometry—SC3 addresses the application of densitometry to the graphic arts industry, including the definition of characteristics *unique* to graphic arts and halftone applications. It works in cooperation with and builds upon the work of the photographic standards groups in densitometry and sensitometry.

- SC4 Process Control—Develops color measurement and similar process control standards for graphic arts. This involves the selection of appropriate measurement profiles based upon the work of CIE and is closely coupled to the work of the densitometry group. It is also working closely with such industry groups as the SWOP committee to move appropriate industry specifications closer to formal standards.

- SC5 Material Handling—The R & E Council of the Graphic Arts has developed a specification for pallet loading for newspaper inserts. This group is currently working in cooperation with CGATS to create a general pallet loading standard for graphic arts materials.

- SC6 Digital Advertising Exchange—The purpose of SC6 is to develop standards that will enable the distribution of advertisements for print in digital form to publishers and/or printers.

- SC7 Data Exchange—This subcommittee develops standards to facilitate digital transfer of information between prepress systems. It combines three former IT-8 subcommittees addressing organization, content, and transport issues.

- SC8 Color Data Definition—SC8 is former IT-8 SC4 focusing on developing color calibration and communication tools to define the color meaning of the data being transferred. This SC works closely with SC3 and SC4 as well as several of the working groups of ISO/TC-130.

Digital Data Exchange Standards (CGATS) (IT-8)

ANSI Standards for the Printing and Publishing Industry (United States) (Not listed are those standards that apply to safety or typography.)

CGATS.2-1992 Graphic technology - Thickness of aluminum lithographic plates

CGATS.4-1993 Graphic technology - Graphic arts reflection densitometry measurements - Terms, equations, image elements, and procedures

CGATS.5-1993 Graphic technology - Special measurement and colorimeter computations for graphic arts images.

CGATS.6-1995 Graphic technology - Specifications for graphic arts printing Type 1

CGATS.7-1995 Graphic technology - Pallet loading for printed material

CGATS.9-1994 Graphic technology - Graphic arts transmission densitometer measurements - Terms, equations, image elements, and procedures

CGATS.10-1995 Graphic technology - Perforations for printing plates

IT-8.1-1988 User Exchange Format (UEF00) for the Exchange of ColorPicture Data Between Electronic Prepress Systems via Magnetic Tape (DDES00)

IT-8.2-1988 User Exchange Format (UEF01) for the Exchange of Line Art Data Between Electronic Prepress Systems via Magnetic Tape (DDES00)

IT-8.3-1990 User Exchange Format (UEF02) for the Exchange of Geometric Information Between Electronic Prepress Systems via Magnetic Tape (DDES00)

IT-8.4-1993	Device Exchange Format for the On-Line Transfer of Color Proofs from Electronic Prepress Systems to Direct Digital Color Proofing Systems (Revision of IT-8.4-1989, including IT-8.4 Addendum)
IT-8.5-1990	User Exchange Format (UEF03) for the Exchange of Monochrome Image Data Between Electronic Prepress Systems via Magnetic Tape (DDES00)
IT-8.6-1991	User Exchange Format for the Exchange of Die Cutting DataBetween Die Cutting and Electronic Prepress Systems
IT-8.7/1-1993	Graphic technology - Color transmission target for input scanner calibration
IT-8.7/2-1993	Graphic technology - Color reflection target for input scanner calibration
IT-8.7/3-1993	Graphic technology - Input data for characterization of four-color process printing
IT-8.8-1993	Graphic technology - Prepress digital data exchange - Tag image file format for image technology (TIFF/IT)

The following are in draft form and have not yet been approved as ANSI standards (as of a May 1995 release). Approval is expected within twelve months.

CGATS.1-199x	Graphic technology - Terminology for the graphic arts
CGATS.8/1-199x	Graphic technology - Physical plate specifications for aluminum lithographic plates
CGATS.11-199x	Graphic technology - Standard reference materials (SRM) for the graphic arts - General requirements
CGATS.14-199x	Graphic technology - Packaging of Aluminum and Bi-metal plates for plate setters
IT-8.7/4-199x	Graphic technology - Three-component color data definitions

International Standards (ISO/TC-130)

ISO Technical Committee 130, Graphic Technology (ISO/TC-130)

In the United States, TAG-130 is the coordinating group through ANSI. TC-130, Graphic Technology, is the committee within the International Organization for Standardization (ISO) that has responsibility for all graphic arts (printing and publishing) industry standards. Its Secretariat is the German National Standards Organization (DIN) in Berlin. ISO/TC-130 is organized in five working groups (WG) with the areas of responsibility as follows:

- WG1 Terminology—This group is developing a multi-language glossary of graphic arts terms.

- WG2 Prepress Data Exchange—WG2 develops graphic arts electronic data exchange standards, page and document assembly information, reference set of digitally encoded images, and color data definitions standards.

- WG3 Prepress Process Control—WG3 develops standards for metrology, proofing, and printing conditions.

- WG4 Media and Materials—Develops standards relating to the physical characteristics and the associated testing procedures for graphic arts materials.

- WG5 Ergonomics/Safety—Specifications relating to equipment design and safety for the graphic arts.

A list of the various international standards that are either in effect or currently proposed for graphic arts may be obtained from the CGATS Secretariat at NPES.

NPES
1899 Preston White Drive
Reston, Virginia 22091-4367
(703) 264-7200

NPES also has information on other standards efforts in other areas that impact the graphic arts. Also available from NPES is a complete listing of Standards for the Printing and Publishing Industry.

With international acquisitions and mergers of printing companies, ad agencies and publishers, the international exchange of data becomes a necessity. The international standards now become a much more important aspect of doing business. Starting in 1989 the United States, through the USA TAG/TC-130, has become very active in promoting U.S. digital data exchange standards to the international community. As of this writing the United States is the major influence at the international level on digital data exchange standards for graphic arts.

For further information on Graphic Arts Standards contact:

American National Standards Institute
1430 Broadway
New York, New York 10018

Specifications for Web Offset Publications (SWOP)
60 E. 42nd Street, Suite #721
New York, New York 10165

Committee for Graphic Arts Technical Standards (CGATS)
1899 Preston White Drive
Reston, Virginia 22091-4367

Specifications for Non-heatset Advertising Printing (SNAP)
Non-heatset Web Section of PIA
100 Dangerfield Road
Alexandria, Virginia 22314

International Standards Association (ISO)
ISO - TAG/TC-130
1899 Preston White Drive
Reston, Virginia 22091-4367

Glossary

Additive primaries - are red, green, and blue, which represent the broad bands of light energy.

Analog separations - are commonly classified as photomechanical or color separations produced from devices that use non-discrete values or continuous values.

ANSI - American National Standards Institute.

Archiving - is the process of saving completed jobs for future use.

Average daylight - partly cloudy skies between 10:00 A.M. and 2:00 P.M. in the northern hemisphere, provides a balanced white light for the illumination and visualization of colored objects.

Brightness - sometimes used for lightness in describing the third dimension of color.

Bulbous cones - sensors in the retina of the eye sense chromatic vision or color such as red, green, and blue. The cones can also see achromatic color such as white, gray, and black. There are more than six million bulbous cones distributed in the retina of the eye.

Charged couple devices (CCD) - electronic sensor technology that is typically used in the flatbed scanners, and consist of an array of light sensitive elements that are critical in the transition of analog signals to digital data.

CMYK - is the abbreviation used to represent the subtractive primary ink colors and black. The abbreviation of YMCK has traditionally been used because of the light to dark pigment laydown sequence required of many proofing systems and some printing inks. Modern digital color software uses the cyan, magenta, yellow, and black color sequence.

Color correction - is a modification of the color separation that can be either global or local in nature, and is designed to compensate for ink impurities and other factors that create difficulty in facsimile reproduction of color originals.

Color fatigue - a common effect that occurs when viewing a color for a period of time and then viewing another; with the bulbous cones still stimulated from the first color it has an effect on the second color.

Color gamut - is the range of color that a particular color system or model can describe.

Contact frame - is a piece of production equipment that provides intimate contact between film and other light sensitive surfaces during exposures through the use of a vacuum.

Density - can be defined as the light stopping or absorbing property of a substrate.

Dichromat - vision to see contrast from light to dark and still discriminate one color pattern from another.

Digital separation - is created by device that assigns discrete values for the image data, such as 0/1, or on/off binary code, and the digital data creates a separation file that can be stored, manipulated, and archived for future use.

Direct digital color proofing (DDCP) - is a method of proofing directly from a digital file without generating films for photomechanical proofing systems.

Direct system - of color separation delivered screened separation negative films, and included camera back separations.

Electromagnetic energy spectrum - a graphic display of energy wavelengths that include the human senses of sight, smell, or hearing.

Electronic scanning - a system of color separation that became the fastest production method, and ultimately the easiest method of color separation.

File servers - give all computers in the system equal access to all jobs, thus making jobs, computer, and operator independent of each other and will reduce the time spent hunting for jobs in larger offices.

Flexography - and letterpress are considered relief methods of printing, or printing from a raised surface, and flexo utilizes a resilient photo polymer printing plate rather than the metal letterpress plate.

Graphic arts standards - the need to easily exchange digital data between various systems was the hot button that sparked not only a renewed interest in graphic arts standards in the United States but also became the needed focal point for a rejuvenated international standards effort in graphic arts in 1989 in Berlin.

Gravure - a major printing process that uses a fluid ink which is contained in a sunken image cell structure, that when transferred to the substrate is absorbed in a continuous tone fashion, and typically prints from cylinders on a rotary press.

Gray balance - refers to a color separation's ability to reproduce neutral gray values in a reproduction using only the yellow, magenta, and cyan process inks.

Gray component replacement (GCR) - is a software improvement of UCR, which allows the tertiary color, or the weak contaminant color, to determine the level of subtractive primary removal in the three color overprints throughout the entire image.

Grayness factor - a value that is expressed as a percentage, and the lower the grayness percentage the more pure the process color, a color will appear more gray if the level of reflectance for the dominant pigment is less than the substrate that the color is printed on.

Hi-fi color - reproductions that use from five to seven colors, to include the four process colors, and red, green, and orange. The majority of hi-fi color reproductions use stochastic screening in an effort to resolve the moiré issues.

Hue - is the first dimension of color, or the difference between the color of red, blue, or yellow. In color models the hue is plotted around the circumference of the color circle.

Hue error - refers to the fact that a color or hue (process ink) is determined by the values of light that it reflects and absorbs.

Incident light - light source that is falling or striking on the colored object, provides energy that is either absorbed, reflected, or transmitted through the colored object.

Indirect system - of color separation involved additional generations of film exposures because a continuous tone separation was made on pan film through the complimentary color filters which was contacted to a film positive and later contacted to ortho film using a halftone screen.

Ink efficiency - of a process color is expressed as a percentage ratio between its correct light absorption and its incorrect light absorption.

Ink strength - strength of an ink used on press to produce a color reproduction as measured through its complementary color filter using a reflection densitometer.

Key printer - is the black ink used to print text or most line art. The word key comes from the keyline or paste-up that contained the type matter and most line art. The black ink provides the greatest contrast with the printing substrate and is also the cheapest ink for the printing of type matter.

Lightness - the third dimension of color, which defines a specific hue and saturation of color and provides a variable in the lightness or darkness that color appears.

Linearization - a test for an electronic scanner or image-setter which involves measuring the output of a laser light source for a specific film emulsion, under controlled processing conditions, as evaluated by a transmission densitometer.

Local area networks (LANs) - consist of a system that connects all of the computers and printers within a given facility.

Memory colors - colors that are distinguishable because of their common occurrence, such as blue sky and green grass.

Metameric - colors that appear to match under one light condition, but are visually different under another light condition.

Metamerism - the effect of color matches changing in visual appearance under different light sources.

Metamers - is another term used to describe colors that have different spectrophotometric curves, but appear visually the same under a specific light condition.

Moiré pattern - an undesirable geometric configuration that distorts the original image, and is created by not rotating or angling the halftone screens properly.

Monochromat - a person with only the ability to see contrast of light to dark.

Nanometer - is a billionth of a meter.

Offset lithography - takes advantage of the direct lithographic process invented by Alois Senefelder on 1796, but uses a resilient rubber blanket to enhance the quality of printing and to extend the life of the image carrier. Offset lithography involves printing from a two-dimensional image carrier, where grease (ink) and water (fountain solution) do not mix.

Open prepress interface (OPI) - and APR allow the user to generate two copies of an image, one high-resolution which will be used for imaging the final piece, and one low-resolution which will be used as an FPO (for position only) while the file moves through the system.

Photo multiplier tube (PMT) - electronic sensor technology that is typically used in higher-end drum scanners and is sensitive to different wavelengths of the light spectrum. The PMT is not as sensitive as the CCD, but is capable of amplifying the signal, which ultimately produces greater tone throughout the reproduction.

Preflighting - refers to analyzing PostScript files for any defects that will cause problems during ripping and imaging.

Press imposition - when press forms are laid out in various ways for the press so that when printing is folded and finished, they are in proper order.

Process camera - a dominant piece of an older generation of production equipment that may still be used primarily for large format rigid copy.

Raster image processors (RIPs) - converts the digital file through a page description language to the imagesetter or platesetter for imaging.

Register - the exact alignment of the cyan, magenta, yellow, and black plates, one on top of the other.

RGB - refers to the additive primary colors of light, red, green, and blue.

Rhodamine magenta - usually costs more and has a purple cast as compared to the fire engine red of the rubine magenta. The rhodamine magenta produces more pleasing flesh tones and wood grains than the rubine magenta.

Rods - there are around 100 million rods in the retina and they function in dim light conditions and produce monochromatic vision. The rods produce vision in times of low illumination. The rods see black and white or gray tonal values.

Rosette pattern - a tight geometric pattern designed to avoid moiré patterns and blends into the original image, creating the illusion of a continuous tone color image.

Rubine magenta - a less expensive magenta ink pigment that appears bright red when compared to the more purple rhodamine magenta.

Saturation - is the second dimension of color and relates to the purity of a color or hue. The saturation refers to a colors or freedom from gray or impurities.

Screen process - printing was originally known as silk screen and/or stencil printing. Unlike the other processes,

screen printing pushes a full-bodied ink through a stencil opening onto a substrate.

Sensory adaptation - refers to a reduction in sensitivity to stimulation as the stimulus persists for a period of time.

Sneaker net - loading a job onto a movable storage system and transporting it manually from one location to another may sound odd, but it is an extremely fast system for file movement.

Specifications for Non-heatset Advertising Printing (SNAP) - is another organization that runs parallel to SWOP and serves the non-heatset web printers in the same vein.

Specifications Web Offset Publications (SWOP) - aimed at providing specifications for input films to the color separators of national advertising, printed by web offset (heatset), and over the years has been expanded to include some criteria for the printer.

Spectrophotometry - a quantitative analysis of light energy measured every 10 nanometers along the visible light spectrum, and is useful for fingerprinting a color or hue.

Stochastic screening - an imaging technology that uses halftone dots that are all the same very small size, but the number of dots or tiny spots of image vary. Another level of this technology uses different spot sizes.

Subtractive primary colors - are yellow, magenta and cyan. The subtractive primary colors receive their name from the fact that each color absorbs one-third of the white light spectrum.

Tone reproduction - is the manipulation of the printable dot range for the purposes of facsimile reproduction.

Trichromat - refers to a person having the ability to sense or discriminate light from dark and red from green, as well as yellow from blue.

Under color removal (UCR) - is the predecessor of gray component replacement, and is responsible for reducing the use of expensive yellow, magenta, and cyan ink pigments where they overlap in the three color neutral shadow areas, and replacing them with black ink.

Value - is another name used for lightness of color, and is the third dimension that defines a specific hue and saturation of color.

References

AGFA. *An Introduction to Digital Color Prepress* (5th ed.). Agfa Prepress Education Recources, Illinois, 1993.

American National Standard PH-2.30. *Viewing Conditions for Graphic Arts & Photography.* 1989.

Billmeyer, F. W., and Saltzman, M. *Principles of Color Technology.* New York: John Wiley & Sons, Inc., 1981.

Burnham, R. W. *Color: A Guide to Basic Facts and Concepts.* New York: John Wiley & Sons, Inc., 1963.

Chiricuzio, Mike. Manager of Sequel, Phoenix, Arizona, April 1996.

Cross, Lisa. Storage Solutions Rise in Importance. *Graphic Arts Monthly,* 80, March 1996.

Cross, Lisa. Computer-to-plate: Long Wait, Hot Issue. *Graphic Arts Monthly,* 36-42, February 1996.

Cross, Lisa. Building the Digital Infrastructure. *Graphic Arts Monthly,* 38-42, January 1996.

DiPaolo, Roberto. Collins, Miller & Hutchings, a division of Wace. Niles, Illinois, April 1996

Dunn. *Dunn Report,* Volume XI, Number 9, September 1993.

Farallon. Available: (http://www.farallon.com), 1996.

Field, G. G. *Color Scanning and Imaging Systems.* Pittsburgh: Graphic Arts Technical Foundation, 1990.

Field, G. G. *Color and Its Reproduction.* Pittsburgh: Graphic Arts Technical Foundation, 1988.

GAMIS/PIA. *An Analysis of the Graphic Arts Prepress Color Proofing Market.*

Graphic Arts Technical Foundation. *Standards for The Graphic Arts.* 1995 Technology Forecast. Pittsburgh, PA, 1995.

Graphic Arts Technical Foundation. *Trends in Color Proofing.* Forecast Number 30, Pittsburgh, PA, 1995.

Green, Barry. Making the Right Connections. *Publish,* 83-88, March 1996.

Hamilton, Alex. Preparing for Takeoff. *Printing Impressions,* 42-43, February 1996.

Kidd, J.R. *How Adults Learn.* New York: Association Press, 1973.

Kodak Bulletin for the Graphic Arts. *Standard Viewing Conditions for Reproduction.* Eastman/Kodak Company, 1970.

LANs, WANs, & Servers Link the Network. *Graphic Arts Monthly,* 50-54, February 1996.

Linotype-Hell Corporation. *Digital Advertising,* Number 7039, 1994.

McClelland, Deke. Desktop Trapping. *MacWorld,* 114-119, January 1995.

McDowell, Dave. Eastman Kodak Co., *Color Standards Activity In The Graphic Arts.* SPIE Symposium February 9, 1994.

Morton, John. President of Heritage Graphics. Phoenix, Arizona, March 1996.

Nagi, Terry. Preflight: Customer Service, Customer Satisfaction. *HVP.* 30-31, October 1995.

NPES. *Standards for the Printing & Publishing Industry.* January 1995.

PIA. *Technology Benchmarks, Printers' Awareness, use and Assessment of New Graphic Communications Technology.* Virginia: Printing Industries of America, Inc., 1995.

Publishing and Production Executive, *Digital Advertising,* April 1995.

Research and Engineering Council of the Graphic Arts Industry, Inc., *Critical Trends,* 1994.

Romano, Frank. Computer-to-Plate: Hot Technology. *Electronic Publishing,* 12-13, March 1996.

Sheppard, Jr., J. J. *Human Color Perception.* New York: American Elsevier Publishing Company, 1968.

Standards Specifications and Trade Practices. *"Pre" Magazine,* March 1992.

TAGA Proceedings. *Characterization of SWOP Printing,* 1995.

TAGA Proceedings. *International Standardization in Graphic Technology,* 1977.

Thorp, Deny. Consolidated Graphics. Houston, Texas, March 1996.

3M Imaging. *Understanding Color.* Printing and Publishing Systems, 3M Center. St. Paul, MN, 1994.

Verbum Books. *The Desktop Color Book.* San Diego, CA: Verbum, Inc., 1992.

View Guide, Inc. Graphic Technology, September 15, 1994.

Well, Tom. Imperial Lithographics. Phoenix, Arizona, April 1996.

Index